PRAISE FOR THE MYSTERIES OF LORA ROBERTS

FOR THE LIZ SULLIVAN SERIES

"A refreshing and offbeat take on the female detective."
—*San Francisco Chronicle*

"Solid descriptions, realistic characters, and authentic voice...
an original character with heart and soul."
—*Fort Lauderdale Sun–Sentinel*

"Liz is a capable and likable character, and Roberts has
managed to mesh the clean and cozy atmosphere...
with the seedier side of life."
—*Publishers Weekly*

"There is a tension between Liz Sullivan, who is trying to figure out
what's happening, and the cop, Paul Drake, that is reminiscent
of the interplay between V.I. Warshawski and the cops
in Sara Paretsky's novels set in Chicago."
—*Palo Alto Weekly*

"The Liz Sullivan mystery series is American cozy at its best,
but it is even more than that."
—*BookBrowser.com*

FOR BRIDGET MONTROSE'S FIRST APPEARANCE IN *REVOLTING DEVELOPMENT*

"...a solid whodunit." (*Ellery Queen Mystery Magazine*)
"...an appealing central character." (*Belles Lettres*)
"...intelligent characters and a strong plot." (*Mystery News*)
"...an American cozy...wickedly apt." (*Peninsula Times–Tribune*)
"...has a special place in local readers' hearts." (*Peninsula* magazine)

Another
Fine Mess

PALO ALTO MYSTERIES
BY LORA ROBERTS

FEATURING LIZ SULLIVAN
Murder in a Nice Neighborhood
Murder in the Marketplace
Murder Mile High
Murder Bone by Bone
Murder Crops Up
Murder Follows Money

FEATURING BRIDGET MONTROSE
Revolting Development (as Lora Roberts Smith)
Another Fine Mess

Another Fine Mess

A Bridget Montrose Mystery

Lora Roberts (signature)

Lora Roberts

For Sandy — I know you'll never make a mess! (handwritten inscription)

2002 · PERSEVERANCE PRESS/JOHN DANIEL & COMPANY

A Perseverance Press Book
Published by John Daniel & Company
A division of Daniel & Daniel, Publishers, Inc.
Post Office Box 21922
Santa Barbara, California 93121
www.danielpublishing.com/perseverance

10 9 8 7 6 5 4 3 2 1
10 09 08 07 06 05 04 03 02

Book design by Eric Larson, Studio E Books, Santa Barbara
www.studio–e–books.com

LIBRARY OF CONGRESS CATALOGING-IN-PUBLICATION DATA
Roberts, Lora.
 Another fine mess : a Bridget Montrose mystery / by Lora Roberts.
 p. cm.
 ISBN 1-880284-54-5 (pbk. : alk. paper)
 1. Women novelists—Fiction. 2. Artist colonies—Fiction. I. Title.
 PS3569.M537635 A83 2002
 813'.54—dc21
 2001007640

THE FIRST THING a writer learns is that other writers are most generous and helpful. This has been true for me throughout my career, and I wouldn't want anyone to think that made-up characters in this book represent any real persons. Truth is, rich, famous, badly behaved *fictional* characters provide many more motives for murder than do regular folks. None of the characters herein is based on any real person, living or dead.

Many thanks to Kim Allen of the Santa Cruz County Sheriff–Coroner's Office for his illuminating assistance. Any errors in procedure are not his fault; they are most likely dictated by the exigencies of my plot.

And special thanks to Meredith Phillips, an editor in a million, without whose patience and perseverance I could not have completed this task.

Another
Fine Mess

1

"*I'M SICK OF BEING A WRITER*," Bridget Montrose said, slamming her teacup down on the kitchen table. "It's the hardest job in the world."

The other two women at the table looked at each other. "Cleaning sewers is probably harder," Liz Sullivan said, taking the half cookie she'd left on her first visit to the cookie plate.

"Or being the mother of four small children," Claudia Kaplan said with a shudder. "Push that plate over here, Liz."

"I *am* the mother of four small children," Bridget said gloomily, with an automatic glance into the living room, where Moira, two and a half, watched "Blue's Clues." The three boys were still in their various schools; she would have to go pick them up in half an hour.

"But at least you have writing as an outlet," Claudia pointed out, selecting her cookie carefully.

"I'm a one-book wonder, that's what I am." Bridget peered into the teapot. "There's no more there there."

"Tea's gone?" Liz looked disappointed.

"There's tea," Bridget explained. "But not book."

"Did you do what I suggested?" Claudia passed her cup over.

"Yes, I did. I applied to the Djerassi Ranch and to the Ars Foundation to attend one of their writers' retreats. Not that I will get in."

"I bet you'll get into both," Claudia said. "How long ago was that?"

"Couple of months. Back in February, when I saw the announcement in *PoetTree*." Bridget waved the cookie plate away when it came by. Supposedly she made the cookies just for the kids, but it was her jeans that had been hard to zip that morning. "You'll see. I won't hear back at all. And even if I do, I'm not sure I can go. After all, someone's got to herd all these children."

"Emery can do it," Claudia said, callously signing up Bridget's husband. "After all, they're his kids, too."

"I'll help," Liz promised. "I can do the carpool thing for you. I want you to write that book, Biddy. It sounds really great."

"It sucks," Bridget said, taking the last drops of tea for herself.

"Somebody's in a negative mood." Claudia pushed back her chair. "Look, I know you have to go get the kids, so I'll take off." She stood, a tall, queenly woman somewhere between sixty and seventy, with a length of Guatemalan cloth patterned in purple and yellow flung around the shapeless knee-length black dress she wore over black leggings. Her unruly iron-gray hair was inadequately confined by a purple scrunchy and a large silver barrette pierced with a turquoise-set pin. "Thanks for the tea and cookies. You make the best cookies in Palo Alto."

"Right." Liz stood, too, looking small next to Claudia. She was about five-foot-two, in her mid-thirties. Bridget didn't know her exact age, because Liz rarely talked about herself. She had once, to Bridget's horror, impatiently seized a pair of kitchen shears and cut her own hair in five minutes. Peering into the mirror beside the cast-iron sink of her ancient cottage, she'd held up hunks and snipped them off. The end result had actually

looked good on her, a fashionably ragged bob of shiny brown hair. Eyes that varied between brown and gray, depending on her mood, had a sharp, penetrating gaze that was often veiled by thick brown lashes. She was self-effacing to the point of fading into the woodwork. Claudia and Bridget were on the short list of people she trusted.

When Moira danced in and glommed onto her leg, Liz smiled with delight. "Here's my girl." She ruffled Moira's red curls. "Barbie overalls?"

"Barbie everything," Bridget confirmed. "I thought she wouldn't know the difference between boys' clothes and girls' clothes for a while longer, at least, and heaven knows I have tons of hand-me-down boys' clothes, but she wants everything pink."

"Pink," Moira screamed. "Pink, pink, pink!" She whirled away from Liz and hopped over to the table, chinning herself on the edge. "Cookies!"

"Ask politely," Bridget chided.

"Pul-eeese!" That was Moira's idea of polite.

Moira's uncontainable energy came from missing her usual morning excursion to the park to work out the kinks. Her mother, reflected that beleaguered woman, holding the cookie plate for Moira's inspection, had been holed up in the study, letting her precious offspring watch cartoons while she "wrote," which these days was a euphemism for staring at the computer screen in increasing desperation.

Liz knelt and tied Moira's flapping shoelace. "Hey, cutie. Want to come to my house and look for worms?" She glanced up at Bridget. "I could take her with me now, and you could drop the boys off after school. That would give you a couple of hours before dinner time."

"You're very sweet to offer," Bridget said. "I'd take you up on it, but I've already wasted a lot of time today trying to write, and now I've got to get groceries and do laundry and call that architect."

"So you guys are finally going to remodel?" Claudia cast an

eye around Bridget's kitchen, which, like the rest of her house, had been unchanged since some daring remodeler in the 1940s had installed a streamlined white Wedgewood stove and an enameled cast-iron sink unit, probably the height of modernity then.

"Kitchen, pantry, two bathrooms, and the back porch. If the architect ever turns over the plans and we can find a contractor." Bridget winced, thinking about the expense. "Lucky my first book made all that money."

"Luck had nothing to do with it," Liz said stoutly. "It was a very good book. And your next one will be, too."

Bridget shook her head, but she didn't speak her thoughts aloud. When she said she was going to give up writing, Claudia and Liz, both writers themselves, took that as meaning that she needed to be encouraged, patted on the back. They didn't seem to understand that she was serious.

"Worms," Moira demanded. "Me want to go dig worms."

"I want to dig worms," Bridget corrected absently.

"No, me!" Moira tugged at her hand. "Dig with Aunt Liz."

"What about Aunt Claudia?" Claudia leaned over and seized Moira, swinging her up into the air with strong, gnarled arms. "I've got worms to dig, too."

Moira shrieked with laughter and dropped her cookie.

"Claudia, you'll kill your back." Bridget caught Moira's cookie before it hit the floor.

"She's heavier than she used to be," Claudia complained, lowering Moira to the ground. "You must be feeding her."

"Occasionally."

"You'd better let me take her," Liz said. "A little digging is just what she needs."

"She'll tear up your garden."

"Not at all. I'm harvesting a whole patch of beets, so she can help pull those, and dig the bed up, and plant something else." Liz's little house a couple of blocks away had more garden space than floor space, which was just the way she liked it. She grew

organic vegetables for herself and her friends, and sold the left-overs to local restaurants.

"Mom," Moira said, with one of those lightning switches from toddler to preschooler that had been more frequent lately, "I want to help Aunt Liz."

"Okay. Get your jacket. The old one," Bridget called after her. "Thanks, Liz. I really appreciate it."

"It's fun for me." Liz ducked her head. Though she was involved with Bridget's friend, police detective Paul Drake, Liz had always resisted the idea of marriage, and at one point she'd confided to Bridget that she was unable to have children. Bridget's instinctive sympathy had been firmly squashed by Liz's assertion that she didn't want children of her own. But she'd been part of Moira's upbringing from the get-go, and seemed to enjoy her position as honorary aunt.

With Moira jigging impatiently up and down, Bridget walked Claudia and Liz to the door. "Thanks for stopping by," she said, giving them each a hug. "I appreciate the moral support."

"We shouldn't have stayed," Liz said, worried. "We took your writing time."

"You took my staring-at-the-screen time," Bridget corrected.

"Your mail's come." Claudia handed over the bundle that had been left on Bridget's steps. "I see they can't make it up the porch steps to the mail slot anymore."

"I told the carrier to just leave it on the step," Bridget said, leafing through the bundle. "The noise of it coming through the mail slot used to wake Moira up from her nap, even though her brothers can argue at the top of their lungs without disturbing her in the least."

"She doesn't nap anymore, does she, though?" Liz held Moira's hand that wasn't clutching a cookie.

"Not much," Bridget said with a sigh. "Seems like that was over way too soon." She stopped abruptly, holding up one envelope.

"What is it? Bad news from the IRS?" Claudia scowled. "Those bast—" She looked down at Moira's interested face. "Those rotten people sent me a ridiculous letter about estimated tax this year. I'm going to have to explain to them that when I get paid by my publisher on a quarterly basis, I'll be glad to cut them in on the deal."

"If you were poor enough," Liz said, with a tinge of smugness, "you'd be getting your refund now. I did my taxes in half an hour in February, and got my check a couple of weeks ago."

"I'll get mine done by the fifteenth," Claudia grumbled, "but I'm paying under protest." She nudged Bridget. "What is it, then? You're in a trance."

Bridget looked up from the letter she'd opened. "It's from the Ars Foundation," she said, gulping a little. "They're pleased to offer me a fellowship to their next writers' retreat at Ars Ranch, at the end of April."

"Only three weeks away. It's a perfect time for you," Claudia crowed. "See, I told you you'd get in. You're going to love it, Biddy. The place is beautiful—one of Julia Morgan's buildings to begin with, though I suppose it was extensively remodeled when Norbert Rance got hold of it. No one will expect you to make cookies. They had the most splendid meals when I was there a couple of years ago."

"That's great news," Liz said, smiling. "All you have to do is line up some child care and pack your bag."

"Right," Bridget said. She felt dazed. One minute, she was a harried housewife whose first novel had just happened to luck into a brief moment of glory on the *New York Times* best-seller list, and whose second novel was refusing to be written. The next minute, she was going to a tony retreat, with two weeks of nothing to do but write.

Somehow, it just seemed too good to be true.

2

THE YOUNG MAN behind the counter of the Davenport Cash Store accepted money for the iced tea to go and looked around for the take-out menu Bridget had requested.

"You staying in the area?" Despite his youth, the man's deeply tanned skin was furrowed; his sun-bleached hair was pulled back with a leather thong. Blue eyes, perpetually narrowed, were fixed on the ocean horizon he could see behind her, through the big window that faced Highway 1 and the bluff that descended sharply into the Pacific. Bridget wondered if he was looking for whales. She had field glasses in her tote bag, hoping to spot a fluke or two herself.

"Yes," she said, realizing that he was waiting for her to reply, his hand holding the take-out menu poised, as if her failure to answer correctly would result in a withdrawal of the favor. "I'm going to Ars Ranch."

She blushed a little as she said it, trying to draw out the Latin word to keep it from sounding like someone with a bad British accent naming naughty body parts.

The young man appeared to see her for the first time. "Oh, yes. Ars Ranch." He said the name broodingly. "So who's on tap this time? Not painters."

"How do you know?" She was amused at his perception. "Don't I look like a painter?"

"No." He nodded at her hands. "They always have paint under their fingernails. Let's see. Poets? They drink a lot. We serve wine and beer until ten, so tell them all to come here."

"It's flattering of you to think I'm a poet." Bridget hadn't dressed like the poets she knew, in flowing garb or striking hats. She wore the Urban Matron Uniform of loose linen pants and jacket, nice T-shirt not yet stained by contact with her daily life, and a random jumble of beads she'd strung herself, the modern version of the twinsets and pearls of her mother's generation. She was nearly thirty-eight, trying to come to grips with looming middle age. She was starting to look, God help her, dignified.

She felt dowdy and conservative among the exotic wares featured in the shop portion of the Cash Store. Flamboyant shawls, tiny tank tops that said they were her size, but which didn't appear equipped to cover even a portion of her torso, and chunky jewelry were interspersed with locally crafted glass and pottery. She had only meant to get iced tea, but had found herself browsing instead. Hoping for flair, she'd been unable to resist buying a pair of bone-and-glass earrings and putting them right on. Evidently, they had worked.

"You're not a poet?" The young man pulled back the menu.

"Just a writer." Bridget caught herself. "I mean, a fiction writer. Not a poet, really."

She wrote poetry. It just wasn't very good. But lately, nothing she wrote was any good. That was why she was all but apologizing to this young surfer dude for not being what he thought she'd be. She was disappointed, too.

"Writers, huh." The young man showed momentary enthusiasm. "Do you know who else is coming?"

Bridget eyed him curiously. "I know a couple of the names. Vicor Sunjupany, for one." She said the name with some reverence. "He is a poet, actually."

The young man shrugged.

"You know. He won the Agner Prize, and was short-listed for a Pulitzer."

"Anyone else?" The young man sounded nonchalant, but Bridget caught a certain tension in his voice.

"Um, let's see. They sent me a list, but I don't remember— oh, yes. Johanna Ashbrook."

The young man turned away, but not before she'd seen the flicker of recognition in his eyes. She hoped he was impressed. She'd been rather impressed herself, to be attending a writers' retreat with the likes of Vicor Sunjupany and a perennial best-seller like Johanna Ashbrook.

The young man turned back with a second piece of paper in his hand. "Here's the lunch express menu, too."

"Okay." Bridget snatched the menus before they were withdrawn again. "Is the food good there? At Ars Ranch?"

"It's not the food that's the problem there." He looked at her straight-on. "You tell the big dude for me that there are no private beaches in California. And even if he thinks he owns as much stuff as God, he doesn't own the surf."

"Um. Well, I don't actually know him. I mean, I've never met Mr. Rance. I'm not even sure he'll be there." Bridget tucked the menus hastily into her bag and seized her cup of iced tea before the young man pulled that back, too. "I take it you've had some run-ins with him."

"We all have." He made an expansive gesture that could have meant all humankind, but which Bridget took to mean all the local surfers. "There's the sweetest surf break at Ars Beach, and the beach is pretty nice, too. But he gets his goons to try to run us off." The young surfer reconnected with her briefly. "There'll be trouble some day soon."

"I hope not. I'm sure things can be worked out." She backed toward the door, clutching her tea. "I mean, that sort of thing is hardly worth violence, you know. It can all be handled."

"Yeah, sure." He'd already lost interest in her and returned his gaze to the ocean.

Bridget didn't linger to ask him about the whales. She stopped just outside the doors of the old building that housed the Cash Store to tuck the menus deeper into her tote.

Davenport itself appeared to be just a wide place on Highway 1 between Half Moon Bay and Santa Cruz. A huge cement factory had been the first thing she saw driving into town. Then a cluster of old wooden buildings, the stone jail about the size of a well house, and a few streets meandering east from the highway up and down steep green hills and valleys. She knew the town hosted several artisans, including a notable glass studio, but it was growing late, and the ocean claimed her attention.

It was certainly something to look at on a clear Sunday in April, with the sun poised for its afternoon descent. She waited for traffic to abate, then scuttled across Highway 1 to stand with a couple of other gawkers on the rocks that led so abruptly down to the sea. She didn't get too close to the edge. At this height above the water, the danger of being swept into the waves was nil. But heights bothered her, and the cliffs looked crumbly.

The water stretched away beneath her, silver and blue and gold. To the north, the headlands met the water; on past them, she knew, was Half Moon Bay and eventually San Francisco. South, the land curved outward again, flatter and green with cultivation. If she drove another half hour that way, she'd be in Santa Cruz.

It was over an hour since she'd left Palo Alto, and her hectic house full of children. This morning, she'd been ready to get away for two weeks.

Now she was ambivalent. She missed the heavy weight of Moira in her arms, even as her ears blessed the absence of incessant questioning. She worried about Corky, who at nine was beginning not to like school. About Sam, too often overlooked next to his flamboyant older brother. About Mick, dueling with Moira for both physical and emotional space.

They would survive the next two weeks. They might even

thrive, learn new responsibilities. But would she survive away from them?

She set her tea on a convenient boulder, took out the ancient field glasses Emery had gotten from his father, and struggled to focus them, trying to remember the instructions Emery had given her in that patronizing tone men adopt for explaining the needless complexities of their toys. After spending a while adjusting this knob and that, she admitted to herself that she'd never manage. April was late to see whales anyway; most of them migrated along the California coast during February.

Another dash across Highway 1 and back to the car. She'd left Emery the rusty old Suburban that hauled their offspring around, and taken his Toyota. It felt liberating to drive such a small car after lumbering around for years. Her apprehension about the writers' retreat, even the surfer's somber warning, faded as she swooped up and down the rolling hills.

The highway swung inland around some low bluffs just as her mileage indicator told her she'd gone the requisite distance south of Davenport. Bridget slowed for the turn, which looked like a farm road meandering westward through brussels sprout fields that stretched over the ground like a knobby gray-green carpet. The road went downhill and around another bluff. Ahead was an elaborate but sturdy wrought-iron gate twining around the letters AR formed like a cattle brand. The road turned due west to parallel a high wall.

Bridget stopped and rolled down the car window to announce herself to the black box mounted beside the road. The gate swung open to let her drive through and swung shut behind her.

Such high security made a shiver run down her spine. Of course, a multibillionaire like Norbert Rance would have security everywhere, even in a place where his only guests were harmless artists like poets, writers, and painters.

Rance, a Houston-based tycoon, had made his money in oil and real estate, but he considered himself a patron of the arts, a

Medici of modern times. The Ars Foundation endowed chairs at several universities, sponsored exhibitions, and ran the ranch as a creative retreat for artists.

Bridget still wasn't sure why she had been chosen to participate, having published only one novel. She was just grateful to have some time to herself to see if it was possible for her to build on her unexpected success, or whether she should just accept that she had, as her grandfather would have succinctly put it, shot her wad.

The attention from that one amazing success had been nice to begin with, but she had quickly found it overwhelming. Her publisher sent her on tour to several major cities in support of the book, and that time away had been hard on her family as well. At least the extra money had enabled her to hire someone to take the kids on their endless errands, and Emery had produced the meals, which toward the end had consisted almost entirely of fast food.

And everyone kept asking about the next book. Her editor was getting insistent, offering more money than Bridget had ever thought herself capable of earning. Her agent was sympathetic, but urged Bridget to make the most of her new-found marketability. In every interview, every reporter said, "So, what are you working on now?"

She had only smiled. "I really can't talk about that."

The driveway curved through lush landscaping, with palms and ferns shutting it in, then curved again, and she was poised atop a gentle slope into the courtyard of the ranch house.

From this vantage, she could see the whole layout. The red tile roof of the ranch house contrasted pleasantly with the textured fields of brussels sprouts that sloped upward to block the view of the now-invisible highway. Surrounded by head-high walls, the main building faced west. She glimpsed the sparkle of water behind it, where red-roofed outbuildings edged a manicured garden.

Bridget drove down the narrow road, through an archway

that displayed the Ars Ranch brand, and into a courtyard centered by a stone fountain where dancing shapes sprayed water into the sky to catch rainbows. She pulled over at one side of the fountain, and instantly a young man came running through the courtyard from the arch on its other side. Behind him through that archway was a long, low stretch of covered parking.

"Let me take that for you," he said, holding out a hand for the keys. "Your bags?"

"Um, in the back." Bridget handed over the keys, not sure what the etiquette was in such a situation. The young man heaved out her bag, and she hefted the smaller case with her laptop in it. "I'll just wheel it," she said, plopping the laptop on the suitcase and pulling up its retractable towing handle.

"Right in there," he said, pointing toward the center section of the house, which soared into the sky, Julia Morgan's turn-of-the-century interpretation of ancient mission churches. Massive, iron-bound wooden doors were approached by a few steps up a brick veranda. On either side, colonnaded walkways fronted two-story wings.

The young man screeched off in her Toyota, and she turned to watch it through the narrow archway. Then she saw the ocean, and forgot about possible scratches to Emery's treasured car.

The house's center section faced the sea, with wings on either side of it reaching west. From the courtyard, the view was spectacular. Where the cobbled yard ended, a long swath of green lawn sloped downward for several hundred feet to a waist-high retaining wall. Beyond it, the waves crashed and foamed, the noise of the breakers like distant music. Then the deep, deep blue merged seamlessly with the blue arch of sky.

Dazzled, she turned slowly around, taking in the huge terra-cotta urns planted with rampant scarlet geraniums, the mounds of ceanothus and rosemary in flowerbeds along the colonnades, the roses with their fresh new foliage. It was like being on a movie set.

She took a deep breath of salt-scented air, and trundled her suitcase toward the studded double doors. Perhaps her apprehension about the coming weeks was misplaced. Perhaps here, in this beautiful spot, she could overcome the terrible writer's block that had begun to consume her self-confidence.

3

BRIDGET MADE ENOUGH noise towing her suitcase over the cobblestoned yard to announce the arrival of a whole regiment of writers. One of the big wooden doors opened, and a woman barreled out. She was tall, at least three inches taller than Bridget's medium height—or perhaps her height came from the heels on her cowboy boots. The boots were white with peach accents and silver cording around their curvy tops. Tucked into them were white stretch pants, which drew Bridget's fascinated gaze up to the white shirt, resplendent with a peach-colored Ultrasuede yoke and little heart-shaped peach patches at the ends of the upswung, western-style breast pockets, all outlined in silver piping. The shirt had enormous shoulder pads, and between them the woman's head rose like a football player's, her hair a shiny platinum helmet.

"Y'all one of our writers?" Her flat, Texas-tinged voice was a bit loud and proprietary.

Bridget choked down her instant urge to deny being anyone else's writer. "Bridget Montrose." She held out her hand.

"Yes, of course." Taking her hand in a hearty grip, the woman beamed at her through a mascaraed forest surrounding blue eyes. "I surely did enjoy your book. It had a real story, not like a

25

lot of people's books." She towed Bridget, who towed her suit-
case, up the terrace steps and through the double doors into the
house. "Welcome to Ars Ranch."

"Thank you," Bridget mumbled, trying to reclaim her hand.
She let go of her suitcase, taking a firm grip on the laptop.

"I'm Sharon Buskins. Norbert and the Ars Foundation have
entrusted me with the care and feeding of their artists." The pro-
prietary note was particularly noticeable when Sharon spoke of
Norbert Rance. "I hope you'll feel very much at home here."

"I'm sure I shall." Bridget looked around. Homey was not
the word that came to mind. Imposing seemed more apt. The
entrance hall was nearly as big as her whole house, with a spiral
staircase in one corner leading up to an encircling gallery balus-
traded with carved dark wood.

At one side, a massive archway opened into an even bigger
living room. Thick white stucco walls with rounded corners sug-
gested early California. The beams in the high ceiling were hand-
hewed timbers. On the wall facing the archway was a huge stone
fireplace, with a rough-hewn mantel. Cabinets on either side of
the fireplace held an eye-catching display of art glass and other
precious objects. Large multipane casements at the front of the
room looked over the lawn to the ocean; French doors at the
back of the room opened onto a terrace and large walled garden
centered by a vine-covered pergola and lavishly tiled swimming
pool. Over the garden wall, Bridget glimpsed the outbuildings
she'd seen before driving into the courtyard, and the tall fence
surrounding a tennis court. In the distance were the green fields
that shut the ranch away from Highway 1.

While Bridget gaped at the opulent vision, Sharon continued
talking in her flat twang.

"Yes—" she pronounced it with two syllables, *yay-us* "—I
couldn't put your book down. It was something! I really fell for
Stephen."

"Umm," Bridget said, staring at the immense fireplace. She
had a hard time when people complimented her book, like the

parent of a gifted child who can't take any credit for the child's precocious success. She had loved writing the book, loved the book itself and how it turned out, and sent it into the world hoping a few kindred souls would like it, too. That it had appeared, for however short a time, on the national best-seller list was still astonishing to her. People who apparently didn't even know how to read had bought it and told her how great it was, discussing it in terms that made it clear they were confusing her novel with the latest Mary Higgins Clark. Or they had argued with her about the ending, or about the characters. Her book had ceased to be her sweet child, and become a public monster.

Even more disconcerting was to share with the world characters she had created for her own gratification. Not even Emery had realized how much Stephen in her book was Bridget's own private fantasy.

Sharon took the handle of Bridget's suitcase. "Well now. We've put you in one of our nicest rooms."

"I can take the suitcase." Bridget made a futile grab for it, but ended up following Sharon as she turned away from the giant living room. Across the hall, another set of massive, iron-studded doors stood open to reveal a long polished table and chairs. Sharon's boot heels clicked on the tiled floor, an accompaniment to the rattling wheels.

"It's nothin'." Sharon turned into a carpeted corridor, and Bridget realized they were in the northernmost of the two wings that bordered the front courtyard.

Sharon opened a door and stepped back. "Here it is. The Gertrude Atherton Room."

Bridget entered, and Sharon followed her, heaving the suitcase onto a luggage rack. The room was bright, with a big window in the end wall through which she could see the ocean, and French doors opening onto the colonnaded veranda that faced the courtyard. A private bathroom opened off the room. An armchair sat invitingly by the French doors, next to a little refrigerator topped with a small microwave oven. The pencil-post bed

sported a colorful duvet that matched the curtains at the tall windows. There was a phone on the bedside table, and a desk at a right angle to the window. No television.

"You know the drill?" Sharon lifted her eyebrows. "We put out a breakfast buffet every morning at seven, and a lunch buffet at noon. Whenever you decide to eat, there'll be something available. There's a swimming pool, tennis court, and fitness room. You can walk on the beach. The only rule is, no disturbing the other writers in their rooms. We all meet at seven each evening for drinks and dinner, and sometimes we have a guest speaker. The rest of the time is yours, to nurture your muse."

"It sounds like heaven," Bridget said, concealing a wince at the idea that she even had a muse, let alone that she had to nurture it. Daily life required way too much nurturing on her part. If she had a muse, she wanted it to nurture her.

"I'm the house administrator, so if you need anything, just let me know." Sharon nodded toward the phone. "You can buzz me on that, or make outside calls with your phone card."

Bridget planned to keep in touch with e-mail, as that was the surest way to get hold of Emery during the day. She nodded and smiled.

"I'll leave you to it," Sharon said, going to the door. She pointed at the desk. "There's an outlet there for your laptop, and we have one of those fancy Internet connections that's always on. Good luck with your writing."

Bridget shut the door behind her and took a moment to shake off the echoes of Sharon's well-meaning but strident voice.

So here she was, actually at the Ars Ranch, selected to receive one of the coveted fellowships for two weeks of intensive writing time. When she had wavered about spending so much time away from her family, Claudia had told her in no uncertain terms not to be an idiot.

"You'll really benefit, Biddy," she'd said, looking around the chaotic living room, where Mick watched the Science Guy on TV, Moira banged blocks into holes with a wooden hammer,

Sam slathered papier-mâché around a blown-up balloon to make a model of the moon for second grade, and Corky entertained a fellow fourth-grader with air-guitar versions of Ray Stevens songs. "You'll never write a word here."

"It's quieter when they're out," Bridget had said feebly. But it was true that it wasn't just the turmoil of her daily life, which was considerable. Inner turmoil made her dither even when the boys were in school and Moira was at a friend's house.

She'd left the inner turmoil behind, or at least she prayed so. She would work hard during her two weeks, and she would have something to show for it at the end. She'd better. Everyone was expecting it. Emery had rearranged his schedule at a very turbulent point in the life of his little software publishing company. Friends had been lined up to care for Moira and the boys after their various school incarcerations ended each day. All of them expected their efforts to accomplish something for her writing career. And fans sent letters, asking for the next book. Her agent offered solicitous comments about the next book. Her editor wrote e-mails, demanding the next book.

Without unpacking her clothes, Bridget carried the laptop over to the desk and set it up. She might have written and published only one book, but she knew already that luck had little to do with writing. It was work that did the trick, and she needed desperately to work.

4

AT FIRST TENTATIVELY, then with growing enthusiasm, she wrote. Words found their way onto the page in a magical process she dared not question. Her story gripped her, poured out of her, as if it had only been waiting for a salty ocean breeze to call it up.

So the interruption was even less welcome.

"Thank God!" The French doors onto the veranda burst open. The serene view of the courtyard fountain was replaced by a tall, elegantly dressed woman. Bridget had to squint to bring her into focus with the sunset light behind her. "I'm so happy to find someone at home here. Hope you don't mind that I looked into your window. Just call me a Peeping Tom."

The woman stepped through the doors, and Bridget wondered for a confused moment if she'd been invited. "Did I say you could come in?" The words popped out before she realized that she'd spoken them aloud.

"Sweetie," the woman said, flinging herself into the armchair by the window, "of course you did." She reached out a long arm and opened the refrigerator. "Do you by chance have anything to drink in here?"

"I—I don't know. I haven't looked." Bridget had just wit enough to save her work. She shut the lid of the laptop.

The woman noticed that protective gesture. "Such a busy little beaver. Or should I say beaverette?" She leaned over to examine the contents of the refrigerator. "Yes, here it is. A little gulp of brandy, just like the one in my fridge. Probably meant to be medicinal, even though it's not enough to kill the pain." She held the small bottle up. "Do you mind if I help myself, dear? Obviously you don't need it."

"I might need it." Especially if this woman was going to be around a lot, Bridget thought, but made a conscious effort not to say. "Why don't you drink your own?"

The woman raised an eyebrow, and Bridget realized that she already had. "It goes down rather fast." She unscrewed the top of the bottle and poured most of it down her throat. "See?"

About to reply indignantly, Bridget suddenly recognized the woman. Johanna Ashbrook, who'd been on TV not long ago when Emery had turned on one of the national morning talk shows to check the market reports. The perky hostess of the show had assumed the reverent tone she reserved for those who were very famous, very rich, or both. And Johanna was both. Her first three books had staked out near-permanent spots on the best-seller lists, and even though the later books were panned by critics, they still sold extremely well. She was rumored to have had affairs with high-ranking government officials, to have invited several Princeton graduate students to join a male harem she was researching for one of her sexy thrillers, to have pushed the then-president of the United States into a swimming pool, and to have threatened to sue over the subsequent roughing-up she experienced at the hands of his Secret Service bodyguards, who were then also invited to join the harem. She was an outrageous publicity-monger, a source of fodder for tabloids, a frequent name in high-profile gossip columns. But Bridget had never before heard that she was a drunk.

"Now, I don't mean to be forward, sweetie," Johanna said, looking at the swallow of brandy she'd left in the bottle instead of at Bridget. "But I don't believe we've met before. I'm

Johanna Ashbrook." She raised that eyebrow again, and Bridget found herself responding.

"Bridget Montrose. We haven't met, but of course I've heard of you, Ms. Ashbrook."

"Call me Johanna. After all, we've broken bread, or at least booze." Johanna held up the bottle in a salute, then finished it off, tossing it at the trash can. It bounced off the desk and caromed into the can. "Two points! Who says I'm a lush?"

Common civility didn't seem called for in this instance. "Are you?"

"Well, yes, as a matter of fact." Johanna leaned back in the chair, closing her eyes. "Whew. Bit of a rush there. They want me to dry out. Sent me here to 'write,' but the subtext was, I would get a handle on my little drinking problem." She giggled and sat up straighter. "Not a problem for *me*, Bertha."

"It's Bridget."

"Right. Bridget Montrose. I've heard of you, haven't I? Aren't you the latest list virgin?"

"I don't know what you're talking about." Bridget felt herself getting huffy, and tried to take deep breaths. She went to stand by the still-open French window and let the sea breeze cool her off.

"You know—breaking onto the best-seller list with your first book. Congratulations and all that." Johanna winked. "Just don't take it too seriously, is my advice. They all jump on you like remoras on sharks, wanting a piece of the action, and then they think they own you. Just tell them all to go to hell. That's what I do." She brooded for a minute. "That's what I do, but they don't listen to me. Bastard searched my bags and took my flask, if you can believe that."

"Who?" Bridget felt confused. "Were you robbed?"

"Every day." Johanna laughed, but there was no mirth in it. "My agent, 'with your best interests at heart, Johanna.' God, how does he know that? How do they all know so well what my best interests are?"

"Well, drinking does cause a lot of health problems, at the least." Bridget didn't know what to say, and the prim statement that came out of her mouth surprised her as much as it amused Johanna.

"Such a sweet innocent." Johanna seemed restored to good humor. "Of course it does, sweetie. They're all absolutely right."

"Sorry," Bridget said. "I think it would be a shame if you couldn't write the books that earn you so many fans. But it's absolutely your decision, and no one else has a right to horn in and get in your way."

"I'll drink to that!" Johanna looked around. "'Cept there's nothing to drink. Too bad, Becky."

"It's Bridget." How could she get rid of this woman who seemed so comfortably slouched in her chair? "Say, did you meet Sharon?"

"Sharon. So many names," Johanna complained. "How can anyone remember all these names?"

"Cowboy boots," Bridget said.

"Oh, yes. Sharon." Johanna laughed. "She's certainly got some kind of fashion sense. I expect rhinestones at dinner."

"Do we dress for dinner?" Bridget's insecurity came rushing back.

"Just what you have on is fine." Johanna shrugged. "Sharon does her lady-of-the-manor thing. I was here once before, and it's all coming back to me now."

"Do you remember the part about not interrupting the other writers during the day?" Bridget felt greatly daring, saying this.

"Not really." Johanna unfolded herself from the chair. "But I can see I've worn out my welcome here, not to mention the brandy. I'll stand you a drink at the place up the road one of these nights, Bruna. Bridget." She smiled triumphantly. "You see, there's nothing whatsoever wrong with my memory. I'll just go see who else has arrived. Only an hour till dinner, and they'll give us some wine then anyway."

She gave Bridget the eyebrow once more and left.

5

BRIDGET WALKED with lagging step down the hall toward the sound of convivial voices. She had been unable to get any more work done after Johanna's interruption, and had spent the last half hour in her room dithering, first about the black skirt and white linen blouse she'd brought for dress-up, and then about whether it would be better to go to dinner early or late. She'd figured it was still early, but judging from the sound of things, the other writers had all started partying without her.

"They're just writers. Perfectly friendly," she muttered to herself, but nevertheless found the prospect of walking into a room full of unfamiliar people intimidating. She was used to a social setting where she knew everyone and could talk to anyone. Among strangers, especially the witty, accomplished strangers she expected the other writers to be, she was not sure of her ability to do anything but stand in a corner and feel miserable.

She paused in the archway of the immense living room. People were grouped around the bar to the right of the doorway. She gazed at them, wishing she knew someone besides Johanna, whom she spotted talking to a tall, distinguished-looking man with wire-rimmed glasses and graying hair pulled back in a ponytail. Johanna appeared to have him enthralled. A shorter man,

bald and stout, stood next to them, putting in a word every so often and being granted an instant of Johanna's time before she turned back to the taller man.

Sharon wielded the wine bottle, going from person to person. She had changed into a long white dress with sequins around the low-cut neck; her stiletto heels clacked on the Saltillo tile floor as she moved. Her hair was even more voluminous, if possible. Bridget could smell the hair spray from where she stood.

"Going in or coming out?" A voice behind her made her jump.

"Sorry," she said, turning. "I'm going in. I think."

"Touch of stage fright?" The woman moved up beside her, smiling comfortably. Her chin-length gray hair was pushed behind her ears with no attempt at style. She was short and very well rounded, with what appeared to be a knitting bag slung over her arm. "I'm Dorothy Hofstadler. I don't bite."

"Bridget Montrose." Bridget held out her hand.

"Oh, yes. I enjoyed your book very much." Dorothy shook her hand, squeezing it warmly. "And of course it makes it harder for you, to know that everyone's read your work and judged it somehow. I don't have to worry about that."

"What do you write?" Bridget blushed. "I mean, I'm not familiar—"

"Don't worry about it." Dorothy waved her into the room. "I've published science fiction novels, but I'm working on something else now. That's why I get to come here. Norbert Rance wouldn't consider SF writing literary enough for this crowd." She gestured toward the group at the bar. "Do you know anyone?"

"Well, Johanna introduced herself earlier."

"She raid your fridge?" Dorothy clucked. "That woman will end up with liver disease or something worse if she doesn't stop." She nodded at the men next to Johanna. "That's Vicor Sunjupany she's flirting with."

"Oh, yes," Bridget said, taking in the dark skin and flashing white teeth of the ponytailed man. "He won the Agner Prize."

"He's a good writer," Dorothy agreed, with reservation in her voice. "The other man is Ed Weis. Have you heard of him? He writes biographies."

"My friend Claudia Kaplan has mentioned him. She's a biographer also." Bridget remembered that Claudia had had nothing good to say about Edward Weis when his name came up, and floundered to a stop.

"Claudia's a very fine biographer," Dorothy said. "I met her last time I was here. A delightful person. I like someone who speaks her mind."

"She does that, all right." Bridget moved forward when Dorothy did, grateful for the older woman's momentary sponsorship. "What about those women over there?"

Dorothy raised an eyebrow. "Well, one of them is here because Norbert doesn't want to be sued," she said dryly. "Sandra Chastain and her—significant other, I guess. I've met her. Elaine, I think her name is."

"Oh," Bridget said again. Sandra Chastain's outspoken lesbian stance was evident in the syndicated opinion column that appeared in newspapers on both coasts, as well as the self-help books she penned; Bridget didn't remember a specific title, but they were something like *Your Inner Gender: Finding the Path to Wholeness.* "Is she a fiction writer as well?"

"Believe she's working on a novel. Or at least that's been the story for a while." Dorothy glanced at Bridget as they neared the bar. "You aren't up on the literary gossip, dear. I would think Claudia would have filled you in."

"I have four children," Bridget said. It was the first explanation for her cluelessness that leapt to mind.

Dorothy nodded in understanding. "Of course. I remember that stage of my life. It's amazing that you get any writing done with that many kids in the house."

"I'm not getting much done," Bridget confessed. "That's

why I'm here, really. I needed some space to work. And then Johanna—" She broke off, not wanting to whine.

"She's a bad girl," Dorothy said. "That's the most important rule of this place, if you ask me, that no one interrupts anyone else during the day. Next time, tell her to leave."

"I sort of did anyway," Bridget said. "I felt terrible doing it, but—"

"Johanna won't mind. One good thing about her, she doesn't hold a grudge."

Sharon came up as they reached the bar. "Good evening, Dorothy, Bridget!" She beamed at them from beneath the pile of platinum hair. "Let me get you each a glass." She nodded at the young man behind the bar, and he took down two glasses. "Sauvignon blanc or pinot noir?"

"I'll take the pinot," Bridget said. Dorothy nodded agreement.

"This is from Norbert's own vineyard," Sharon said brightly, pouring from the bottle she held. "He has so many interests."

"Where is Norbert?" Dorothy sipped the wine with the air of a connoisseur.

"He's been delayed, but he plans to be here tomorrow. Meanwhile, I want you all to make yourselves at home. We'll serve dinner in about twenty minutes."

"Sharon, darling." Johanna came up, holding out her wineglass. "I see you're acting as handmaiden of the grape tonight." Despite what she'd told Bridget, Johanna had changed into pants and cropped jacket of bronze silk, with a scarf in brilliant jewel tones tied insouciantly around her throat.

Sharon's smile became a little fixed. "Another one?" She tilted the bottle over Johanna's glass. "Oh, there's just a little left here. Let me get a fresh bottle."

Johanna looked at her retreating back. "Well, I guess that's all I get. Sharon can be mighty stingy with the wine." She winked at Bridget and Dorothy. "Lucky I fortified myself before I came."

Another white-coated young man came around with a tray of hors d'oeuvres. Bridget took one of the little mounds and ate it absently. She was in the habit of eating anything that was offered to her that someone else had cooked, and in this case, she was rewarded by flavors so intense they were sensations—fresh crab, pungent cheese, a swift, buttery crunch.

"These are too wonderful," Dorothy said. "I hope he doesn't come back."

Johanna watched the waiter walk away, her gaze assessing. "He does look good from the rear," she agreed.

Bridget choked and took a hasty gulp of her wine. When she could speak, she changed the subject. "Is there a program tonight?"

"We're just supposed to get acquainted," Johanna said languidly. She was watching Sharon, who was pouring from what appeared to be a full bottle of wine, but on the other side of the room. "As if we didn't know each other already. Nothing so dull as the inbreeding of the literary set."

"Bridget doesn't know everyone, and I'm going to introduce her, if you don't mind." Dorothy put her glass down and took Bridget's arm. "Nice chatting with you, Johanna."

"You too, Debbie dear." Johanna shook her head. "Not Debbie. Sorry."

"Dorothy. It looks like you could stand a few introductions yourself." Dorothy spoke to Johanna in the "mom" voice that tells you to pull yourself together. Bridget was amused to hear it applied to a grown-up.

"Just introduce me to that bottle and I'll be happy." Johanna made straight for Sharon across the room.

Dorothy pulled Bridget in the opposite direction. "Such a shame," she muttered. "She was a good writer once."

"Is there a reason for her drinking? Some tragedy or something?" Bridget looked over her shoulder. It appeared that Sharon was giving Johanna more wine, though not much.

"Probably more than one. She's left a trail of wreckage

behind her." Dorothy shrugged. "Anyway, she's a big girl and can take care of herself."

They stopped in front of the two men, and Dorothy introduced Bridget. "V.J., Ed, how are you? This is Bridget Montrose."

"Dorothy." Ed Weis spoke with uninterested condescension. He didn't really look at Dorothy, or at Bridget for that matter. He scrutinized the room at large. "Bridget."

"Of course, I saw your name on the list." Vicor Sunjupany bowed over Bridget's hand. He spoke with a British accent, most charmingly, she thought. Behind the trendy frames of his glasses, his dark eyes were compelling. "The best-seller list, that is," he added, with a roguish twinkle.

Ed's attention was caught for a moment. He shook hands limply. "Haven't read your book," he announced, as if that was the one thing she'd been waiting to hear all evening. "Don't have time for fiction."

"I've read yours, though. One of them. The one about Teddy Roosevelt."

"Oh, yes. *Rough Rider*. That one was very popular." Ed's lips drew back, revealing sharp, stained incisors, and Bridget realized after one shocked moment that he was smiling, not preparing to drink her blood. "Which part did you like best?"

"Um, I enjoyed it all. Very readable." She turned to the other man. "And of course I've read so much of your work, Mr. Sunjupany. You use language with exquisite precision."

"Thank you, Bridget. Just call me V.J. Everyone else does." His teeth were very white, and his smile was incandescent. "I must tell you, I have not yet had an opportunity to read your book. But I look forward to it."

"And you should," Dorothy said, patting Bridget's arm. "I've read it. It's splendid, like a breath of fresh air in the literary establishment. I'm looking forward to your next one, dear."

"Aren't we all." Bridget felt more hopeful after her success

that afternoon, but she still couldn't talk about the next one with any degree of confidence.

Ed sharpened to attention, and they noticed Sharon waving from the middle of the room. "Y'all!" she summoned in tones worthy of a bullhorn. The room quieted immediately. "Dinner is served."

Bridget turned to put down her wineglass. By the time she'd turned back, Ed was bustling through the archway into the hall.

"If dinner is as good as that little canapé was, I'm going to need to spend all my time working out instead of writing," Bridget said.

"It is that good." Dorothy smiled with anticipation. "I'll be walking the beach every day to keep from taking home more than I brought."

"The chef is excellent," V.J. assured her. "Shall we, ladies?" He offered an arm to each of them.

Bridget felt some of her apprehension lift. The company of writers wasn't so fearsome after all. Dorothy was nice, and even Ed Weis was tolerable. The handsomest man in the room, whose work she had long admired, was escorting her in to dinner, and he was not only handsome, but pleasant to be with. Things were looking up.

6

IN THE DINING ROOM, Bridget was once more reminded of the movie set. Dark beams arched overhead, holding wrought-iron chandeliers that shed mellow light on the long slab of polished wood surrounded by high-backed chairs. Crystal glittered and china shone at each setting, complete with place cards.

The company of writers milled around, looking for their names. Sharon stood at the head of the table. The chandeliers had been supplemented with small halogen downlights, one strategically placed to highlight Sharon's tower of blondness.

"Please find your cards." Her voice was that ladylike bellow that only Southern women can produce. "Y'all take your places, please."

Bridget noticed that Sharon had put the only two men in the company on her right and left hands as she presided over the table. She found her place card between V.J. and Johanna. Dorothy was across the table, between Ed and Sandra Chastain's friend, Elaine. Sandra's place card was beside Johanna's, but only for a second. Sandra swooped down on it, plopped a new one in its place, and carried her own over to the place beside Elaine. The new place card was for someone named Madeline Bates, who slipped into the seat while Bridget was still dumbstruck over

Sandra's blatant behavior. When she turned back to her own place, she saw that in those few moments, her card had been swapped with Johanna's.

"Here you are, V.J." Johanna beckoned him to her side. "Right next to me." She glanced over her shoulder at Bridget and winked. "You don't mind, do you, darling Brianna?"

"It is Bridget." V.J. smiled lavishly at her while he pulled out Johanna's chair. "How pleasant."

"Right." Johanna leaned closer to Bridget. Despite the wine on her breath, her smile was charmingly conspiratorial. "You don't drink much, as I recall. Just let me know if your glass is more than half full. I'll be glad to help."

Since Johanna promptly engaged V.J. in conversation, Bridget turned to her other neighbor and held out her hand. "Hi, I don't think we've met. I'm Bridget Montrose."

"Madeline Bates." The woman wore a satiny mauve blouse that tied in a droopy bow around her neck, somehow adding to her overall resemblance to a basset hound. Her brown hair hung lankly around her long face, and her smile showed a mouthful of excellent teeth. She was, Bridget thought, in her early forties, but it was hard to tell from her face. "I'm so thrilled to be here."

"It is a great honor." Bridget smiled, feeling much the same way.

The young man who had served the canapés now paused between Madeline and Bridget to serve them each with soup in a gold-rimmed Limoges bowl. "Crab bisque," he said with a smile. "Enjoy."

"Mmm." Madeline leaned over the bowl, inhaling its savory aroma. "Isn't that wonderful."

"It looks good."

Not everyone had been served, but Ed was already sampling his soup. Madeline, observing this, promptly grabbed her spoon and dug in. "Yummy," she sighed. "Let's see, crab, maybe celery, cream—potato? No, I don't think so—"

Bridget waited for Sharon to pick up her spoon, then

followed suit. The soup was indeed delicious, as was the salad that followed, a fan of avocado and grapefruit slices perched on a bed of glistening greens.

Bridget ate more or less in silence. Johanna threw her an occasional conversational sop, but was mostly absorbed in V.J., who obliged her with a delightful flirtation. Dorothy shouted a few remarks across the table, but its girth discouraged cross-talk. Madeline talked only of the food. Bridget noticed that she had pulled a notebook and pen out of her bag—not the small, hankie-and-lipstick kind of purse the rest of the women were carrying, but a businesslike tote—and every so often she made a note.

The food was worthy of attention. Bridget tucked into grilled salmon with dill sauce and passed her time in observation. She had an excellent view of Sandra Chastain and Elaine feeding each other stalks of grilled asparagus. Sandra had a bad case of butterfingers, judging from the frequency with which she dropped her napkin. Perhaps she was nearsighted, too; she spent an excessively long time under the table retrieving it, while Elaine giggled.

Seated between Elaine, who paid attention only to Sandra, and Ed, who like Madeline paid far too much attention to the food, Dorothy was also having a silent meal. Bridget wished they were sitting together, and vowed to do a little name-card switching herself the next night.

The salmon was removed, and a tomato-basil *granita* was served as a palate cleanser. Madeline roused herself from her food reverie and turned another toothy smile on Bridget. "I'm sorry, Ms. Montrose. I got distracted, and I wanted to talk about your book."

"It's Bridget."

"And you must call me Madeline." She clasped her hands together. "Of course I've read your book. It's wonderful. And what an inspiring thing, to make the best-seller list like that. I only hope my book does half as well." She pitched her voice to be heard over the hum of conversation, and succeeded all too

well. Bridget tried to shift a little farther away without being obvious.

"Is it your first book? When is it out?"

Madeline drew herself up. "My first thriller. It's already out. E-published. Now a New York publisher wants it, so I'm here to polish it for them."

Ed snorted, but Dorothy, next to him, must have kicked him. He gave her a look, but didn't say anything.

V.J. stood, wineglass in hand. "I would like to propose a toast," he said, holding the glass aloft. "To our host, Norbert Rance, even though he could not be with us tonight."

"He'll be here tomorrow," Sharon said. "And glad to know y'all excuse him for missing the first day or two."

"To Norbert, and to our beautiful hostess, Sharon, who heaps such delicates with her glowing hand." V.J. bestowed his ravishing smile on Sharon. She fluttered her thickly mascaraed eyelashes, looking disconcertingly as if a covey of spiders were dancing on her eyelids. "And to Ars Ranch, which offers beauty, too. We will write well here."

"I'll drink to that," Johanna said. She tilted her glass to her lips, and pouted. "It's all gone, beautiful hostess."

Sharon's smile faded. She summoned one of the servers with a brusque nod. Bridget wondered how anyone's wineglass could be empty. Hers had been topped off every time she'd drunk an inch or so, and as a result, she'd drunk far more than she was used to.

"Thanks," Johanna murmured, casting a roguish look at the young man when he filled her glass. He smiled back, but didn't respond, and she blinked. "Do you think he's gay?" she whispered to Bridget.

"No idea," Bridget said, secretly amused. "Maybe he's married or has a girlfriend or something."

"I don't think so." Johanna fortified herself with a sip of wine, watching the young man circle the table. "He seemed immune, if you get my drift."

When everyone had wine, they all pledged the toast. Bridget found herself on her feet before she realized that she was going to speak.

"Yes, Bridget?" V.J. smiled. "You have a toast, too?"

"Not a toast, exactly." Bridget gulped, not sure how she'd gotten herself into this. "I, um, thought perhaps we could all join in beseeching the muses for their assistance in the next two weeks. I know I need it."

"Hear, hear." Dorothy raised her glass in reply.

Sandra raised her glass. "It certainly couldn't hurt."

"My glass is empty again," Johanna said plaintively. This time, Sharon ignored her. The rest of the party drank to the muses, and Bridget sat down, vowing to drink only water for a while.

The servers brought in dessert, individual custard tarts crowned with slices of mango and kiwi. Madeline took a bite and made another note.

"Are you writing a cookbook?" Bridget observed this with growing curiosity.

"No, no." Flustered, Madeline shut the notebook and stuffed it back into her tote. "I have written some articles for cooking magazines, though, and I was just—making a few notes out of habit. I keep a very complete journal. For my writing. You know."

"I know." Bridget kept a journal, too, but not so religiously. "I admire your zeal. I mean to write in my journal every night, but it's more like every couple of weeks, really." And that was giving herself too much credit, she reflected, but journaling was a luxury with so many kids around.

Dorothy spoke loudly to be heard across the table, causing the noise of other conversations to die down. "I have the same problem. Although I find when I'm in the middle of a project, I write more in my journal just to clarify my thoughts."

"I do that in my work journal," Sandra said. "I write in that every day about the progress of whatever I'm working on. I have a different journal for personal stuff."

"Does everyone keep a journal?" Bridget looked around the table.

"I have a notebook," Ed said, scraping his dessert plate thoroughly with his spoon. "This journal stuff is all crap, if you want my opinion."

"What do you write in your notebook?" V.J. sounded interested.

"Notes, what else? I do a lot of research. Do more of it on the computer nowadays, but I still have to go to libraries and archives and make notes."

"Don't you use a tape recorder for that?" Madeline's high, breathy voice was easy to hear. "I mean, when I'm doing research, I just talk into the tape recorder, or read stuff in. It's a much more complete record."

"I like to jot notes," Ed said stubbornly. "So that's what I do."

"How about you, V.J.?" Dorothy asked the question. "Do you have a journal, or whatever Ed wants to call it?"

"I, too, have a notebook, as does Ed. But what I keep in it is a journal." V.J. smiled around at them. "I know it is considered foolish in this computer age, but I must compose with pen and paper. I must write the words on the page with a well-sharpened soft-lead pencil. I erase and erase, and copy over and over, and only then will I enter the poem into the computer. Not until I know how it looks, how long it is, what the structure has become."

All the dessert plates had been removed, and Sharon rose. "Y'all," she announced, "we have coffee and liqueurs in the living room. Let's all go in there."

Obediently they trooped after her and stood around while she dispensed drinks from the bar. Though distressed by a sudden tendency to reel, Bridget nevertheless opted for a port, feeling devilish and cosmopolitan. She sat quickly on the sofa that faced the fireplace and took a sip. It was sweet and tangy, with a mellow creaminess that just suited the evening and the room. But it didn't do anything for her spinning head. When the hand-

some young server offered coffee in thin, gold-rimmed cups, she had some even though she didn't much like coffee, just to keep from falling asleep where she sat.

Sharon touched a match to the kindling in the huge fire-place, and by some alchemy the logs actually caught fire. Bridget found this feat uncanny, since she was notorious in her family for her ability to make one adjustment to a blazing fire and have it go out.

People drifted over to the fire in ones and twos, until they were all collected on the sofa and chairs gathered around it. Dorothy looked around the circle. "So," she said, "is everyone working on fiction?"

Ed shook his head. "Not at all," he said, his tone of voice showing what he thought of fiction. "I've got Howard Hughes in my sights. One of his heirs allowed me high-level access to his papers. I just spent a week in Long Beach going through source materials."

"So, your usual," Dorothy said. "What about you, V.J.?"

"I am working on fiction, yes." V.J. stood with one arm on the mantel, looking down into the flames, but he smiled at them all when he spoke. "An attempt at a picaresque novel. If you do not mind, Dorothy, I can say no more than that. It is still very—" he spread his hands "—nebulous."

"Yeah," Bridget muttered. "Good word."

"Are you writing another novel?" Dorothy turned her question to Bridget.

Bridget nodded mournfully. "I should have written it already, I know, but I couldn't even start it until recently. And, well, what V.J. said. It's nebulous right now."

"And Madeline is polishing her thriller. What publisher did you say was interested?" Dorothy smiled at Madeline.

"Cadmus," Madeline announced, her voice squeaky with pride. "They're starting a line of hard-edged thrillers that feature a lot of travel, because those books are popular at airports. That's what the editor told me. And my book has a lot of travel. My

main character is an international art dealer who's secretly an anti-terrorist agent of this high-level NATO sub-command...."

How was it possible that Bridget's eyes could close and her mind drift away with Madeline's voice in her ear? And yet it happened. She came back to consciousness only when the sound of a soft snore woke her, and she realized with great embarrassment that it had come from her.

Luckily, no one else appeared to have heard it. They all listened with glazed eyes as Madeline went on telling the intricacies of her plot.

When she paused for breath, Sharon stepped in. "That's fascinatin', Madeline honey. So glad you're gettin' that book out into the world." She turned to Dorothy. "What did you bring to work on this time, Dorothy?"

"Same as last time," Dorothy said with an easy smile. "I couldn't finish it to my satisfaction, and I had committed to other projects, so I didn't have time to take it up again until now." She turned to the others. "I am writing a novel loosely based on my ancestors' experiences as immigrants to New York in the early seventeen-hundreds. I actually have some family letters, and got some more information when I visited relatives in the Netherlands, but there was still a lot of research to do."

"Well," Madeline said with commiseration, "that might be hard to get published. You have to have some kind of track record these days in New York."

"Dorothy knows that," Johanna said, setting down her empty brandy snifter. "She's published many highly regarded science fiction and fantasy novels, haven't you, darling? I believe she's won the Nebula a couple of times."

"Really?" Madeline exclaimed. "And I've never heard of you. Amazing!"

Exasperated into attempting to talk, Bridget turned to Dorothy. "Well, I've heard of you, though I hadn't remembered until just now. Both my husband and I greatly enjoyed *Strangers Gate*. The richness of your alternative universe was remarkable."

Dorothy blushed with pleasure. "Thank you." She turned the subject adroitly. "I believe we've heard from everyone but Sandra. What are you working on, dear?"

Sandra looked faintly defensive. "I'm writing a novel as well, but it's kind of a memoir based on my life, really. You know, growing up in a small town and always knowing you were different, but not how to express that difference. It's actually been very hard to write, compared to my nonfiction." She hesitated, glancing at her friend. "Elaine tells me to just keep working on it, that it's normal to be blocked, but I must say I have my doubts."

Bridget nodded. "I know about that. Maybe you're too close to the material. You need to objectify it more."

"Yeah, that's what my writing coach said." Sandra moved her shoulders uneasily. "I'm going to work on that here."

There was a moment of silence, and then Johanna got to her feet with considerable grace, given the amount she'd drunk. "Well," she announced, "before you get around to asking me what I'm working on, which wouldn't be productive for any of us, I'm going to take myself off to beddy-byes. Good night, everyone." She paused in the archway to turn and give them a smile. "Lovely evening. Thank you so much, Sharon."

"Not at all," Sharon was obliged to say graciously.

V.J. began talking about the difficulties of working with characters based too closely on real people, but Bridget couldn't attend. Her eyelids wanted to droop, and it was harder and harder to suppress her yawns. She decided to follow Johanna's lead and go to her room before she could snore in public again.

She excused herself during a break in the conversation, feeling very much like a child who's unable to stay up with the grown-ups, and found her room with no mishaps. "The Gertrude Atherton Room," she muttered, unlocking the door. "Way to go, Gertrude. Nobody reads your books anymore." She stood in the dark room, with moonlight flooding through the French doors, unable to remember where the light switch was.

The moonlight dimmed briefly, and she saw a shadowy figure hurry past the French doors toward the end of the colonnade.

Curious, Bridget went over and pressed her face against the glass. Hers was the last set of doors before the end of the colonnade, where the waist-high hedge that encircled the walls of the house broke to allow access to the courtyard. She could see someone pass through the break in the hedge—someone tall and slim.

Johanna, she thought. Sneaking out, and not to meet V.J.

It was none of her concern. She found the light switch, closed the curtains, and got ready for bed. She checked her e-mail and found a message from Emery telling her that the boys sent her good wishes at bedtime, and Moira wanted the story read the way Mom always did.

Foolish tears welled in her eyes, which she blamed on excessive wine consumption. But thanks to the wine, she was asleep before she could get too emotional about the family she'd left behind.

7

BRIDGET WOKE at her usual time of 5:30. She hadn't slept too well alone in a strange bed, and for a moment she forgot that she didn't have to jump up and change Moira and get breakfast on the table for a hungry family. When she remembered, she was swept by the immense luxury of having only herself to care for. Underlying this was guilt, of course; what mother could be so far away from her responsibilities without guilt? But it was transient. She turned over and went back to sleep, and when she woke again at 6:00, she was thinking about her book, not her children.

She threw on some clothes, turned on her laptop, and got to work.

The idea for her new book had come to her in the months since her success. Like all fiction writers, she'd thought, "What if?" What if an ordinary woman, living an ordinary life, was suddenly given an unexpected gift, one that added a previously incomprehensible dimension to her life, but brought with it new and frightening complications? How would she cope? What would be left when she'd learned to deal with what she had been given? Although Bridget had made several starts on it, all had felt wrong, forced.

Now she felt a sense of authority as she wrote, a feeling that

she knew what came next, how to reveal the elements of the story in the right order. It was not a feeling she could claim familiarity with; she had been so blessed only a few times in the writing of her first book, and each time had felt that she was two people, one writing with purpose and direction, and one standing in amazement that such a thing could be.

For the first time since she'd begun this book, the words flowed through her fingers as if she was merely the conduit, not the originator. When she finally pushed back her chair an hour and a half later, she'd amassed ten pages.

Her stomach growled, and her head screamed for caffeine. She couldn't remember what the procedure was. Should she shower, dress, go to the dining room? She opened her door a crack to listen for the sound of voices from the common living areas.

Hanging on her doorknob was a small basket. Inside, wrapped in a napkin, was a warm muffin that exuded the perfume of cinnamon and apples. She brought it into her room and began gobbling immediately. Rooting around in the basket for crumbs, she finally noticed the piece of paper telling her that breakfast was served buffet-style in the dining room, and she was welcome to carry it back to her room on a tray, which could be left outside her door for later collection.

Bridget debated between a quick dash to the dining room for tea and food, despite her unshowered appearance, and making a more complete toilette before she encountered anyone else. One look in the mirror and she was in the shower, then fussing with her hair.

After all that, the dining room was unpeopled. She found a tray and dithered happily at the buffet set out on the sideboard, finally choosing smoked salmon with capers and minced red onion. She smeared a bagel with cream cheese and added that to her plate, along with a dish of fruit salad. Mini-thermoses were clearly labeled for hot water or coffee. She seized a few bags of the strongest-looking breakfast tea and a deep china mug.

Back in her room, she paged through what she had written while she inhaled her breakfast. The work seemed good to her, another astounding thing; even her internal critic, quick to damn with the delete key, was silent. She started writing again, her unfocused gaze on the brightening sky and glinting water outside her window, and hours passed before she remembered to set her breakfast tray out.

When she opened her door, she felt fragile and uncertain, like an alien creature emerging into another world. The hall was empty, but the smell of cooking stole through the air, and she could hear the clatter of dishes from the dining room. Bending stiffly to set the tray down, she realized that she had barely moved except to fetch food. She decided to take the tray back herself, scope out lunch possibilities, and then walk around the gardens and check out the facilities. She needed an infusion of fresh air and sunlight.

The dining room was still empty, but the buffet had been cleared of breakfast items, except for the urns of coffee and tea and a depleted store of little thermoses. A basket of bread sat next to a dish of pickles and olives. She could hear the clink of crockery in the distance, so she followed her ears through an impressive butler's pantry lined with shelving that bore a vast array of china, and into an enormous kitchen.

High ceilings were dotted with skylights the size of bedspreads, which flooded the room with light. A long island with a scarred butcher-block top occupied the center of the room. To one side were huge stainless-steel sinks and counters, and an industrial dishwasher that the two young men who waited table were unloading. On the other side of the room, a woman in a white chef's jacket was busy at the big hot-top range. A most savory aroma came from whatever she was doing there.

Bridget cleared her throat. The three workers stopped to stare at her.

"I brought my tray back."

The woman came forward, wiping her hands on the towel

that hung from her aproned middle, and took Bridget's tray. She was young and fit-looking, so Bridget guessed that she didn't eat a lot of the rich sauces she'd prepared the previous night.

"You didn't need to do that," the young woman said with a smile. "Albert makes the rounds of the halls every so often." She handed the tray to one of the young men, the one Johanna had tried to hit on, who waved cheerfully at Bridget.

"I don't want to make extra work—"

"You're not, really. It's factored into our jobs." Her white toque sat insouciantly on short blond curls. "I'm Tiffany, by the way."

Of course. All the younger women, Bridget reflected, were called Tiffany or Amber or Ashley. "I'm Bridget. Have you worked here long?"

"This is my first stint." Tiffany rolled her shoulders and stretched her neck. "I've been a sous-chef on the Peninsula since graduating from the Culinary Academy. It's good to get a shot at running my own kitchen."

"So is Sharon good to work for?" Bridget really was curious about that, but realized after she'd asked her question that it wasn't fair to put Tiffany on the spot.

"She's okay. Pretty well organized, actually." Tiffany stirred the pot that simmered on the stove.

"Your dinner last night was superb."

Tiffany flushed with pleasure. "Thank you. It's a lot of work to cook a big meal, and it helps to know people are enjoying it."

"You should come out and take a bow tonight."

"Maybe I will." Tiffany gestured at the center island, which bore several plates of sliced meat, salads, and more fruit, ready to put out on the buffet. "We don't go to as much trouble for breakfast and lunch."

"It's all delicious anyway."

"We'll be setting it out in about twenty minutes, so come back then for your lunch, Bridget. And don't worry about bringing back your tray. We'll take care of it."

"Say, can I get into the back garden from here?" Bridget saw
a glimpse of greenery out the half-glass door in a corner.

"Just go that way. And thanks for the positive feedback."

Bridget emerged on a wisteria-shaded colonnade, masked
from the rest of the garden by a high box hedge. She walked
down the colonnade, past the tall iron gate that was evidently the
service delivery and pickup area, judging from the row of neatly
marked refuse bins, and turned through an archway, to find her-
self in a long, narrow garden of raised wooden beds filled with
lettuces and other spring vegetables. Fruit trees were espaliered
against the tall stucco wall that enclosed the grounds. A head-
high hedge of pittosporum walled the other side of the kitchen
garden.

Bridget wandered down the gravel path, admiring the herbs
and the ripening plums and peaches. The air was warm and
fragrant with lavender and bergamot. Where the fruit trees end-
ed, the perimeter wall was interrupted by an iron gate and a
small paved yard lined with compost bins and other garden
materials, near a functional-looking potting bench. Opposite
the gate in the outside wall was another, more ornate one, with
fanciful curlicues of wrought iron depicting dolphins and mer-
maids intertwined with the Ars Ranch brand. She pushed it
open.

Ahead of her was the formal garden overlooked by the rear
of the house that she had seen through the living room's French
doors. Geometric flower beds were intersected by immaculate
gravel paths, meeting in the center at an elaborate stickwork per-
gola twined with flowering vines, and sheltering a wrought-iron
table and chairs. The pool and its surrounding lawn, made of
pavers and chamomile in a checkerboard pattern, was sunken
two steps below the level of the garden. Against the far wall,
facing the pool, was another terrace seating area in front of
the pool house, which was a small-scale replica of some familiar-
looking Southwestern building. Bridget thought at first it was
one of the California missions, but then realized that it was

meant to evoke the Alamo. This version had a built-in barbeque station along one side, inset with handmade tiles.

The thought of a swim was very tempting. She walked down the two steps to the pool surround, breathing in the scent of chamomile. The pool was lined with cerulean tiles; the end closest to her had a circular spa set above grade. On its rim, a satyr danced, spilling water from an urn into the spa, which in turn overflowed into the pool.

The French doors from the living room burst open and Madeline came out in a zippered terry-cloth coverup, a towel over her arm. Seeing Bridget by the pool, she waved and called, "Isn't this something? Just like a palace. Are you swimming, too?"

"Just walking," Bridget said, regaining the central path. "Just a brief walk, and now I must get back to work."

"Oh." Madeline's mouth drooped. "I thought maybe V.J. was going to swim, because he just had his trunks on and his shirt was unbuttoned and everything, but he said he'd already had his swim. Even though his hair was dry," she added reflectively. "And I asked if Johanna was going to swim, because he was coming out of her room, but he said she was napping." She shot a glance at Bridget as she related this.

"Hmm." Bridget smiled vaguely. "Disappointing for you. Have a nice swim." She started toward the living room terrace, but realized that she hadn't investigated a door and outside staircase on the south corner of the house. Curious, she veered toward the door, cupped her hands and peered in through its upper glass panel.

Madeline joined her. "That's the staff's quarters," she said knowledgeably. "And farther down are some studios for artists. I guess those waiters are glad they're in a different part of the building from Johanna."

Bridget backed away from the door. "I just wondered what was in there." It sounded lame even to her, and she expected that Madeline would start telling everyone that Bridget had shown an

unseemly interest in the staff quarters. "Guess I'll get back to work now."

Madeline didn't follow her through the French doors into the living room, and she was grateful for that. The living room was cool and dim after the bright gardens. She stopped in the dining room and saw that the lunch buffet had been set out. No one else was there yet.

Bridget assembled a salad, took a glass of iced tea, and scuttled to the refuge of her room. Her story still ran strong in her, and she was unwilling to be with other people, to speculate about their relationships to each other, to wrench her brain too far away from the world she was weaving, for fear it would go away again and leave her bereft.

Once more she ate in front of her computer, and once more the story caught her in its meshes. She wrote without noticing the time, waking to reality only occasionally to offer grateful thanks to the muses for the flow of words that blessed her.

8

EVENTUALLY THE SUN dropped low enough to shine in
her eyes as she sat at the desk. The salad plate beside her com-
puter was half-full of limp greens. She was hungry, and a little
spaced out from concentrating so hard.

As soon as she stood, she felt as if the energy that had pow-
ered her work was slipping away, and this time she was content
to let it go. She went into the bathroom and stared at her pale
lips and hollow eyes. "I look like I've been on a bender," she said
to her reflection. After washing her face, she felt better. She put
on her other dress-up outfit, black slacks and an iridescent silk
blouse that had the advantage of drying very quickly if washed
in the bathroom sink.

When she opened her door, Dorothy was just locking her
room—the Ina Coolbrith Room, Bridget noticed.

"Good evening," Dorothy said. She seemed more subdued
than she had the previous evening. Bridget realized that she her-
self was feeling very good indeed. Getting all those words out of
her system had been such a relief.

"Hi, Dorothy." Bridget joined her. "I just realized that I sat
most of today, and most of yesterday, and ate fabulous meals the
whole time. This cannot continue."

Dorothy's smile was preoccupied. "I'm afraid the food is very good, dear," she said.

"Is something the matter?"

Dorothy turned to her, and for the first time seemed really to see her. "No, not at all. I'm at a place in my story where a character dies. That's always so hard for me."

Bridget nodded in agreement. "In my first book, I knew Stephen's mother had to die in a car wreck. I dreaded it so much. I couldn't write that chapter for days."

Dorothy looked at her for a moment. "It's distressing. And it's hanging me up."

"Believe me, I know about that." Once more, Bridget savored the relief of getting past her block, at least for the time being. "Who was it who said writers don't like writing, they like having written? It's not so much that I don't like writing. I just like having written so much more."

"I don't remember who said that." Dorothy paused in the archway to the living room. "But there are lots of those sayings, aren't there? Like the one about the recipe for writing: Apply the seat of the pants to the seat of the chair."

Bridget felt a bit of ache in her own rear from a day spent hunched over her keyboard. "Or, writing is easy. Just sit down at the typewriter until drops of blood appear on your forehead."

"I believe Red Smith said that," Dorothy said. "My, everyone seems very lively tonight."

The living room was already busy, with Albert, the server, circulating a tray of canapés, and Sharon moving from group to group like a blond Border collie. She bustled Madeline over to a tête-à-tête going on between Johanna and V.J., brought Ed to join Sandra and Elaine, and brightened at the sight of Dorothy and Bridget. "There y'all are!" Her twangy yodel directed all attention at them. "Now, what can I get you girls to drink?"

Dorothy asked for a Bloody Mary. "I need a stiff drink," she said to Albert's counterpart behind the bar. "It's been a long day."

"I feel like something fizzy." Bridget wanted to celebrate her day of writing success, but remembering the whirlies that had plagued her the previous evening, she elected sparkling water with a twist of lime. It was refreshing, and gave her a feeling of great virtue until she tasted the canapé, a little pastry cup filled with artichoke heart and creamy sauce. She wanted another one immediately.

Madeline came over to join Dorothy and Bridget. "I had a lovely swim," she told Bridget. "You should have come."

"I got some work done." Bridget felt a great sense of satisfaction saying this.

"Well." Madeline moved closer. "While I was there, I heard the waiters talking to each other. They were using the weight machines in the pool house. I guess they didn't know I was there. Anyway, one of them was saying that Johanna and one of the local surfers were—" Madeline looked at them with great significance.

Bridget blinked. Dorothy didn't say anything, though she looked rather grim around the mouth. "Why do you tell us this?" Bridget said finally.

"I think V.J. knows," Madeline said, ignoring Bridget. She craned her head to watch Johanna and V.J. as they talked.

"Why, did you tell him?" Bridget was trying to be sarcastic. She wasn't good at sarcasm, for some reason. People tended to take everything she said seriously.

"As a matter of fact, I might have said something." Madeline sounded contrite. "I mean, it just slipped out. Things do, you know."

"I need another drink," Dorothy said, heading abruptly for the bar.

"Me, too." Bridget left Madeline standing alone without a qualm, but the woman's skin was thick enough that she trailed after them to the bar.

Fortunately, Sharon chose that moment to march everyone into the dining room.

This time Bridget intended to swap the place cards around, but she got caught in the scrum around the dining room door, and when she got to the table, Johanna was waving at her.

"You're over here again, Bruna."

Bridget could hardly refuse to sit where her place card turned up. She resigned herself to another silent meal when she saw that Ed was her other neighbor. At least she wasn't sitting next to Madeline, who was across the table between Dorothy and Sandra, with Elaine on Sandra's other side. Bridget figured Sharon would never have seated the two scarce men on the same side. Probably Sandra had swapped Ed's card with Elaine's to get her desired result.

Sharon's eyebrows came together in a brief scowl when she saw how the seating had been rearranged. "I'd like everybody's attention." She pinged her water glass with a knife. "I just wanted to share with y'all that Norbert will be with us some time this evening. He hoped to make it for dinner, but there was some weather out of the Gulf, and he was delayed. He's lookin' forward to meetin' all of you."

She paused, and then went on, with a sugary smile, "Now, I'm sure you know that in any bunch of folks like yourselves, people can tend to form little groups and not mingle. It's okay for tonight, but after this, I want y'all to be open to sittin' by different folks each night, and learning more about each other."

Bridget glanced at Ed to her left, and Johanna to her right. She felt that she already knew all she wanted to about them.

She emulated Ed and concentrated on her dinner. The seafood risotto was perfect, as were the accompanying baby artichoke hearts sauteed with sweet onions. The crisp sauvignon blanc went well with the food, but she tried to keep her consumption down.

V.J. and Johanna continued a low-voiced conversation, and though Bridget might have eavesdropped out of rampaging curiosity at any other time, with Madeline's example in front of her, she went out of her way to avoid hearing what they said. She

did notice that Johanna drank steadily. Albert appeared to be under orders not to refill her glass until it had been empty for a few minutes, but as quickly as he poured her half a glass, she drained it.

Dorothy and Madeline were talking, or at least Madeline was talking. Dorothy had evidently attempted to deflect more gossip by asking a question about e-publishing.

"It's been great," Madeline enthused. "I mean, my book got out there. And the New York publisher got interested in it that way." She laughed. "Of course, I'm totally rewriting and expanding it for the print edition." She pulled a card case out of her big handbag and started passing cards around the table. "Here's my website. You can follow the links to the e-publisher's page and read my book there if you want, or download it."

"So you just send the text to the e-publisher and they put it on their website?" Dorothy sounded interested. "Do they edit or do any fact checking or anything?"

"They edit," Madeline said, sounding a bit defensive. "They don't publish just anything. Your book has to be good. An editor read mine and told me what changes to make."

Johanna took a card and handed the stack to Bridget. "Fascinating," she said, in a voice that contradicted her words.

Bridget passed the stack of cards to Ed, fingering the one she'd taken. Madeline's card was printed on shiny maroon cardstock in yellow letters that proclaimed her MADELINE BATES, WRITER. In smaller letters were her website and e-mail addresses and her book's title, *Conspiracy of Anger,* and ISBN number.

Ed tossed the cards across the table to Dorothy without bothering to take one. "E-publishing." His voice was derisive. "We all know it's just a lot of crap."

Everyone turned to look at him.

Johanna took him up, swirling the dregs of wine in her glass. "Ed, darling, everyone also knows that New York spits out a vast quantity of crap, too. Just because it's between hard covers doesn't necessarily make your book a good one."

Ed narrowed his eyes. "My book? You're saying—"

"Not you personally, darling. Of course I was speaking generically. If you want, though, I can be more specific. It doesn't necessarily make *my* book a good one. You see, I'm a realist. I know they're only publishing me because people are used to buying my books. Not because I'm writing them well anymore." She smiled around at the stunned company of writers. "See how honest I can be? *In vino veritas.*"

"Johanna, dear—" Dorothy's voice was strained.

"Isn't this fun? Why don't we go around the table and each of us tell one unpleasant truth about ourselves?" Johanna clasped her hands together in a parody of girlish delight. "I've just begun. Maybe one of you can tell me something I'm dying to know. Which of you is my new ghost?"

The silence was absolute.

Sharon's steel-magnolia voice broke it. "Johanna, what are you talking about?"

"I thought everyone knew. I'm here because my publisher has decided my books should be ghost-written. One of you is my new and very well-paid ghost. I just wondered which of you it was."

Bridget looked around the table, and saw that everyone else was doing the same thing. The projects mentioned the previous night had not included ghost-writing.

"No one speaking up?" Johanna looked disappointed. "Well, I guess I'll find out tomorrow, when we're supposed to get to work."

"Didn't your publisher tell you to keep this under your hat?" Sandra sounded puzzled. "I mean, I thought no one was supposed to know about ghostwriters."

"Why? Do you have one?" Johanna leaned across the table. "Of course, you must. You have a high-profile name, and some publisher probably offered you big money to write a novel, and when you said you didn't know how, they told you someone else would take your treatment and make it into a book." She clapped her hands. "Maybe we have the same ghost!"

Sandra turned dull red. "I don't have a ghostwriter. I'm writing my book myself."

"Of course. That's why you brought your sweetie along." Johanna nodded wisely. "I'm sure you get more work done with her here."

Elaine flushed. "I'm not going to be insulted," she said through her teeth. "Tell her, Sandy."

"She's just drunk, Elaine." Sandra shifted uneasily.

"Well, I'm out of here." Elaine grabbed her bag and left, tossing a black look at Johanna on her way out.

"Elaine—" Sandra got up. "Please, excuse me. Elaine just isn't used to the rude behavior of some writers." She glared at Johanna and followed her friend out the door.

Bridget looked around the table. Ugly as the scene had been, it had shifted the attention of the group. People leaned toward each other, whispering, or looked down at their plates. Dorothy caught Bridget's eye and made an expressive face.

Bridget grimaced back and tried to pretend she wasn't eavesdropping on V.J. and Johanna.

"You must know," V.J. was saying, his melodic voice almost too low for Bridget to hear, "that your editor will not be happy to hear about this. Are you not supposed to be discreet about this person who will assist you with your next book?"

Johanna didn't bother lowering her voice. "V.J. darling, I couldn't care less. I didn't want to do another book anyway. This is their stupid idea, to dig up some has-been hack and put my name on the book." She lifted her glass, saw that it was empty, and glanced speculatively at Bridget's half-full glass. "No one with a shred of pride would agree to such a thing, isn't that right, Betty?"

Bridget moved her wineglass to the other side of her plate. She was tired of Johanna, who seemed to trade on her notoriety and charm to behave as badly as she wanted. "Most writers don't have the luxury of turning down money for writing. In fact, Johanna, your huge advance would make probably twenty lesser-

known authors very happy if it was spread around a little. Your publisher could cut you loose and boost some mid-list authors with the money they save."

Johanna stared at her, and the rest of the table was silent. Then Madeline clapped; Dorothy joined in, and Ed and V.J. nodded in agreement.

Johanna rose to her feet. "It's obvious that I've outstayed my welcome, both at the table and in the book business. If you'll excuse me, I'll take my leave."

She walked with great dignity from the room.

Sharon breathed an audible sigh of relief. "Now, we still have dessert," she admonished. "Don't all of y'all leave."

"More for the rest of us," Ed Weis muttered at Bridget's side.

V.J. moved over to occupy Johanna's empty seat at Bridget's other side. "You were right," he said seriously. "But even though Johanna seems very brittle and careless, she has insecurities."

"I hurt her, you mean."

"Perhaps."

"Well," Bridget said, watching the helpers carrying in trays of what looked like profiteroles drenched with chocolate, "I will go to her room after dinner and apologize. I didn't mean to hurt her. But she said some outrageous things."

V.J. shrugged. "That is our Johanna. And she can be generous as well. I do not like to see her so unhappy."

Dorothy leaned toward them. "You were absolutely correct, though, Bridget. When the rest of us try so hard, and work to fulfill our obligations, and never seem to get ahead no matter how good a book we write, it's really unfair that Johanna can create these scenes and not even write and still get an enormous contract."

V.J. looked troubled. "It isn't fair, Dorothy, but tell me what is fair in publishing?"

Bridget shrugged off the uneasy feeling that she had spoken out of turn. She was usually the peacemaker, the one who

ducked trouble. But when she thought of some of her friends whose writing deserved far more reward than it garnered, she wasn't sorry about what she'd said.

The unpleasant necessity of apologizing loomed ahead of her. For the time being, she savored her profiterole. Publishing might be uncertain, but chocolate was dependable.

9

THE PROFITEROLE had been excellent, but it didn't sit well in Bridget's stomach. She had lingered in the living room after dinner, chatting to V.J., but she couldn't continue to postpone the moment when she'd have to apologize to Johanna. "I make Corky and Sam do this," she muttered to herself. "But I didn't realize it was so hard."

Dorothy had told her which room was Johanna's—the Kathleen Norris Room, right next to Bridget's on the first floor. She knocked, then knocked again, wondering if Johanna had passed out.

Bridget was alone in the hall. Everyone else, judging from the convivial hum that found its way down the hall, was still in the vast living room, enjoying port and conversation.

Since no one was there to see, she tried the doorknob ever so gently. It didn't turn.

Shrugging, Bridget went on to her own room. She, too, had locked her door, because she didn't want anyone looking at her computer. Tired but restless, she was in no mood to work. Going back to the party wasn't appealing either.

Opening the French door, she listened to the boom of the surf. The night air was chilly but fresh. Acting on impulse, she seized a jacket and stepped outside.

While she was on the veranda, it occurred to her to check out Johanna's room from her French doors and make sure she was all right. Johanna could be on her bed, face down in a pillow, too drunk to realize she was slowly suffocating.

"Easy to tell I'm a fiction writer," Bridget thought, going to the next set of French doors. The light was off in Johanna's room, so she couldn't see in, but the doors were slightly ajar. She pushed them open and stood there, letting her eyes grow used to the dark, letting the starlight into the room. After a moment, she could see that no one was there, though the room was full of clothes flung over every surface in a kind of orderly chaos. Evidently Johanna had had a hard time making up her mind what to wear for dinner.

So the apology would be put on hold. Bridget felt relieved. She would still have to make it, but she would be able to sleep on it, and find the right words more easily. She hoped.

Pulling the doors to, she left them ajar as she'd found them, and retraced her steps back along the veranda and through the break in the shrubbery. Her footsteps rang too loudly on the cobblestone courtyard; she hurried across it onto the lawn that stretched down to the seawall. The air was fresh and salty, spicy with the scent of chamomile. She drew in great lungfuls, wishing Emery was there with her, wondering how he was coping with bath- and bedtime on his own.

The seawall was waist-high, made of stone with a wide, flat top. She sat on it and swung her legs around to face the ocean, mesmerized by its moving darkness. The waves were studded with silvery points of foam that flashed in the light of a half moon. The beach sloped for fifty feet to meet the water, where a white ruffle of surf formed and broke. Sitting with her back to the lights of the house, she could pick out the dark shapes of driftwood that dotted the beach, and the nearby circle of beach stones that would contain a fire. She imagined the cheerful blaze, and wondered if there would be a bonfire before they left.

"It's nice out here, isn't it?"

Bridget jumped at the sound of a voice. Johanna's voice.

"Yes, it is." She peered into the darkness. Johanna sat a few yards down the wall; Bridget hadn't even seen her, so fixed had her attention been on the ocean and beach.

"This is my favorite part of coming here." Johanna's voice sounded different in the darkness—not so drawling and self-involved. Bridget had to strain to hear her over the boom of the breakers. "I love watching the waves on the beach. I could spend all my time right here."

"Johanna, I'm sorry for what I said at dinner." Bridget raised her voice to make sure she was heard. "It was unkind. I apologized to the others, and I'd like to apologize to you, too."

Johanna slid off the wall and came closer to Bridget, picking her way through the sand. "Hey, forget it. I was in my insufferable mood, as I recall. It's good for me to be slapped down once in a while. Nobody does that much anymore." She stopped and turned to face the ocean. "Do you want another job? You could be on my staff as my putter-downer. Everyone would be glad to have you voice what they think."

"Not the kind of job I want to do." Bridget had caught a whiff of unhappiness in Johanna's voice. "Do you really have staff?"

"Oh, yeah." Johanna shivered and folded her arms around herself. She wore the same thin jacket she'd worn at dinner, with only the scarf around her neck as a wrap. Bridget, nestled in warm wool, thought she must be cold. "Yeah, when you make so much money, you have to have staff to soak some of it up. They tell me what to do, in case I don't know." She giggled. "It's funny, isn't it. I used to know what to do. I worked as a legal secretary all day and wrote all night. Now I don't write or work, just drink. Makes for a change."

"Why don't you stop drinking and write again?" The powerful anonymity of darkness let the impulsive things Bridget shouldn't say hop right out of her mouth.

"Honey, were you born Pollyanna, or did it just happen to

you? If it was easy, I would have already done it. I'm good at what's easy."

"Your first couple of books must not have been easy. I thought they were very good."

Johanna was silent. "Thanks," she said after a while. "Those were the books that were in me. Kind of like your first book, I imagine."

"My book?"

"Don't sound so surprised. I read it. I can still read, you know." For the first time since beginning the all-too-frank conversation, Johanna sounded huffy. "It was very good. Had that power, that intensity. It's the hardest thing to do as you keep writing—to keep the emotion fresh, to keep the reader bound to your narrative. That's what's giving you trouble now, I bet."

"How did you know—"

"That you were blocked? I've seen that look in my own eyes often enough." Johanna stopped abruptly, and when she spoke again, it was in her usual mocking tone. "Do you know the time, darling? I have an appointment I wouldn't want to miss."

Bridget shook her head. "I don't wear a watch. But it's probably around ten."

"Excellent." Johanna swung herself over the wall. "It's easier to walk on grass than sand," she said, and Bridget noticed she was still wearing the spike-heeled sandals she'd worn at dinner. *"Ciao."*

She set off, walking next to the wall toward the northern boundary. Bridget stared after her, wondering who in the world she would be meeting on the beach at that time of night. Listening long after Johanna's shadowy figure had disappeared, she thought she heard the sound of a VW engine, like the bus Liz drove around Palo Alto.

Though she dismissed the episode, it had disturbed her communion with moon and ocean. Before long, she headed back to her room.

From the beach, the lights of the ranch house were low-lying

stars. She walked back across the lawn, the sound of the breakers diminishing. The compound's lights didn't dim the stars' glittering canopy. As she got closer, she heard the faint strum of a guitar from beyond the courtyard.

A long black limousine was parked in front of the entrance doors, which were open, spilling golden light into the courtyard. Bridget could hear Sharon's commanding voice; people were carrying things from the car into the entrance.

She hesitated for a moment, thinking of the other writers gathered around the fireplace, having drinks, swapping stories, regaling the latecomer, whoever it was, with literary chat. She should be there, too, mitigating her woeful lack of gossip.

Instead she ducked through the shrubbery to the colonnade and the French doors to her bedroom. She was tired, too tired to go see what was happening. And she realized, with a shock, that she was homesick. It was hard to think of her children going to sleep without her tucking them in.

If she hurried, she could send Emery an e-mail before he went to bed, and maybe even get one back that night. That seemed more important than gossip.

10

BRIDGET WOKE the next morning to the sound of breakers crashing in the distance, and realized that she'd heard them all night in her dreams. Yawning, she went to the door to retrieve the little muffin basket. It was blueberry streusel, still warm.

She turned on her computer, but this time no magic portal opened to whisk her into her story. She felt dull, drained of words, as if she'd never have an original thought again. By 7:00 she was in the shower. All she needed was breakfast and copious amounts of tea to rediscover the flow. Or so she told herself.

The buffet was lavish again, but the rich food of the past couple of days was catching up with her. She chose granola and fruit, and the strongest-looking tea in the selection offered.

As she turned to leave the dining room with her tray, Sharon came in. She wore white again, a swirling skirt with a lacy crocheted hem at least four inches deep above the obligatory white cowboy boots, this time with turquoise snakeskin insets. Her wide-shouldered shirt had a crocheted yoke, which her enviable squash-blossom necklace and concha belt set off. Her big-haired head was bent attentively toward a companion.

Catching sight of Bridget, Sharon beckoned her over. "Darlin', meet Norbert Rance. Norbert, Bridget wrote that book we both liked so much."

"Howdy, Bridget." Norbert was shorter than Sharon, shorter even than Bridget's five-foot-five. "Pleasure meetin' you. Hope Sharon's lookin' after you okay." He had a leathery face and the biggest nose she'd ever seen, which made his dark little eyes seem even beadier. He wore freshly pressed, unfaded denim jeans, a white Western shirt with pearl buttons and more of those curvy pockets, and a belt buckle embellished with a huge nugget of turquoise. His boots were bright tan ostrich skin.

"Oh, yes." Bridget took Norbert's proffered hand and found her own shaken vigorously. "It's wonderful to be here. Already I've gotten so much work done."

Norbert smiled, but his eyes searched around behind her in a way that let her know she wasn't the writer he wanted to talk to. "Settled in okay? Met the others? I didn't see you when I stepped into the living room for a drink last night."

"Early night," Bridget said vaguely.

"Saw V.J. and Ed," Norbert said, turning to Sharon. "Who else we got?"

"Sandra Chastain and Elaine—Elaine—" Sharon wrinkled her forehead. "Goldarn it, I forgot her last name."

"Bunch of dykes. But that's okay," Norbert added hastily when Bridget's eyebrows went up. "We welcome everyone to Ars Ranch." He turned back to Sharon. "Who else?"

"Um, Dorothy Hofstadler."

"Don't know her."

"She's been here before, hon. Writing a literary novel after winning some science fiction awards."

"Oh, yeah." Norbert made a beckoning motion, and Sharon reeled off more names.

"New author, Madeline Bates. Oh, and Bart Maslow sent last-minute regrets. He has some kind of stomach bug."

"Ole Bart's always ailing."

"Bart Maslow was going to come?" Bridget was interested. "My husband thinks he's one of the best writers in that whole philosophy-of-technology area. Is he writing another book about man versus nanomachine?"

Norbert shrugged. "Says he's got a novel in him. Trouble is, the doctors cain't get it out." He kept his face serious.

Bridget smiled weakly. "Right."

"So Bart's not coming. Too bad. He still owes me a fifth of Wild Turkey from the last time." Norbert turned back to Sharon. "That all of 'em? Thought there was more."

"Oh, right." Sharon looked down her nose. "How could I forget Johanna?"

That appeared to be the name Norbert was waiting for. "Yep, that's right. Johanna's here. Should be a humdinger of a time."

"She's already making trouble," Sharon began, then glanced meaningfully at Bridget.

"Well, I've got to get going," Bridget announced. "Nice to meet you, Mr. Rance."

"Call me Norbert," he said genially. "We don't stand on ceremony here at Ars Ranch."

"Well, Norbert, thanks for inviting me. I really appreciate it."

"My pleasure, uh…"

"Bridget," Sharon said. She'd been scowling since Johanna's name had come up, and Norbert's obvious anticipation had only deepened those little frown lines.

"Bridget. Of course." Norbert gave her hand another vigorous shake. With difficulty, she maintained her grip on the tray in her other hand, barely keeping the dish of fruit from plummeting to the floor.

"Guess I'll go back to work," she said, regaining her hand and making for the door.

On the way back to her room, she noticed that most of the baskets were gone from the doorknobs. Johanna's was still there, though. Evidently she was a late sleeper.

Or maybe she was sleeping somewhere else.

An image formed in Bridget's mind of Johanna with a buff young surfer dude like the one Madeline had gossiped about; perhaps they were now having coffee in his modest beach shack. Or Johanna might have risen early to go upstairs to V.J.'s room and share his... muffin.

Shrugging off the scenarios provided by her overactive imagination, Bridget let herself into her room. It was none of her business, and she wanted her tea.

Bridget carried her breakfast tray over to the desk by the window, pushing her laptop aside. She ate slowly, watching the gray light of an overcast morning grow on the distant sparkle of water, listening for sounds around her, and hearing only the occasional muffled clatter of a keyboard drifting through the open window.

The hot water ran out before her need for tea did. She put her empty tray outside her door and took the thermos back to the dining room for a fill-up.

This time Madeline Bates and Ed Weis were hovering over the buffet.

"Good morning," Madeline said brightly. "Wonderful spread, isn't it?"

"It was good, but I need more hot water." Bridget filled her thermos.

"Oh, I just can't decide." Madeline held a serving spoon over the chafing dish of scrambled eggs. "Should I have blintzes instead?"

"Get 'em both. I'm going to." Ed sounded surly.

"Now let me see." Madeline set her tray on the dining table and rooted in her big tote bag. "What did I do with them? Is that—?" She pulled a prescription bottle out and squinted nearsightedly at the label. "No, these are my nighttime pills. I need my morning pills."

"Got any vitamin E?" Ed actually attempted cordiality. "I forgot mine."

"I don't take vitamins," Madeline stated. "I have a little dizziness, that's what the morning pill is for." She held up another prescription bottle triumphantly. "And at night I have to take a sleeping pill to get any rest at all. I just never sleep unless I take it. I'm up all night, and then I feel so dull during the day. But those pills make me sleep like a baby until morning. Otherwise, I'm just roaming the halls all night getting into trouble." She laughed heartily.

Ed didn't laugh. He grunted something and left.

"I must get back to work," Bridget said hastily. She slipped out of the dining room with her thermos before Madeline could reply.

The big entrance hall was empty when she stepped into it, but she could hear voices from above. It sounded like Sharon and Norbert were in the gallery that circled above the hall; Bridget remembered Sharon mentioning that the ranch office was up there, reached by the wrought-iron spiral staircase in the corner.

Judging from their voices, neither Sharon or Norbert was happy.

"Where did you go last night?" Sharon's voice was shrill. "You said you'd be back by midnight at the latest. I waited and waited, but you didn't show."

"None of your business. If I won't let my wife boss me, I'm surely not gonna let you." Norbert's voice had become a bit high-pitched.

"*She* was gone, too. You were with her, weren't you?"

"Who? I don't know what you're talking about." Even Bridget could hear the guilty bluster in his voice.

"You know, all right. Little Miss butter-wouldn't-melt-in-her-mouth Johanna. Well, I hope she was sober enough to show you a good time." Sharon's high-heeled boots clicked back and forth.

Bridget realized she was eavesdropping, and scurried down the corridor to her room. It seemed a haven, and her computer

was waiting for her. She would be alone again all day, working on her book, without having to do a single domestic chore. It was blissful.

It should have been blissful, anyway. The words that had flowed out the day before became elusive. Norbert and Sharon and Madeline and Ed and Johanna and V.J. were bumping around in her head, complicating things, sabotaging her concentration, making her fictional characters seem vague. Even though her breakfast had been lighter, her stomach still felt overburdened. Despite the tea, her eyelids wanted to drift shut.

They popped open when someone rapped on the French door. Surprised by the intrusion, Bridget jumped up to let Sharon in.

Sharon's hair was a little windblown, and she appeared to be in a pettish mood. "Sorry to interrupt you," she apologized. "I know it's a dad-blamed rude thing to do."

"Is anything wrong?" Bridget offered Sharon a chair. "Are you hurt?"

"I'm okay. I just can't find Johanna." Sharon spoke bitterly, plopping down on Bridget's bed. "That bitch just can't stop causing me trouble."

"Why are you looking for her?" Bridget didn't really mind the interruption. If writing wasn't happening, something else might as well.

A tinny ring filled the room. Sharon pulled a tiny cell phone out of her shirt pocket and answered it. "Not so far," she snapped, and holstered the phone.

"Norbert." Sharon sniffed. "Havin' a hissy fit until she's found. And she's probably shacked up with that surfer boy." Sharon scowled. "If anyone can take care of herself, it's Johanna. No need for me to go chasin' after her."

"She's not in her room?" Bridget thought of that rumpled bed. "Come to think of it, I haven't seen her since last night."

"Nobody has, or at least nobody admits it, with Norbert

practically putting his branding iron in the fire." Sharon picked a thread off the duvet. "It really galls me," she burst out, "when I work and work to make this place a success, and he gets himself tangled up with a hussy like that!"

"She's not—with someone else?" Bridget didn't want to say V.J.'s name, but that was whom she meant.

"Well, V.J. hasn't seen her either, if that's who you mean." Sharon got up. "Guess I'll drive down to the Cash Store and talk to that surfer boy. Maybe he knows where she is."

"I hope you have success." Bridget stood up, too. Joanna would probably not be too pleased about Sharon calling her posse out.

"She will never be invited here again," Sharon vowed. "This is a place for working artists, not working girls."

"That's a little harsh," Bridget found herself protesting. "Johanna is struggling with a lot of demons, but she is a writer, and she will come through."

"Hah." Sharon looked superior. "Didn't you hear her at dinner last night? Her publisher has signed up a ghost for her. That means she can't write for beans anymore."

"She's blocked. It's scary." Bridget shivered, blessing the pages she'd accomplished the day before. But could one amazing day of writing, even if it did result in nearly thirty pages after editing, signal the end of writer's block?

"Well, I'll leave you to it. And if you do see Johanna, would you tell her Norbert's lookin' for her?" Sharon got to her feet. "I guess he's gonna have to get this out of his system."

"I'll tell her," Bridget said, shutting the door.

She spent a little while longer editing what she'd done the previous day, surprised at how well it stood up. Still, when she tried to write more, nothing came.

She needed a brisk walk along the ocean. A walk she could take without changing a diaper, cleaning the stroller, encouraging others besides herself to go potty, finding several jackets,

wiping noses and other sticky bits. Without having to assemble snacks and drinks and amusements designed to entertain the young long enough to restore their parent to partial sanity.

Bridget grabbed her jacket, let herself out, and headed for the beach.

11

THE AIR WAS COLD and briny. She headed across the court-yard and drive toward the lawn and the ocean, drawn by the distant thunder of the breakers. The sun hadn't yet burned off the low-lying fog; the sky above was a luminescent gray, like the inside of an oyster shell.

When she reached the seawall, she noticed a white picket gate filling a gap a little farther down; it had been invisible the night before. She made the transition from grass to sand and walked down to the water, stumbling a little until she reached the firmer, damp sand where the tide was going out, leaving fading scalloped watermarks behind. She stared at the heaving mass of water for a while, at the jagged rocks that thrust up just offshore, then turned and walked north along the beach, looking for sand dollars and finding only pieces left by the importunate gulls.

At a small rise, she stepped over a long, smelly rope of kelp and paused to take her bearings. The Ars Ranch seawall was behind her, and from this distance she could tell that the beach in front of the seawall had been groomed; on that stretch, there were no piles of decaying kelp to mark the high-tide line.

She looked the other way, toward Half Moon Bay. An elderly

VW camper bus, older even than her friend Liz's, had been pulled up a few hundred feet farther down, at the point where scrubby vegetation left off and the beach sand began.

She walked toward the bus, which was parked at the end of a faint track leading back toward Highway 1. A bevy of people bustled around it, changing into wet suits, waxing surfboards, sipping coffee.

Two wet suit-clad men hoisted their surfboards and walked down the beach into the water. She watched them wading through the surf, guiding their boards on leashes beside them like pets. Then they were on the boards, paddling with quick strokes back the way she'd come, toward the surf that curled in front of the Ars Ranch beach.

"Hey!" She turned at the shouted greeting, and saw the young man she'd spoken to at the Davenport Cash Store waving at her. He was smiling, but as she walked closer, his smile disappeared. "Oh. It's you."

"Hi." She glanced around. "This is where you surf. It looks nice."

He rolled his eyes at her ignorance. "It's a first-class break," he said. "Right, Nance?"

The woman next to him finished zipping up her wet suit and turned to face them. Bridget tried not to stare; the woman was a good fifteen years older than she was, with a lined, weathered face and long, thick gray-streaked hair that she gathered and began braiding.

"As good as they come," Nance said. She smiled at Bridget. "Do you surf?"

"No. I mean, I never have." Bridget blinked. "I always thought of it as a young man's sport, somehow."

"Not anymore," the young man said. "We got so many of those gray-haired, ponytailed guys out there, it's like being at an AARP meeting."

"Now, Dave," Nance said, finishing her braid. "The waves are open to all. That's one of the best things about surfing."

Bridget was watching Dave, who gazed down the beach the way she'd come. He hadn't put his wet suit fully on; the top part dangled down, revealing a tanned, muscular chest.

"Who were you expecting?"

Dave turned to look at her. "Huh?"

"You were expecting someone else when you saw me."

"His girlfriend." Nance spoke dryly, but there was an undercurrent of concern in her voice. "From the Ranch. Dave is smitten."

"You're full of shit, Nance." Dave scowled. He stuck his arms in the wet suit sleeves and reached around for the long string that dangled off the zipper behind him. He pulled the zipper up with a quick jerk, picked up one of the two remaining surfboards, and ran lightly down the sand, despite the weight of the board.

Nance watched him, shaking her head. "Bad business," she muttered, sighing. She transferred her gaze to Bridget. "He shouldn't get mixed up with the artists. They come and go, and each time he's heartbroken. This woman he's mooning about today has really got him going. Fact is, she was here a year ago, and he didn't get over her for months after she left. Who is it, do you know?"

"I can guess." Bridget smoothed her foot over the sand. "And I think she could be trouble for him. Are you his mother?"

Nance stared at her. "No. Never been married, never had kids. Surfers look out for each other, that's all. I just don't want to see him hurt again." She picked up her own board. "Nice to meet you," she said perfunctorily, before striding down to the water.

Bridget walked back slowly, watching the surfers. They perched on their boards just beyond the swells. Every so often, by some kind of mutual knowledge, they paddled frantically for a wave. In their dark wet suits, they were indistinguishable at a distance except for Nance, whose braid set her apart. By the time Bridget had arrived back at the picket gate, she'd seen them

rising to catch a wave, subsiding as it smoothed into ripples, paddling back up the face of the next swell, a number of times. Even from the shore she could tell that their gaze was focused, their attention fixed on the ocean, the next wave.

She stood at the gate for a few minutes, pondering Johanna's bad-girl behavior. That it was Johanna who had Dave in a tizzy was not in doubt. The woman was a danger to herself and those around her, but Bridget could see no recourse. Johanna was certainly old enough to know better, and wouldn't take kindly to intervention anyway.

The waves, the gulls, the rhythmic circling of the surfers were hypnotic. One of the surfers drifted north, breaking the chain by paddling over toward the biggest of the rocky outcrops that rose from the foaming waves just offshore. Watching the surf smack violently into the jagged, towering sides of the outcropping, Bridget thought that if she was on a surfboard, she would do everything she could to avoid that area.

She stared more closely at the rocks, which, clumped together, resembled a stone castle topped by irregular crenellations. Resting on a ledge above the waterline, about two-thirds of the way up the rock face, was a long bundle that looked at first glance like a snarl of kelp. A sea lion on a day trip from their preserve at Año Nuevo? She wished she'd brought the field glasses. The sun hadn't really come out from its veil of mist, making it unlikely basking weather for sea lions. Something brightly colored amidst the bundle flapped in the breeze, probably what had attracted the surfer's attention.

Straddling his board, the surfer grabbed a rock to keep himself steady and peered upwards. Another surfer drifted closer. The first one turned and shouted something unintelligible. They both turned and looked back at the shore. One of them waved and then semaphored his long black-clad arms in the air. Bridget knew from herding Cub Scouts that he was making a distress signal.

Puzzled, she pointed at herself and then back to the ranch

house, and the one signaling waved vigorously before paddling toward the rocks. The first surfer had wedged his board into the outcropping somehow and was clambering up the rocks, his bare feet slipping on the seaweed-strewn sides.

Bridget waited no longer. She ran back to the house as fast as she could.

12

BRIDGET SAT ON THE SEAWALL, trying to stay out of the way and inconspicuous. She shivered inside her jacket, and not just because the wind off the ocean was brisk. On the beach in front of her, people scurried to and fro; an ambulance was pulled up at the nearby Ars Ranch access road. Behind it were a couple of cars from the Santa Cruz County Sheriff–Coroner's Office. Their flashing lights gave the overcast day a lurid tinge.

Bridget shivered again. Coastal weather differed from that in Palo Alto, thirty miles and a range of hills inland. She hoped it was still sunny in Palo Alto, that Emery wasn't being tortured by gloomy weather with a house full of children to tend. She hoped he didn't somehow get word that a death had occurred in her temporary circle.

The bundle that was a body had been retrieved from the rocks. The surfers had brought it in on a surfboard, earning themselves a scolding from one of the coroner's minions, but Bridget couldn't fault their behavior. After all, what young man in love could have found his beloved dead on a rock and just left her there? The image of Dave floating the limp body to shore on his surfboard, and then gathering it into his arms to carry it up

85

the beach, would be with her for a while. He had stood there, his face wet with seawater and tears, looking vacantly around for some place to put the body, until Nance had said very practically, "Put her here on my board." And then he had walked off down the beach alone, the others looking after him soberly. He hadn't returned before the ambulance arrived, followed shortly by the patrol deputy.

Bridget realized her mind was skittering around the subject of Johanna, so she forced herself to think about the woman whose body was now stowed in the ambulance for its journey to the morgue. Her brittle gaiety, her edgy charm, had not concealed the desperately unhappy woman beneath. Might she have taken her own life?

Someone turned off the ambulance's flashing lights. Bridget couldn't repress a shudder. She'd been to a morgue. She'd seen sudden, bloody death. But it had not given her enough detachment to contemplate what would happen to Johanna next without a sick feeling.

Nance and the other surfers were off to the left, their black wet suits giving them the look of mourners, their surfboards crouched beside them like obedient sea-beasts eager to return to the water. They stood with arms crossed and wary expressions, watching the various groups of county officials.

Three people in burly jackets with SANTA CRUZ COUNTY SHERIFF–CORONOR emblazoned on the backs were moving methodically along the waterline, their regulation boots wet, scanning the sand and occasionally digging at some object with long-handled tools. A pair of scuba divers surfaced just offshore and came duckwalking up the beach, shaking their heads at another official-looking group clustered on the shore in front of the basalt outcropping. The rocks were still partially submerged, though the tide was ebbing and the water had receded from the ledge where the body had been lodged. A dark coronet of seaweed around the topmost peak of rock showed that high tide would nearly cover them.

Bridget hopped off the seawall and started down the beach. One of the patrol deputies saw her and veered away from the pack to meet her.

"Please don't come any farther." The deputy was a woman, young, dark-skinned, with an assured manner. "We're investigating a death here."

"I know. I called it in."

The young woman looked at her narrowly. "Are you one of the people up there?" She gestured back toward Ars Ranch.

"Yes."

"Detective-Sergeant Gonzales will want to talk to you. He's asked all of you to meet him up there at—" she checked her watch "—ten-thirty."

"Can't you tell me something before then?" Bridget touched her sleeve. "I am having such a hard time accepting this. Johanna—" She hesitated. "There's no chance she might have taken her own life, is there?"

Once more the young woman subjected her to scrutiny. "Wait here," she said, and wheeled around, jogging easily over the damp sand to the people grouped in front of the outcropping, and tapped one on the shoulder. When he turned, she pointed back to Bridget and said something. The man nodded, turned again to the rocks. The young woman jogged back to Bridget.

"Wait a little longer, okay?"

Bridget saw that the name embroidered on her jacket was ROSHAWN WHITE. "Of course. I'd like to do something to help."

Her impulsive speech earned her only a measuring stare from Roshawn's brown eyes. "Just wait here, ma'am. Detective Gonzales will be with you in a minute."

Bridget waited, while the cold wind blew her hair, made her eyes water, made her wish she'd put on a scarf. The conference around the rocks finally ended, and the group of people trudged up the beach. A couple of them veered off toward the ambulance. One of the men continued in her direction. He was a few

inches taller than she was, stocky, with dark hair and olive skin. His eyes, also brown, were difficult to read.

"Hi," he said, sticking out a hand. "I'm Detective-Sergeant Gonzales. You're one of the writers?"

"Bridget Montrose. I was out here this morning when the surfers discovered the body, and I called you all in." She hesitated. "I spoke to Johanna on the beach here last night. She was unhappy, not hiding it too well. I just wondered—"

"You thought she might have decided to drown herself," Detective Gonzales said. "Of course we're considering that. It's really too early to call at this point. Did she say anything specific to make you think this?"

"Not really." Bridget hesitated again. "Actually, we'd kind of had words earlier, at dinner. She was—she could be—a bit mean in her remarks, and she'd made dinner kind of uncomfortable, and I—"

"Catfight?" He looked interested.

"Nothing so dramatic. I wasn't happy with my reply to her, and when I saw her down here, I took the opportunity to apologize." Bridget spoke stiffly. Her actions sounded, even to herself, both priggish and suspicious.

"Right." He nodded, not agreeing or disagreeing. "So you talked, apologized, and she revealed how unhappy she was."

"Not really." Bridget wished she'd never gotten into this conversation. "She—we were just chatting, you know. But from what she said—"

"Can you remember what she said?"

"Not exactly, but I can take a stab at it." Bridget frowned. "She waved off my apology. Said it was good for her to be slapped down. We talked about her staff, about the burdens of her success. She was...not exactly drunk, but not sober." Bridget looked at Detective Gonzales. "She did seem to have a drinking problem."

"Then what?" He had a little palm-sized computer out, and was making swift notes with a stylus on its tiny screen.

"We talked about writer's block. And about her earlier books. They were good, really good. She said—well, I got the impression she didn't think she could write like that anymore, which is very depressing for a writer." Bridget felt that she was telling the man more than he needed to know about the insecurities of writers. "Then she asked the time, said she had an appointment. She walked off beside the seawall, and that's the last I saw of her."

Detective Gonzales looked at her for a long moment. "Did you see or hear anyone else?"

Bridget hoped her momentary pause would be taken as cogitation, not evasion. She remembered hearing the distant sound of a VW engine, but it was too nebulous to mention, and in any case, it didn't have to have been Dave. VW buses weren't exactly scarce along the coast.

"No. I went in soon after. It was cold." Bridget couldn't help the shiver that seized her.

"Well, that's very interesting, Ms. Montrose." Detective Gonzales shook her hand briskly and gave her a gentle push toward the picket gate. "I'll still want to see you with the others at the house in a few minutes. Thanks for the input."

Bridget went back to the ranch house. She felt as if she'd been measured and found wanting, and it wasn't a comfortable feeling.

"I was only trying to help," she muttered to herself, heading up the brick walkway. "Thanks for nothing, Mr. Detective."

It was so exactly what her son Corky would have said that it made her smile. But the smile faded when she thought of the interrogation to come. From experience, she knew that witnesses to a crime, or those involved in a crime scene, could be made to kick their heels while investigators worked. It might be a long time before she got back to her computer.

She felt selfish for dwelling on her own concerns, but what she needed was to get back that wonderful spate of words she'd experienced the previous day, and now all she could think of was Johanna.

13

THE MASSIVE ENTRANCE HALL felt cold and cavernous. Bridget could hear conversation from the dining room, and surmised that the other writers were taking advantage of the coffee service.

She didn't want to be with the other writers. She knew how quickly they could examine an event, transmogrify it, and claim it for their own. By the time Detective Gonzales got there, a dozen fictions would be perpetrated.

Logs were arranged on the grate in the living room fireplace. She found long matches on the mantel and lit the kindling, hoping that at least this once, fire would work for her. Flames licked through the fatwood and released the aromatic fragrance of fir. She held out her hands to the warmth, realizing that she was shaking with cold and reaction. The fire had a reassuring heat, and when she was warmer, she sank into one of the leather wing chairs to watch it, letting her mind go blank for a time.

Footsteps and voices coming into the living room interrupted her meditative funk. V.J. and Dorothy were talking. Bridget could see them reflected in the glass doors of the bookcases that flanked the fireplace. Madeline followed the other two, listening avidly.

Bridget raised a limp hand, but they didn't notice her in the big chair pulled up to the fire.

"I still cannot believe it." V.J.'s dark face was mournful, his eyes downcast. "She was so full of life, so beautiful and charming...."

"Right," Madeline said, the skepticism plain to hear. "Well, certainly old Norbert will miss her. He's taking it very hard."

Dorothy stopped in the archway. "I have to rest." She looked every bit of her age. "It's been such a shock." She left the room, passing Ed on his way in; he joined V.J. and Madeline.

Bridget turned sideways in the chair, her feet tucked under her. She didn't bother to say anything. They would discover her there soon enough, and she felt as drained as Dorothy had looked.

"Well," Ed said, stuffing a last bite of something into his mouth, "I don't know about you two, but I've got better things to do here than sit around waiting for some rural know-nothing sheriff to interrogate me about Johanna. I'll be in my room if anyone wants me. I have a deadline, you know." He stomped away toward the bedroom wing.

"Hmph." Madeline flounced into a chair. "Guess it's just you and me, V.J. Nobody else cares enough to get to the bottom of this." She whipped out a hankie and carefully touched her eyes. Bridget suspected the hankie remained dry.

V.J. came closer to the fire and noticed Bridget. "Why, here you are. We wondered where you were."

"The surfers found Johanna." Madeline moved to a closer chair. She tried without success to sound regretful. "She drowned. Out there."

"Someone from the sheriff's office has asked us to gather here," V.J. told Bridget. "We could all use some time to pull ourselves together, perhaps." He passed a hand over his forehead. "Poor Johanna. What an ending for her."

"The detective came into the dining room and asked if everyone was there, and I noticed you were gone," Madeline

said, anticipation shining in her face. "He'll probably be extra interested in talking to you."

"I've spoken with Detective Gonzales." Bridget tried not to let her distaste for Madeline show in her voice.

"Really?" Madeline was skeptical. "When?"

"I was at the beach when the body was discovered."

V.J. winced. "It's Johanna. Not a body. Not some anonymous body."

"He's probably already writing a poem about it," Madeline said to Bridget in what she probably thought was a whisper.

V.J. gave Madeline a look of intense dislike that she didn't see because she was watching Bridget.

"So you were there when the body—when Johanna—was found," she said with relish. "I bet the detective thought that was interesting."

"I don't know what you're talking about." Bridget was not good at put-downs. She generally found herself in the role of peacemaker. But Madeline was so irritating that Bridget wanted to slap her.

"Don't you read murder mysteries?" Madeline opened her arms wide to indicate the immense quantity of mysteries that Bridget had left unread. "The last person to see the victim is always a suspect, and the person who finds the body is a suspect, too."

"Well, neither of those is me." Bridget stopped for a minute to consider her grammar. "I am neither of those persons." That didn't sound right either. She gave up grammar in favor of clarity. "In the first place, do they suspect foul play? Why are you thinking about murder?"

Madeline wasn't as good at being on the hot seat as she was at applying it. She squirmed a little. "Well, just in case. I mean, it could be."

"Or not." Bridget tapped a finger against her chin. "Interesting that you bring it up. That you want us to believe it's murder."

V.J. winced. "Would you please not use that ugly word? Johanna's death is more important than a tabloid headline."

"Sorry, V.J." Bridget *was* sorry. She had just wanted to give Madeline's medicine back to her, not make V.J. unhappy. "However it happened, she's dead, they're investigating, and it's up to us to tell the truth as far as we know it. Not what we think sounds interesting or sensational, but simply giving the investigators the facts."

"Who made you the expert in all this?" Madeline gave her a suspicious look. "You must watch a lot of reality TV."

Bridget decided, too late, that discretion was the better part of any conversation with Madeline. She turned to V.J.

"Is there anything I can do for you? Do you need some time to be alone?"

He attempted a smile, but it was a pale rendering of his usual expression. "I am all right. Just anxious to have this over. I cannot think about her, about the loss of Johanna, while all this ferreting into her life is going on."

"It'll just get worse," Madeline predicted with relish. "There's going to be major press about this, especially if it turns out that she was—" She stopped, closing her lips tightly.

"That's probably true," Bridget admitted. "I don't know how successful Norbert will be at keeping the press out." She recalled the walls around the compound, the locked gate. "Maybe pretty successful. But Johanna's death will be played up everywhere because of her celebrity."

"She was worried about her safety," V.J. said. He dropped into the chair beside Bridget and put his head in his hands. "She had bodyguards. I thought they were just for show, but then I realized she was really worried."

"There were no bodyguards here," Madeline said, sounding disappointed.

"She told me she didn't need them here, that Norbert had good security. And look what happened." V.J. sat up. "Someone has wanted her dead, and now she is."

"So someone from outside, you think." Madeline's nose quivered. "Followed her here, got the drop on her, and *pow!*"

V.J. winced again. Bridget turned on Madeline.

"It's easy to see who watches too much reality TV. Do you write mysteries as well, Madeline?"

"My book is a thriller," Madeline corrected. "This is all very interesting to me."

V.J. surged to his feet, but what he would have said was lost in the *bong* of the front door bell. They fell silent, listening. After a moment, Sharon's boot heels tapped briskly on the stairs, and she crossed the foyer to open the door.

"The detective," Madeline breathed. She whipped out her notebook from her omnipresent tote bag. "Where is everyone else? He wanted us all here."

On cue, Ed came into the hall, with Dorothy behind him. Sandra and Elaine came out of the dining room, holding big steaming cups. Bridget found herself craving a big steaming cup of her own, filled with fragrant black tea and a dollop of milk. While Sharon greeted Detective Gonzales with a stiff parody of her usual hospitality, Bridget slipped across the hall and into the dining room. It was deserted, but the swinging door into the kitchen was opened a crack, and Tiffany peered out of it. She waved at Bridget. "What's happening?"

"The detective from the sheriff's office is here." Bridget made a beeline for the hot water.

"So it was Johanna Ashbrook? That's what we heard." Albert's head joined Tiffany's in the doorway.

"Johanna was found dead, probably drowned, caught in the rocks just offshore. Detective Gonzales is investigating. We don't know yet how it happened." Bridget scooped up tea in the tea-ball spoon and poured hot water over it in a big cup. She added milk, and because she felt a little shaky still, a couple of sugar lumps. "I've got to get back to the living room."

"Okay." The door swung shut, but Bridget could hear their excited voices.

She hastened back in time to be included in the group introduction Sharon was making. Holding her cup carefully, she perched on a chair near the archway. Ed had taken her chair by the fire; V.J. had resumed his seat, and Madeline sat ready with her notebook, her face full of eager expectancy. Dorothy was on one of the small sofas, her hands busy with knitting needles and pink yarn.

Detective Gonzales looked at each face as Sharon spoke their names. He nodded at Bridget, causing Madeline's eyes to narrow.

"I'm Roy Gonzales, and I'm sorry to be here on such a sad errand," he said when Sharon had finished. "By now you all know that Johanna Ashbrook's body was found in the ocean this morning by some local surfers."

Sharon sniffed and held a hankie to her eyes. Another dry hankie, Bridget thought.

"As you may realize," Detective Gonzales continued, "the death of such a well-known person will bring intensive scrutiny. Our investigation may involve use of state and even federal resources. I need to ask all of you some questions to rule out any possibility of foul play."

"She was murdered, wasn't she?" Madeline spoke impulsively. "We've already figured out that someone from outside did it."

"Have you?" Detective Gonzales looked at her, his face expressionless. "Well, before I can make that same determination, I want to go over the last couple of days with all of you. The rest of my unit will be here in a moment, and we'll start the interviews." He looked around the room. "Mr. Rance is in residence, isn't he?"

Sharon drew herself up. "He's prostrated with grief. He and Johanna were very close."

V.J. let a little snort escape.

Detective Gonzales turned to him. "You don't agree with that, Mr. Sunjupany?"

V.J. hesitated. "Johanna found him amusing."

Sharon sputtered. "Why, what a thing to say."

Detective Gonzales interrupted. "I think Mr. Rance needs to be here. Would you let him know?" He looked steadily at Sharon, and after a moment she nodded.

"Maybe Norbert did it," Madeline said, as Sharon swept from the room.

"Don't worry, we'll get to the bottom of it." Gonzales looked around at all of them. "We will be asking questions of each of you. We've already heard something about Ms. Ashbrook's actions last night. I understand there was some unpleasantness at dinner?"

"Not that I noticed," Ed grunted. "It was a fine dinner, as usual—"

"I didn't think it was so lovely," Madeline said, her voice getting squeaky as it did when she was agitated. "Johanna as good as insulted me—her and Ed."

"It was a little lively," Dorothy said, knitting away obsessively, "but a gathering of writers often is. We believe in the free exchange of ideas, Officer."

"Detective-Sergeant, actually." Gonzales looked around the room. "Ms. Montrose told me she spoke sharply to Ms. Ashbrook and then felt she had to apologize. That doesn't sound like just the free exchange of ideas."

"You apologized to Johanna?" Dorothy seemed amused. "Bridget, dear, she'd insulted more people in her short life than you've probably met. Don't think she'd ever bothered to apologize, either."

"You knew her well?" Detective Gonzales's attention centered on Dorothy.

"As well as anyone, perhaps. We were actually in the same critique group several years ago, before she became famous. Even then, she was charming and thoughtless. And a fine writer, incidentally. We all knew she was going to go places."

"What's a critique group?" Gonzales scribbled in his notebook. "It sounds like it could be harsh."

"It's a way of getting feedback on your work from other writers." Dorothy finally stilled her knitting needles for a moment. "And it doesn't have to be harsh. We have a rule, in fact, that any criticism has to be constructive. It helps to say what you like about a work, as well as what you perceive as flaws."

"Bunch of crap," Ed grunted. "Critique groups never work. If you say what you really think about someone's stuff, they just trash yours to get even. Mostly women there anyway."

"They don't work for everyone," Bridget said, nettled enough by Ed's attitude to jump into the fray. "You have to be open to listening, certainly."

"I see," Detective Gonzales said. He looked back at Dorothy. "So if you and Ms. Ashbrook were in a group together, you both must have lived in New York?"

"We both still do, or rather, I do." Dorothy's hands faltered on the pink wool. "Poor Johanna. She wanted so much from life."

"Who else was close to her before she died?" Detective Gonzales's gaze swept the room. "Ms. Montrose, I think you said you hadn't met her previously."

"I'm new in these circles," Bridget said, with as much dignity as she could muster. Ed stared at her as if she had "Judas" tattooed on her forehead. Talking to Detective Gonzales on the beach had obviously been a bad idea.

"I'm new, too. I'd never met her before. I didn't know anyone." Madeline chimed in. "I didn't even know I'd been accepted here until last week. I was so excited. Such a turning point in my career."

"I knew her," V.J. said quietly. "We have known each other for years; at one time, very well indeed. I have always loved her. She was a lovable woman, even when she was most maddening. I shall miss her greatly."

Detective Gonzales looked at him for a minute. "We'll speak of that later. Your insights into her character will be most helpful. And you, too, Mrs. Hofstadler."

Dorothy nodded and picked up her knitting again. "If I can help at all, of course I will."

"Anyone else?" Detective Gonzales looked around, but no one spoke. In the silence, the resonant *bong* of the front door bell sounded louder than usual. Detective Gonzales waited a moment, then went to the door himself. From her seat, Bridget could see that Patrol Deputy Roshawn White and a couple of colleagues were at the door. They had a low-voiced colloquy, and then one of the deputies went back outside, while the others came into the living room.

Detective Gonzales introduced them. "We're going to start with one-on-one interviews. Deputy White will assist me. Who knows where Ms. Ashbrook's room was?"

No one spoke at first. Gonzales surveyed the group, and picked out Bridget. "Ms. Montrose, will you show Deputy Aikens her room? We need to make sure it's untouched, seal it up for the county crime scene investigators."

"It is murder, then!" Madeline's face shone.

"It's a precaution, only that." Detective Gonzales looked at Madeline curiously. "We'll start with you, Ms. Bates. Let's go into the dining room there. That coffee smells very good. The rest of you, please wait here until we ask for you." He nodded to Bridget. "If you'll go with Deputy Aikens, please."

Madeline, looking equally elated and terrified, followed the detective into the dining room. Bridget, perforce, went with Deputy Aikens, down the corridor to the bedrooms.

14

DEPUTY AIKENS would have been totally nondescript if not for a shock of uncontrollably curly blond hair. A man of few words, he followed Bridget silently down the hall. She stopped in front of Johanna's door. She noticed that someone, probably Albert, had removed the muffin basket.

"She was here, in the Kathleen Norris Room." Bridget reached for the doorknob, but he forestalled her.

"Don't touch." He moved in front of her and leaned over to subject the knob to a long scrutiny. Dropping to his knees, he did the same for the hallway floor. Bridget watched him for a while.

"Do you need me? Because I should be getting back," she said, gesturing toward the living room.

"No hurry." Deputy Aikens got to his feet and pulled on a pair of latex gloves he took from his briefcase. "They're just interviewing everyone now. Nothing much happening." He reached out, tried the doorknob, and the door opened.

Eyebrows raised, the deputy turned to Bridget. "Do folks not lock their doors around here?"

"I do." She thought of her laptop, her precious words. "I should think everyone would."

"Deceased didn't."

Bridget winced at his casual description of Johanna as *deceased*. "She may have meant to return. Or if you're committing suicide, you probably don't care if your things are stolen." She stopped, struck. "Actually, her door *was* locked last night. I tried it, about twenty minutes after dinner."

"Now, why would you do that?" The deputy looked at her.

"I knocked and she didn't answer," Bridget began, and realized that sounded even worse. "Well, I thought she might have passed out. I was checking on her."

"Hmm." Deputy Aikens stood in the doorway of the room for a moment, then moved aside to let Bridget stand next to him. "It was locked, you say. Had you ever been in here?"

"I looked in through the French windows last night," Bridget admitted. "Probably left my footprints outside the window, and fingerprints on the glass." She stepped up, peering curiously into the room. "The bed was rumpled, and there were clothes everywhere, but in a more deliberate way. I don't believe it looked like this."

Johanna's room was tempest-tossed. A suitcase had been emptied on the bed, its contents pawed through. Another suitcase was open on the floor, disgorging expensive-looking clothes and filmy underwear. Jewelry glittered in a heap on the dresser top; the leather case that had held it was upended on the floor.

Bridget looked around for a computer or laptop or even a pad of paper. "I don't see her computer."

"Would she have had one?" Deputy Aikens still surveyed the room.

"Well, this is a writers' retreat. She would have had something to write on, and most of us use computers these days."

"So you looked in here last night and it was neater?"

"Not exactly neater." Bridget closed her eyes, trying to remember what it had looked like. "I didn't really pay attention. I was looking for Johanna, and she wasn't here, unless she was in the bathroom or something. She might have been there, or come back later and been looking for something herself."

"She a tidy person, would you say?"

"I didn't know her that well. She always looked very fastidious, but she could have been messy underneath."

Deputy Aikens flipped off the light he had turned on, and began to close the door, making sure it would lock. "So those French doors open? Not just for show?"

"They were open last night." Bridget squinted across the room. "Looks like they're still ajar."

"You on the ground floor, too?"

"Right next door." Bridget wondered uneasily if that made her an even more likely suspect. Probably at that moment Madeline was telling the detectives all the reasons why Bridget looked good for it.

"Okay, well, you can go back to the living room now. I'm going to put up some caution tape, seal this door and the French doors."

"Aren't you going to search the room?" Bridget stopped. "Oh, right, you probably have a forensics team or something."

"County has a crime scene investigation unit." Deputy Aikens started to say something else, then stopped. "You say this woman was famous?"

"Well, her books were almost always on the best-seller list, and she was on those TV talk shows a lot." Bridget remembered Johanna as she'd seen her on Jay Leno's show, being scandalously funny and wicked, and felt sad all over again. "She was good at that."

The deputy nodded. "Well, someone like that, the investigation gets tricky. If New York gets involved, they might find fault with our procedures, and that would screw up the trial. So we let the crime scene people do their thing. Anything goes wrong, they take the heat."

"That's probably a good idea," Bridget admitted. "But doesn't it gall you? Don't you want to find out the answers?"

Deputy Aikens looked at her. "It's a job. There's always work. And ma'am? Just a word of advice. It always messes things

up when people think they're that TV woman and go around
sticking their noses in."

"TV woman?" Bridget frowned. "Oh, Jessica Fletcher."

"Her. Right." Deputy Aikens shooed her down the corridor.
"Let us get to the bottom of it. We'll figure out what happened
to your friend."

"She wasn't my friend. I barely knew her."

"Whatever." The deputy guided her into the foyer, and
pointed to the living room. The hum of voices was clearly audi-
ble. "Just go ahead and join the others. Detective-Sergeant
Gonzales will be talking to you."

Bridget felt like she was being herded by a large, stubborn
dog. "Well, it was nice meeting you, Deputy Aikens."

"Pleasure, ma'am." He nodded and turned toward the front
door. Then he came back. "You all are writers, you say."

"That's right."

"Any of you mystery writers?"

Bridget thought. "I believe Madeline Bates is writing a thrill-
er. She's the only one I know about."

"Just be sure to pass that about Jessica Fletcher along to her,
all right? Make it easier all around."

"I think it would be better if you told her." Bridget leaned
closer and lowered her voice. "I don't think she'd listen to some-
one who wasn't a professional."

She didn't say that Madeline would no doubt be around
with her notebook, pestering Deputy Aikens and any other in-
vestigators for information on how they worked, and then, prob-
ably, loudly proclaiming that she would have to do it differently
in her book.

"We'll do that, then." Deputy Aikens nodded soberly. "See
you, ma'am."

Bridget went back to the living room.

15

SHE STOPPED JUST inside the archway. Norbert Rance was in the living room, and he was not happy. He strode around, his cowboy boots clunking on the floor. Bridget decided to stay out of the way. His feet were small, like the rest of him, but those high-heeled boots could do some damage.

"I can't believe it. Johanna dead. Dead!" Norbert's arms made emphatic exclamation points. "And on my watch. We've never had a death before, have we, Sharon?"

Sharon had taken time to smooth her big hair and firmly lacquer it into place. Her eyeliner had been reapplied. She had changed into a white shirt with pansies embroidered across the yoke. Her white stretch pants were tucked into white cowboy boots with purple embroidery swirling across them. She held a hankie, also embroidered with pansies, to her nose, sniffing delicately.

"We sure haven't, Norbert honey." She reached out a hand to him as he stalked by, and he gave it an absent squeeze. "It's just too hard to take in. Poor Johanna. Well, she was dreadfully unhappy, that's for sure."

"Are you sayin' she killed herself?" That got Norbert's attention. He stopped and stared at Sharon, then around at the rest

of the writers, who had prudently stationed themselves as far away from the center of the room as they could to avoid his pint-sized pacing. "Is that what all y'all think?"

Ed nodded lugubriously. "Only thing to think," he said. "Who'd bother to kill her? She was clearly going to destroy herself, the way she was going."

"I disagree." Dorothy still knitted steadily. "She hadn't hit bottom yet. She could have gone into rehab and come out trumpeting the joys of living clean and sober, like so many celebrities do these days. But she was so impetuous, poor girl."

"You sayin' you think she did kill herself?"

Dorothy nodded reluctantly. "It's the only thing that makes sense."

V.J. spoke up. He stood near the door, his expression tightly drawn. "She would not have killed herself. She still had zest for life." His Indian accent was more pronounced than Bridget had heard it before. "She had plans, interests."

"All this is pointless, anyway." Madeline sat in one of the big leather armchairs by the fireplace. She bounced in her chair to draw their attention. "That detective—who seems very laid back, I have to say—probably already knows whether she killed herself or it was an accident. Why bother to speculate?"

"It's just so horrible." Sandra hunched in the other leather armchair. Elaine sat on the arm, patting her shoulder. "I didn't think it would be like this here. I want to leave."

Everyone fell silent, looking at her, and in the silence came the *bong* of the doorbell. "I'll get it," Sharon said, hurrying from the room. Bridget turned to watch her open the door. A uniformed deputy stood there; Sharon escorted him across the hall to the dining room.

"Who's being interviewed now?" Bridget murmured to V.J.

"No one at the moment," he whispered back. "I believe they have been waiting for some information. Perhaps from your excursion to Johanna's room."

This last got Madeline's attention. "Yes, Bridget," she said,

her voice syrupy with concern. "Was that awful? Did they find out anything?"

"The deputy just sealed the room. We didn't even go in." Bridget glanced around, wondering if she should mention anything about the absence of a laptop. "Does anyone know Johanna's writing habits?"

"Did she have any?" Ed sounded contemptuous. "Seemed like she was only drinking, not writing."

Norbert, standing by the hearth watching the fire, raised his head. "That ain't fair. She had a drinking problem. Just like some folks might have an eating problem." He gave Ed's ample stomach a pointed look.

"Why do you ask, anyway?" Dorothy paused in her knitting, ignoring the scowling faces of Norbert and Ed. "Did you notice something?"

"It was hard to see anything," Bridget replied truthfully. "The room was a terrible mess."

Sharon came back in time to hear that. "Tell me about it, honey. That woman needed a full-time maid. I said to Norbert, I said, 'Part of the agreement is that we provide meals and quiet time, and the artists have to pick up after themselves.' But she wouldn't do it. Thought she was so special."

"Look, all of you," Norbert exploded, striding into the middle of the room and putting his fists on his hips. "I don't want to hear another word. Johanna was a wonderful woman, and she's dead. The least y'all could do is stop speakin' ill of her. She don't—didn't—deserve that. Whatever she did or didn't do, she didn't hurt any of you."

V.J. spoke softly, but everyone could hear him. "I would not be too sure about that. It seems to me that Johanna must have hurt someone very badly indeed. And now she is dead."

Bridget thought that everyone was staring at V.J., but when Detective Gonzales spoke behind her, she realized her mistake.

"That's an interesting observation, Mr. Sunjupany." Gonzales

walked into the living room. "Perhaps later we can talk about why you made it."

Norbert went over to Gonzales. "Norbert Rance. I'm the head honcho here. You've met my assistant, Sharon, and my writers already." He gestured around the room.

Detective Gonzales was not a tall man, but he towered over Norbert. "And I'm glad to meet you, Mr. Rance," he said. "I understand Ms. Ashbrook had been a guest of your foundation a year ago. Do people often come back a second time?"

"Oh, yes, that's not unusual." Norbert seemed uneasy with that line of questioning. "Yes, we went a ways back, Johanna and me." Norbert puffed out his shirt, then caught Sharon's beady gaze on him. "And of course Sharon knew her," he said, a spiteful smile curling his lips.

"I'll be glad to tell you what I know, Detective." Sharon didn't look at Gonzales when she said this; her eyes were fixed on Norbert. Under her gaze, he turned red.

"I've met her before," Sandra offered, "but I can't say I really knew her. When can we leave, Detective? This atmosphere is not conducive to my writing anymore." Elaine murmured an assent, one hand on Sandra's shoulder.

"Forgive me for bringing up old history, but that's not really true, is it, dear?" Dorothy looked at Sandra, then at the detective. "I mean, about not knowing Johanna. Everyone knows the two of you had an affair a few years ago. She was big on novelty."

There was a moment of silence. "Bitch," Sandra said venomously.

The ringing of a cell phone broke the tension. Several people patted their pockets, but it was for Gonzales. He moved into the entrance hall as he spoke, asking muted, indistinguishable questions. They all strained to hear. V.J., closest to the door, held up one hand.

"It's about the autopsy," he said, low-voiced.

The conversation went on for a few more minutes. Then

Detective Gonzales came back into the room. Earlier, he'd seemed intent, but now Bridget felt he had turned it up a notch. "Mr. Rance, I'll need that interview now."

"Well, fine," Norbert said. "Just how long will it take?"

"That's really up to you, isn't it?" Gonzales turned to Sharon. "Do you have an office here? A fax machine?"

"Why, yes. Do you need something faxed?" Sharon drew herself up, calling on her professional smile.

"I think it would be better if we just kind of occupied the office. Perhaps you could move your operations out for a while."

"A while? How long is a while?" Sharon wasn't pleased.

"Hard to say." Gonzales looked at Sandra. "As to when you can leave, I'm afraid none of you can go for a while yet. You see, it turns out that Ms. Ashbrook had a blow to the head before she went into the water. And there are other indications which make suicide far less likely."

16

EVERYONE WAS SILENT after Gonzales and Norbert left. Bridget looked around at the others. No one would meet her eyes. The quiet filled the room up to its carved rafters.

Finally Ed broke it. "I'm still not convinced a crime was committed." He made this announcement in a professorial tone. "It seems to me there are any number of scenarios which could point to accident."

"Great. You can take that up during your interview." Sandra moved restlessly in her chair; Elaine squeezed her arm. "I really don't want to be here. This is not what I expected."

"Honey, none of us expected this," Sharon pointed out with great reasonableness.

"Oh, look," Elaine exclaimed, pointing out the French windows that led to the patio. "They're even searching back there."

A couple of men with the SANTA CRUZ COUNTY jackets were moving in a purposeful way across the back garden.

"I wonder what they're looking for," Dorothy said.

"Clues," Madeline said. "Maybe weapons."

"Hmm." Ed drew the word out with ponderous gravity. "Perhaps someone shot Johanna before she went in the water. They might be looking for a gun."

Dorothy shivered. "I just can't believe this."

V.J. noticed the shiver. He went to poke the dying fire, and arranged another log on top.

"You do that very well," Madeline observed. "I thought it was hot in India. Do you have fireplaces there?"

V.J. was courteous. "Of course we have fires in India, though our fireplaces are different. However, I lived for many years in England, where you must know how to make a fire, or freeze."

Elaine was still riveted to what was happening in the back garden. "They've found something in the pool," she said, hugging her elbows in girlish excitement. "See?"

Everyone looked out the French doors, where the uniformed men were standing around the pool, peering into the depths. One of them talked into a cell phone. Another one went to the miniature Alamo that served as a pool house, and returned with a long-handled pool-cleaning net. They fished around in what appeared to be the deep end, and finally pulled the net out, heavily filled with something black and rectangular.

"Well," Dorothy said. "Looks like they found a laptop." She glanced around the room. "Did anyone lose one?"

No one replied. They all knew whose computer it must be.

"Did you know," Madeline said chattily, "that some things still show fingerprints even after they've been in water? There are the neatest chemicals these days."

"We didn't know," V.J. said, bowing with the most exquisite irony. "Thank you so much for telling us."

"Not at all. You're welcome." Madeline smiled.

The doorbell resonated, and Sharon started to answer it. Before she could, Deputy White had swooped into the hall and let in the men who'd been fishing in the pool. They held a plastic evidence bag that dripped a little. She ushered them into the dining room.

"Not on my floors," Sharon moaned, jumping out of her chair. Then she subsided, sniffing. "It's like having the storm troopers commandeer your place."

Dorothy gathered her knitting into a bag with wooden handles and stood up. "Well, I for one am feeling all in. Please tell Detective Gonzales to call my room if he wants me."

She started from the room, but reappeared almost immediately, followed by Deputy White.

"Detective wants all of you to just stay put for a while longer," Deputy White said, allowing a brief trace of smile to cross her face. "We're searching your rooms right now."

Sandra gasped, and she and Elaine exchanged horrified glances. "You can't do that!" Sandra's voice was a breathless squeak.

"We've got search warrants, and if you think we're bad, wait until the state investigators arrive."

"More cops are involved?" Ed straightened.

"She was a famous woman, not a local," Roshawn explained patiently. "There may need to be a lot of interaction with the New York City police. Might have to be handled on a state level."

Dorothy looked thoughtful. "So you definitely think a crime has been committed, then."

"We don't rule anything out at this point." Deputy White moved away from the archway. "I'll be calling you in to the dining room as Detective-Sergeant Gonzales decides he wants to see you. Until then, if you would just stay put a while longer, it would make everything much smoother."

Dorothy sighed, and Bridget thought she looked exhausted. She put her arm around the older woman. "Take back your comfy chair," she said, leading her over to it. "Why don't you just put your feet up for a while? Here's a footstool." She pushed the bulky square across the rug, not without effort.

"Thank you, dear." Dorothy swung her legs onto it. "Footstool. I haven't heard that for years. You must be Midwestern."

Bridget smiled at her. "I grew up in Missouri."

"Somewhere around Nebraska, isn't it?" Dorothy gestured vaguely.

"In the neighborhood." Bridget decided not to go into it. She'd noticed this before in those from either coast, a geographic haziness that occluded the middle of the country from clear view.

Everyone fell silent again.

"Finding that computer does poke a hole or two in your accident theory, Ed," Sandra said, directing a look of faint malice at Ed.

He nodded. "I was just trying to think that through. Would a suicidal writer throw her computer away as a final gesture to repudiate her work?"

"It's a theory," Dorothy said wearily. "But why bother to come up with theories? What do they have to do with the facts? Johanna is dead. Someone, perhaps one of us, is thought to have caused her death. That is our reality, my dears."

"Besides," Elaine ventured, "if she was going to throw herself into the ocean, why wouldn't she throw her computer there, too? I mean, if she was going to throw it anywhere," she added.

"Good point," Sandra said approvingly. "If all she wanted was to drown herself, she could have done that in the pool. Taken the computer down with her."

"We cannot know the answers to these things," V.J. said, taking off his glasses and cleaning them in an agitated way on the handkerchief he produced from the pocket of his immaculately cut slacks. "We only know our friend is dead." He turned away, looking down at the fire, poking the logs in an absent way.

More silence. Bridget thought longingly of her room, so quiet, so empty of people, and wished she was there.

"Well," Madeline said to fill the void, "I just hope they go easy on Mr. Rance. Norbert." She sighed heavily. "I wouldn't want him to get the grilling I got."

People exchanged glances, but no one replied to this hopeful wish. Madeline looked around. "All I mean is, they were really pretty harsh. Kept asking me what I had against the deceased."

V.J.'s grip on the poker tightened, but he said nothing.

Dorothy studied Madeline. "You know, there's a poet, Madelyn Bates. She spells it with a *y*. Is she any relation to you?"

Madeline laughed. "I've heard of her—people are always sending letters to her at my website. I even went and read some of her poetry at the library. Really, it was pretty good."

Bridget exchanged a swift look with V.J. The English poet Madelyn Bates was famous, both for the richness and quality of her verses and for her wild, unbridled beauty; she was wont to appear at her readings in Pre-Raphaelite garb, all flowing hair and brocade gown. She had flaunted numerous lovers, from politicians to playwrights, athletes to esthetes. At one time, her name had been linked to V.J.'s.

Now V.J. looked thunderous. "Pretty good," he repeated, his British intonation stronger.

"Yes," Madeline said with gracious condescension. "But I do get tired of getting messages meant for her. Maybe if you know her, you could ask her to kind of tighten up her web presence, you know?"

His face held rigid, V.J. inclined his head. "I will tell her."

"You know, I wouldn't be surprised if that's who Mr. Rance meant to send his invitation to," Madeline said with a giggle. "The letter said something about my poetry, but I just thought he'd gotten me confused with her, instead of the other way around. And when I sent him my novel, he accepted me, so it must have been me he meant all along."

Bridget nearly groaned. If someone on the Ars Foundation staff had meant to offer attendance to the renowned poet Madelyn Bates, and had gotten this self-important neophyte instead, it was just another sign, if any had been needed, that the whole experience had been doomed from the start. A woman who had once written well was dead, probably not from natural causes. Those who mourned her were immured with those who did not miss her in the least.

And although Bridget was troubled and uneasy about Johanna's death, her biggest concern was the interruption of

work she needed desperately to do. Obviously the muses had given her one good day and then abandoned her.

Madeline was restless. She got up and walked over to the arched entrance, peering toward the dining room. "He's been in there quite a while. But they're probably treating him with kid gloves. Not like the way they treated me."

"Your interview couldn't have been that long," Bridget observed. "You were just going in when I went with the deputy to seal Johanna's room, and I was gone less than ten minutes."

"It was lots more than ten minutes," Madeline said. "I know. First he asked me a lot of personal information that was none of his business, and then he asked me what I'd done this morning, and then about last evening."

"We'll all be getting those questions, I suppose." Ed fidgeted with the hammered nailheads that trimmed the leather wing chair he had taken over when Madeline left it. Bridget could see Sharon watching him narrowly, and knew she wanted to slap those busy fingers before they succeeded in scratching the leather.

"Well, I hope it's not as hard for the rest of you." Madeline straightened in her chair. "Even when I told him everything, he kept hammering and hammering at me, saying I was keeping something back, until finally I had to tell him about the fight in Johanna's room."

17

THAT CAPTURED everyone's attention. "What fight?" Sharon went to sit on the arm of Ed's chair, taking his fidgeting hand and patting it with her red-taloned one. "Ed, honey, this chair looks fine just the way it is. We'll find you something else to play with. What fight, Madeline?"

"The one I overheard. It was directly after dinner. I happened to be walking along the colonnade out there—so romantic." Madeline looked around to see if she had everyone's attention. "Anyway, I heard these voices coming out of Johanna's room, because her French door was open."

"Did you look in?"

"Who was in there?"

"What did they say?"

Everyone, it seemed, spoke at once. Madeline preened in gratification.

"Calm down. I already told the detective, I couldn't see into the room. And actually, they weren't talking that loud. Johanna said, 'It's none of your business, is it?' And the other person—I couldn't even tell if it was a man or a woman, because whoever it was spoke kind of softly—said something about bad behavior. And then Johanna said, 'I behave as I want, and always have. It

simply doesn't concern you, so stop bugging me.' And the other person said something, I couldn't catch it, and Johanna said, 'There's no point in threats. Look, I'm sorry. But what's in the past is over. And what do you imagine you could do to me, anyway? Just accept it and move on.' And then a minute later I heard a door closing, and then I heard moving around in her room, and I thought she might be coming out of the French doors, so I left."

Madeline recited all this with great fluency. When she finally came to a halt, everyone in the room just gaped at her.

"So you see," she said after a pause. "My interrogation was so grueling. I can't imagine what he's saying to Mr. Rance."

"Well, if we're lucky, Norbert will tell us all about it, just like you did," Dorothy said, sounding a little dazed.

"Yes, let's do tell each other everything we say to the police. It'll be just like 'Murder She Wrote.' We'll figure out who did it and everything." Madeline opened her notebook.

"With any luck," Sandra muttered, "we won't have to figure out anything of the sort. The police will solve things and we can get away from this horrible place."

Sharon bridled. "You just give us a chance, here. This really is a wonderful experience for most of the artists who come."

"I don't think of myself as an artist, exactly," Madeline said judiciously. "I'm more of a craftsperson, really. I mean, it's more work than inspiration to write novels, isn't it?"

"Writing is a craft," V.J. said, breaking his silence. "When a craft reaches its highest expression, then it is art as well."

"Well said." Dorothy rummaged in her knitting bag for a tissue, and blew her nose. "I'm just getting so emotional over all of this. Poor Johanna."

"Well, it wasn't an art for her, at least not in the last few books," Madeline said. "In fact, if you ask me, she barely had the craft part down."

"Nobody asked you, you horrible woman," Sandra said, turning on Madeline. "Can't you shut up for a while? We are sick of you!"

Madeline drew back. "Well, I must say—"

"Don't." Dorothy looked at Madeline over her reading glasses, and the younger woman subsided. "Let's all just take a few minutes and think about what makes us humble, shall we?"

Bridget knew all too well what made her humble—her unfinished manuscript, looming like an iceberg in the path of her writing career. No point in thinking about that, however, when she was trapped far away from her computer.

She thought instead about which of the other people there could have taken a life. It wasn't difficult to see Ed bashing someone in the head if that person stood in his way. But how could Johanna have impeded him? They moved in different literary circles.

And she could see Sandra taking out an obstacle, striking out in blind, frenzied self-interest. She and Johanna had a history; perhaps the history had repeated itself.

Bridget looked around the room, remembering that these people had been strangers forty-eight hours ago. She knew only as much of them as casual observation could glean in such a short time.

Several of them, however, had known each other before. "Dorothy, didn't you say you and Johanna were in a critique group together once?" Her question, breaking into the quiet Dorothy had requested, earned her a look of reproof from V.J.

Bridget started to apologize, but Dorothy was answering her. "Yes, that's true. My, that was a long time ago. Johanna was the youngest one in our group." She was silent a moment, then said, in a tone of wonderment, "Fifteen years ago. She was in her mid-twenties then."

"I thought she was only in her mid-thirties now," Madeline said. "In fact, I'm sure that's what the interview in *Parade* magazine said, just a year ago. And she didn't look a day older than thirty on her last book jacket."

Dorothy looked at her with pity. "Dear, they just keep using

the same bio over and over. Nobody bothers to change them, or to replace those nice youthful pictures with more accurate ones."

"What was she like, the young Johanna?" V.J. leaned toward Dorothy from his position at the mantel.

"She was—enthusiastic." Dorothy smiled. "Her style was fresh and vigorous, if a little unpolished. We all thought her book had great potential, and she did a lot of work on it—we went through several revisions with her. We were so excited when it was bought by a big house and brought out with a lot of fanfare."

"Lucky her," Madeline muttered.

"She was lucky. A well-written book is not necessarily a guarantee of publication, let alone the kind of treatment she got. But she was young and beautiful, and they thought she'd be promotable. She had a quality...." Dorothy stopped for a moment. "When you were with her, she compelled your attention. She carried you along."

V.J. nodded. "She did have that. But I believe it became harder and harder for her. The alcohol, the extravagances. Above all, she feared becoming that which she mocked, the kind of writer who obsessively scrutinizes her own small life. As a result, she had difficulty working."

"Yes." Dorothy smiled at him. "You knew her well."

V.J. hesitated, and then words poured out of him. "Whenever I saw her, I would feel the connection between us as strong as ever, and she, too, would be affected by it. And yet we could never stay together. When anyone got too close, she pushed them away. Always she pushed."

"That's true." Dorothy looked thoughtful. "She did that to the critique group, because we reminded her of where she came from, I guess. For a while after her success, we would all lunch together, but she stopped coming. Too busy. Nothing in common with those pedestrian old women."

"I'm sure she didn't, couldn't, think that. Your writing is wonderful. I told my husband you were here, and he reminded

me how much I loved *Strangers Gate.*" Bridget didn't usually read science fiction, but Emery had thought she'd like it, and he was right; the alternative universe was imaginatively constructed, and the characters had realistic dimensions often lacking in science fiction. She had put it next to Ursula Le Guin's *Left Hand of Darkness* and felt they complemented each other well. "Who else is in your critique group? Anyone we would know?"

"Let's see. A mystery writer, Valerie Jons."

"Oh, I've enjoyed her books."

"Yes, she has a devoted following. And a historical novelist, Lee Jacobs. She's had a lot of successes. Harris Wolzien, who writes the thrillers, is one of us. And four or five others, poets, journalists. Not everyone's been published, but everyone is serious."

"Your group sounds great. I would think Johanna would be proud to be part of it."

Dorothy shrugged. "Frankly, I don't think she had time when she got to be such a celebrity. And probably her work habits were too undisciplined to allow regular critique. I'm just judging from her recent books. Each one seems more rushed and careless than the last."

"Hmm." Madeline wrote something in her notebook. "You can outgrow your writers' group. I mean, after I got my novel published, and this big publisher is interested in it, well, those people just didn't seem to have anything they could help me with anymore, you know?" She glanced from Bridget to Dorothy. "Hey, we could get an Internet group going. Send each other stuff and do written critique, or just edit right on the file! Now that would be some help!"

Bridget, a little wild-eyed, looked imploringly at Dorothy.

"I'm afraid that's not the kind of critique I can benefit from, dear," Dorothy said, looking at Madeline over the tops of her glasses. "I prefer to meet with a group who knows my writing, as my own group does after twenty-some years, and whose comments I can value properly, knowing the people who make them.

Our group is no longer accepting new members, but if you are in need of a critique group, I suggest you try your local adult education or community college."

Madeline turned her imploring gaze on Bridget. "I have four small children," Bridget said, using the line that got her out of many a PTA fund-raiser. "It's all I can do to write my own books and look after them. I really can't take on Internet critique as well."

Sandra held up her hands when Madeline looked at her. "I don't do critique, though listening to Dorothy I'm wavering. But even if I did, it would be nonfiction. Sorry."

V.J. shook his head without saying anything. Ed turned his shoulder.

"Well, I think a group is highly overrated, anyway," Madeline said, recovering her equanimity. "Even if it might have helped someone like Johanna, who had no discipline. That's probably why her publisher decided she needed a ghostwriter. Didn't she say she was supposed to meet with her ghost here? Is it one of us?" She turned to Sharon. "Is someone else coming in?"

Sharon looked flustered. "I don't know what you mean. This is the group I was told to expect."

Madeline bounced in her chair. "It's one of us! Who is it?"

Ed eyed her with dislike. "This isn't the Nancy Drew Club. What is the deal with you, anyway?"

Madeline looked hurt. "I'm just trying to make the best of things. After all, I am a thriller writer. It's only natural that I should look for a solution to the mystery here."

"There may not be a ghostwriter," Bridget said. "Johanna wasn't above making something up for effect. If she really was in need of a ghost, why would she announce it to the world? Most people keep that quiet."

"V.J., you knew her best. What do you think? Did she make it up?" Madeline turned toward the fireplace.

They all looked at V.J., who stared down into the fire. At last

he said heavily, "I believe that it was true. She said to me that they wanted her to have help. She was not happy about it."

"Who? Did she say?" Madeline was eager.

"She did not say who," V.J. told her. "Just that the publisher had selected someone."

"I don't understand why you think the ghostwriter might get rid of her," Bridget said to Madeline. "Wouldn't it just put that person out of a job?"

Madeline pouted. "Well, I think it's funny no one's admitted it, that's all."

Ed opened his mouth, no doubt for a blistering diatribe, but they all turned at the sound of footsteps. Norbert came across the hall, followed by Detective Gonzales.

"Well," Norbert said bitterly, "that was more fun than a visit to the proctologist. Where's the whiskey?"

Sharon stood up. "Norbert, honey, it ain't high noon yet. You better hold off a bit."

"I need a drink. This here sheriff left a powerful bad taste in my mouth," Norbert said, glaring at Gonzales. "He seems to think I might have bumped off poor Johanna. Me!"

"Norbert would never do such a thing," Sharon said, turning on Gonzales, her pansy-covered bosom heaving in distress.

"At least not until after he'd edited her manuscript, if you get my drift," Ed said to Dorothy, in what he probably thought was a whisper. Bridget heard it, and it seemed that V.J. heard it, too, judging from the look he bestowed on Ed.

"I am as sorry as I can be," Norbert said loudly, "that y'all are subjected to this treatment. But Detective Gonzales insists on talking to each and every one of you, and he wants the rest of you to wait here until it's your turn."

Gonzales was conferring with Deputy White. He turned around, his palm held up to stop the protests voiced by everyone.

"We've finished going through your rooms for now, so you can go back there after your initial interview is finished. I'll try to get through the interviews as quickly as possible. And as I

believe Deputy White told you, the state investigators may do their own, possibly more extensive, interviews."

Bridget went over to Gonzales. "If you don't mind," she said in an undertone, "would you take Dorothy next? She's really about done up and wants to rest."

Gonzales looked at her for a minute, then nodded. "And I'll want a real interview with you, Ms. Montrose. Our chat on the beach doesn't exempt you at this point."

Bridget nodded. "Fine." But she wondered why he looked at her that way, as if he had good reason to think she was behind Johanna's death.

18

DOROTHY WENT OFF to her interview and was subsequently seen no more. Norbert headed up the spiral staircase to the office that overlooked the entrance hall, and every so often they could hear him cursing while he straightened up after the detectives.

Having been publicly admonished, Ed quit picking at the nailheads. He browsed the bookcases that covered the wall next to the archway, and came back with *Paths of Glory,* which engrossed him. Sandra and Elaine sat together on the sofa, speaking to each other in low voices.

Madeline pulled a straight chair closer to Bridget. "So who do you think it was in Johanna's room last night?"

Ed looked up from his book, glaring. "You know, the detective said you could go to your room after your interview."

"Well, but the rest of you are here," Madeline said, looking around the room with her cheery smile.

"I hope they didn't make too much of a mess when they searched your room," Sandra said craftily.

Madeline jumped to her feet. "That's right, they searched our rooms."

"Did you have any secrets there?" Ed's voice was tinged with malice. "Because if you did, the police know them now."

"Of course I don't have any secrets." Madeline laughed uneasily. "I'll just go check, shall I?"

She left, and the room was blessedly quiet.

"Thanks, Ed," Sandra said. "I might have committed a murder if she'd stuck around much longer."

Elaine hushed her. "Don't say that even as a joke." She looked at the doorway. "They might be listening. It might be like talking about bombs in airports."

"Whatever."

Ed returned to his book. Sandra and Elaine resumed their conversation.

"Mr. Weis?" Deputy White appeared in the doorway. "We're ready for you."

Ed left, taking *Paths of Glory* with him, and V.J. came to sit in his chair. "Rather like Madame Guillotine," he observed. "Who will be next?

After ten minutes, Sandra was called. Only V.J., Bridget, and Elaine were left. Elaine moved restlessly around the room, winding up on the window seat that overlooked the front drive.

Bridget and V.J. faced each other in the leather armchairs before the fire. Every so often, V.J. tended the fire, adding logs, turning them. He sat forward in the chair, resting his elbows on his knees, one hand holding the poker, watching the flames as if they consumed his thoughts.

Bridget also watched the fire. She was too unsettled to find a book as Ed had done. She wondered about that pointed glance from Gonzales. He must have run searches on all their names in some police database, and her name had triggered something. It was not unexpected. In fact, she wouldn't have been surprised to see Paul Drake, her friend from the Palo Alto police force, walk in. But nothing in the database would make her look suspicious, Bridget thought. It had been her misfortune to be involved on the fringes of a murder case or two. These things happened.

V.J. broke the silence. "You are very undemanding to be around, Bridget," he remarked, raising his head and smiling at her. There was great charm in his smile. Though in his mid-forties, he had none of the middle-aged paunch that afflicted Ed; V.J. was slim and moved with an economical grace. Bridget thought it was no wonder he had a reputation as a ladies' man.

"I'm blessing the quiet." Bridget smiled back. "Thank God, we got rid of Madeline."

"She was driving me crazy." Elaine turned away from the window, then came over to curl up in a corner of the sofa. "I could see she had Sandra so on edge. She never would have spoken like that otherwise." She turned to Bridget. "V.J. knows that, but I just wanted you to know, because you haven't met Sandra before, that she's not herself today."

"Um, sure," Bridget said.

"I don't think we've met before, anyway." Elaine went into a social, chatty mode. "Do you spend much time in New York?"

"No." Out of politeness, Bridget refrained from saying that she went there as little as possible. "Do all the rest of you live in New York?"

"I do not live there," V.J. said. "I live in Virginia. But I spend quite a bit of time in New York."

"I thought you had to," Elaine said. "That's what Sandra told me. If you're not in New York, the publishers don't take you seriously." She regarded Bridget with her head to one side. "Of course, you made the best-seller list, and you're West Coast. But West Coast is almost the same as New York, don't you think?"

"Only if it's L.A.," Bridget said. Elaine was fine-boned, with highlighted blond hair and tasteful makeup. She wore a sweater set, probably cashmere (though Bridget had no frame of reference for that), tailored slacks, and exquisitely perfect loafers on her small feet. She gave the appearance of an upscale suburban matron. Her voice was soft and chirpy, but Bridget sensed that long exposure to it would be as irritating as to Madeline's high, squeaky voice.

V.J. didn't seem to feel that way. His automatic response to an attractive woman was to flirt, and he succeeded well enough to have Elaine laughing when Sandra came back in.

"Now he wants to talk to you," Sandra told Elaine, jerking her thumb over her shoulder to the dining room. Sobering quickly, Elaine nodded to V.J. and Bridget and left the room.

"Are you putting the moves on my lady?" Sandra came to stand in front of V.J.'s chair, her back to Bridget.

V.J. rose courteously to his feet. "We talked, that's all. Surely you don't think she could be attracted to a man when you are around?"

Sandra drew back. "Just don't try anything. I know your tricks."

V.J. smiled. "You crush me, Sandra. Our night of transcendent bliss meant so little to you?"

Sandra gulped and darted a look over her shoulder at Bridget. "I don't know what you're talking about. And if you were the gentleman you always claimed to be, you wouldn't kiss and tell." She turned and bolted from the room.

"So is there no end to your conquests?" Bridget tried to keep the disapproval out of her voice.

"I do not think of them as conquests," V.J. said, sinking into the chair again. "I like women. I even like women who don't like men." He laughed softly. "Sometimes, such a woman realizes that it is not all men she dislikes, but only the ones she has known so far."

"And what if she falls in love with you? That probably doesn't do your cause any good."

V.J. regarded her soberly. "I promise you, Bridget, I have learned to tell which women would welcome a liaison with me, and which are looking for something more. For instance, it would be pointless for me to waste my charm on you. You do not send out the signals."

"Hmph." Bridget didn't feel particularly flattered by this.

"You should be glad." V.J. leaned forward and patted her

hand. "I respect monogamy. I myself prefer it. What do you call it? Serial monogamy. I would even welcome real monogamy in some circumstances. But those women with whom I believed I could have been happy for a lifetime have not wanted to attempt that voyage with me." He shrugged. "And so I live a butterfly existence, flitting from one nectarous flower to another, unable to linger with any of them."

"Where did Johanna fit?" Bridget felt very daring asking this question, but she was wildly curious about these glamorous creatures. They seemed to live so much more publicly than she would ever want to.

V.J. didn't mind the question. "We met soon after the woman I had thought was my soulmate told me she could not be only with me." He sighed, and Bridget wondered if that woman was Madelyn Bates, the poet whose place Madeline had probably usurped. "I was in a reckless state, and Johanna liked reckless people. At first it was only about that. I became concerned about her when I saw that she had no care for herself. For a while, I tended her, but she hated to feel burdened by my solicitude, my affection. And I could not risk another rejection. I let her dismiss me." He looked at Bridget. "For that I feel very guilty."

"You shouldn't." Bridget patted his hand. "Johanna made her own choices. She was a grown-up. You can't make people do what you think, or even know, is in their best interests. Life just doesn't work that way."

"I know this," V.J. said, tapping his head. "But I do not feel it." He put his hand on his heart. "I only know that losing Johanna makes me feel very old and very tired."

Elaine came across the hall and poked her head in the door. "You're next, V.J." She looked curiously at Bridget. "Gosh, he's really making you wait, isn't he? Lunch time will be over before he's finished in there. The kitchen staff kept looking around the door. Did Sandra go to our room already?"

"Yes." V.J. was already on his feet. "I will get this over with now." He strode out of the room.

"He's sweet, isn't he?" Elaine looked after him, speculation in her gaze. "Different from American men."

"Not all that different," Bridget said.

Elaine drifted away, and Bridget was left alone. She wandered around the elegant room. She could still hear Norbert's occasional curses; now Sharon's soothing murmurs were interspersed. From the French doors that looked onto the back garden, she watched the groundskeepers mowing the lush grass, and contemplated a swim in the now-computer-free pool. The sun had emerged, finally, washing the formal space in light, gilding the new foliage on the standard roses. She almost expected the Red Queen to come barreling into the scene.

So it was hardly a surprise when a gate at the back of the garden opened, and Claudia Kaplan came striding through, followed closely by Liz Sullivan. Both should have been thirty miles away in Palo Alto, and yet here they were, hustling past the swimming pool. Liz had a hunted expression, but Claudia simply wore the determined look that meant she was not to be dissuaded from her path of choice.

Bridget opened the French doors and stepped out on the flagstone terrace that overlooked the garden. "Hey, you guys," she said. "What are you doing here?"

19

CLAUDIA CHANGED COURSE and headed toward her. Liz swiveled her head around anxiously as she followed.

"We're going to get kicked out," Liz said baldly as they mounted the terrace steps.

"So what?" Claudia was magnificently unconcerned. "I've been thrown out of places before. And we'll get a chance to speak our piece to Bridget." She reached Bridget and enveloped her in a hug. "Are you okay? We came as soon as we heard."

"I'm okay." Claudia's hug, for some reason, made tears well up in Bridget's eyes, but she dashed them away. "It's wonderful to see you. Seems like a long time since we were sitting in my kitchen."

"I wish we were there again," Liz muttered.

"What did you hear, exactly?" Bridget looked at the two of them, unlikely partners in crime. "And I thought the police had cordoned the area off. How did you get in?"

"Manuel, the groundskeeper, remembered me from my last visit," Claudia said. She pointed to the flowering vine on the central pergola, which sported fragrant trumpets. "That Mandevilla was ailing, and we doctored it together. He let me in the service entrance."

"Well, don't tell the police that or he'll be in trouble." Bridget led the way into the living room.

Liz's eyes widened as she took in the carved ceiling beams and deep leather furniture. "Wow. This place has serious luxury."

"It's nice, isn't it?" Bridget gestured them into the leather armchairs. "I would get you some muffins or something, but the fuzz are camped in the dining room."

"So what has happened?" Claudia settled herself and looked expectantly at Liz. "Drake told Liz that you were in trouble here."

"Not me personally, I hope." Bridget thought again about that hostile look from Detective Gonzales. "But it's very sad. Johanna Ashbrook's body was found this morning, caught in the rocks just offshore."

"Johanna Ashbrook." Liz looked impressed. "Even I have heard of her, though I've never read her books."

"The first two were good," Claudia said. "I read one more." Her tone made her opinion clear. "I take it her death wasn't an accident?"

"I don't know if they've ruled that out. Or suicide. But from the way they're investigating, something clearly strikes them as fishy."

"Hmm." Claudia looked thoughtful. "So they're looking into the other writers' backgrounds? That must be why they contacted the Palo Alto police."

"Um—also, I kind of was there when the body was found," Bridget admitted.

"That's not good." Claudia shook her head. Liz came and sat on the arm of Bridget's chair, patting her shoulder.

"Well, they also suspect one of the local surfers, I think." Bridget smiled at Liz. "It's okay. The worst thing from my point of view is that I was just starting to get some momentum on my book, and now I'm spinning my wheels."

"Is there anything we can do?" Claudia leaned forward. "Do you want us to ask any questions or find anything out for you?"

"I'm not investigating," Bridget protested. "I'm sure Detective Gonzales will do a great job."

Claudia snorted. "Bet the Santa Cruz County cops know more about drug busts than murder."

"I don't need you to go sleuthing around for me," Bridget said firmly. "But I admit to being curious about some of the other writers."

"Who else is here?" Claudia whipped out a pad of paper from the pocket of her enveloping jacket.

"V.J. Sunjupany—"

"Good heavens. V.J. and Johanna at the same time? Somebody was careless." Claudia chortled. "They've been off-and-on for a while."

"How do you know so much gossip, anyway?" Liz looked curiously at Claudia.

"I'm on the boards of a couple of writers' organizations. Everyone talks incessantly about everyone else, and the famous people really get talked over." Claudia waggled her pen. "Who else?"

"Sandra Chastain and her friend Elaine something."

"Good old Sandra. Didn't she have an affair with Johanna once?"

"So Dorothy said. Dorothy Hofstadler is here."

"Dorothy's great," Claudia said. "I'd love to see her."

"She really needed a rest, from the looks of her."

"She had some kind of history with Johanna, didn't she?" Claudia said.

"She and Johanna were in the same critique group. She didn't exactly say so, but I got the impression their feedback was one reason for the success of Johanna's first book."

"Hmm. I didn't know that. The story I'm thinking of is more personal. I can't remember the details, though. I'll find out and send you an e-mail."

"I don't like to be going behind people's backs," Bridget said. "It seems unscrupulous, to say the least."

Claudia waved that away. "They're Easterners," she said dismissively. "They invented unscrupulousness."

"Don't be absurd." Liz spoke sharply. "I agree with Bridget."

"So in the interests of getting all the facts, when our friend is in danger of being railroaded, you would just hold up your hands and say, 'Ooh, it's not nice'?" Claudia demanded.

"Of course not." Liz stood her ground. "I just don't think Bridget is in danger of being railroaded. And if she was, I would turn to Paul for help."

"That hurts," Claudia said, holding the back of her hand to her forehead in a swooning way. "The boyfriend chosen over the poor old woman who only wants a crumb or two of respect…"

Liz punched her in the arm. "That trick never works," she retorted. "Face it. They have resources you don't have."

"Ah, but I have resources they don't have." Claudia nodded solemnly. "And actually, I agree that Dorothy is not a particularly fruitful person to look into. I'm also going to collect up any tidbits I find out about V.J. and Sandra. Might as well sniff around for something on Norbert while I'm at it. They're all in the public domain, as it were."

"Would you like it if someone did that to you?" Bridget still felt it was wrong, but she was wavering toward doing it anyway. Not just because it would be interesting to know more about V.J. and Sandra and even Norbert. More in the interests of full disclosure, she assured herself.

"I wouldn't mind. And why? Because I've led a blameless life, and anyone investigating me would die of boredom before they'd find something scandalous." Claudia stood up. "But if you object, we could just ask Dorothy about it, straightforward. I take it she hasn't volunteered anything?"

"Not where I could hear it," Bridget said. "She might have told the police all about it, whatever it is. And she's gone to her room for a nap, and probably won't be out again until dinner time. You'll be long gone by then."

"Yes, we shouldn't hang around," Liz said nervously. "I told Claudia just to phone you, but she couldn't get through, and she insisted on coming over."

"You didn't have to come," Claudia said.

"As if any thinking person could let you drive yourself over to the coast," Liz said. "You'd be at the bottom of some ravine by now."

"You all act as if I can't drive at all, and yet I've driven myself for years, and I'm still here," Claudia pointed out.

"At any rate," Bridget said, interrupting in the interests of keeping the peace, "I appreciate your concern, and am happy to have seen you. What's happening at home? Has either of you heard from Emery?"

"I went over this morning and drove Mick and Moira to their play group," Liz said. "Emery was maintaining. He had Corky washing up the cereal bowls."

"Excellent," Bridget said. "I must remember to keep that going when I get back."

"I noticed an envelope from your architect on the kitchen table," Liz, the sharp of eye, added.

"Hmm. I hope Emery's not okaying any changes in the plans until I get back." Bridget made a mental note to send him an e-mail as soon as she could.

"Was that all the writers?" Claudia looked over her list.

"Did I tell you Ed Weis?"

"Oh, him." Claudia wrote down his name. "I'll certainly enjoy finding out dirt about him."

"I know he's not your favorite."

"He has his readership. I have mine," she sniffed. "Is that all?"

"New writer named Madeline Bates."

"Not the poet?" Claudia's gaze sharpened.

"No, though we speculate that Norbert meant to invite the poet Madelyn Bates and ended up with this woman, who's e-published her book, and has a nibble from a New York publisher."

"What a shame you didn't get the real Madelyn Bates. V.J., Johanna, and her in the same house. Who knows how many people would be murdered then?"

"We don't know that anyone's been murdered here," Liz said.

"That's right. It's all speculative now." Bridget remembered something else. "Oh, by the way, Johanna announced at dinner last night that her publisher had hired a ghostwriter for her next book, and that person is supposedly here. No one admits to knowing anything about it. Johanna said she didn't know who it was, either."

"A ghost. And she just came right out with it?" Claudia was amazed. "That woman had no sense of the fitness of things. Shameful enough to need a ghost. No need to tell the world."

"And no one 'fessed up," Liz said. "Maybe the person isn't here after all."

"Maybe Johanna just invented it to stir up trouble." Claudia waved her pen again. "Is that all? Is the great Norbert in residence?"

"He and Sharon are up in the office," Bridget said softly, trying to convey that sound traveled.

"We should leave," Liz said urgently. "If the police find out we crashed their line, Manuel could get in trouble. And they'd question us for a while. And maybe detain us."

Bridget started to pooh-pooh that notion, then shut her mouth. Liz, having survived imprisonment for trying to shoot her abusive husband, and having then lived in a VW microbus for several years, knew things about the justice system that Claudia and Bridget could only imagine.

She directed a look that was full of meaning at Claudia, who got the message. "Okay, we're out of here. Can we stop at that wonderful glass place in Davenport? I promised myself one of those paperweights that looks like the earth from space. It's Lundberg Studios, I think."

"Wherever you like." Liz bounced up. "Where are all these writers, anyway?"

Bridget gestured around the room. "Everyone was made to stay in here for a while after Johanna's body was found, and they searched our rooms. Now the detective is interviewing V.J., and probably not for much longer. Then it'll be my turn, and then I'll spend the afternoon trying to make up for lost writing time."

"Okay, we'll get out of your hair." Claudia looked worried. She gave Bridget another hug. "Listen, call any time if you need help. We'll get Drake to rally around."

Liz snorted, and Claudia spoke over the sound. "Admittedly I've said a few harsh things about Paul Drake, but he does a decent job."

"I will be in touch constantly," Bridget promised. "Unless they haul me off to the pokey."

She let them out the French doors and watched them slip around by the pergola and out the gate at the far end of the garden. It had been very enterprising of Claudia to find a way in. But Bridget hoped the media didn't find it that easy. All they needed at Ars Ranch was a full-court media press to make their lives totally miserable.

20

V.J. CAME INTO the living room moments after Bridget had closed the French doors. "Over to you," he said, turning the corners of his mouth down in an exaggerated frown.

"Rough?" Bridget muttered on her way past him.

"Not pleasant," he said. "I am looking forward to being alone for a while."

Bridget walked across the hall, where Deputy White stood guard next to the dining room doors. She had not seen the doors closed before. The heavy oak planks bound with iron were imposing. When they shut behind her, she felt a little as if she'd entered a dungeon.

The dungeon was nicely appointed, though. Coffee and hot water pots on the sideboard looked very tempting next to a plate of muffins covered with a glass dome. She started toward them.

"Mrs. Montrose." Detective Gonzales looked up from his seat at the end of the long table.

"Hi." She nodded at him. "I'm just getting a cup of tea. I'll be right with you."

"A cup of tea sounds good," he said, joining her at the sideboard. He watched closely as she selected a cannister, stuck a

mesh tea-ball spoon into it, and then poured hot water over the spoon in her cup. "What kind is that you have?"

"English Breakfast. It's got caffeine."

He touched his stomach absently. "Is there one without caffeine?"

"Coffee drinker?" He nodded, and she picked up the tin of green tea. "Try this. It has just a little caffeine, and is soothing to your stomach."

He took one of the mesh spoons and fixed a cup of green tea. "It's got a lot of health benefits," Bridget told him chattily. She looked at the muffins displayed under a glass dome. "Free radical scavenging and stuff."

"I can always use help with free radicals." Gonzales eyed the muffin she put on her plate. "You writers get the royal treatment here, don't you?"

"It's certainly very nice," Bridget agreed. "I've never been to one of these before. It surprises me how lavish it is. I was thinking more in terms of outdoor camp for grown-ups."

"Well, let's get down to it." Bridget's stomach growled again, and he quirked an eyebrow. "I'm sure you're ready for lunch."

"It certainly seems like a long time since breakfast."

Detective Gonzales sat at the end of the table, Bridget on his right. She dabbled her tea-ball spoon up and down in her cup to strengthen the brew. The muffin was moist and studded with pecans. She hoped it would appease her stomach.

Gonzales picked up a small tape recorder, checked the tape, and turned it on, placing it on the table between them. He gave the time and her name. "Mrs. Montrose, are you aware that this interview is being taped?"

"Yes," Bridget said, eyeing the tape recorder uneasily.

"This morning you told me about your fight with Ms. Ashbrook last night." Gonzales flipped through a pile of notes in front of him on the table.

"I wouldn't call it a fight. She said outrageous things and I simply countered. However, I was—not exactly rude…"

"Snippy," he suggested, his pen poised over the pad of paper he had pulled out.

"Naturally I won't admit to snippy," Bridget said with some reserve. "I was not tactful."

"You writers always find the right words, don't you?" He sounded a little resentful. "So what happened then?"

"I told you—"

"Tell me again for the tape recorder."

Bridget recounted how she'd looked through the French doors at Johanna's room, and not seen her.

"Just a moment." The detective went through his notes again. "What time would that be?"

"About nine-thirty, I guess." Bridget tried to place it more exactly. "After dinner by a bit. I talked to V.J. for a few minutes. Decided to take a walk on the beach, and looked in Johanna's room before I left."

"You could see into it?"

"Not really, but the outlines were clear."

"And you told Deputy Aikens that the room was messy then?"

Bridget nodded.

Gonzales rolled his eyes. "Mrs. Montrose, you need to speak for the tape. You confirm that the room was messy. Would you describe it as you saw it then, from the French door?"

Bridget thought. "Well, the dresser was covered with those little bottles that booze comes in. A couple of pairs of shoes on the floor. The bed was unmade—"

"Please describe the bed," he interrupted.

"Let's see." Bridget pictured herself peering in through the French windows. "The covers were flung back all higgledy-pig-gledy."

"What?"

"Sorry. I have young children. It impairs the brain. The bed was not made." Bridget sat up straighter. "Hey, I just realized. I could see the sheets and duvet, and today when I looked in with

Deputy Aikens, the bed was heaped with her clothes. I don't believe it was like that last night."

"Hmm." Gonzales made a note. "Now, please tell me what happened then."

"I went on down to the beach." Bridget saw him open his mouth, and hastened to add, "I walked down the grass, because I didn't see the path in the dark. I got to the seawall, and I sat on it for a few minutes."

He took her through her meeting with Johanna, and asked her to give any impressions or opinions of it. "Did you see or hear anything else?"

Bridget hesitated.

"Mrs. Montrose, I might remind you that this is a suspicious death, that in order to determine what happened, we need all the information we can get. I might add that others of your party have given me their accounts of things. If everyone is truthful, we'll get results much sooner. Maybe we can even avoid having to run everything through the state investigators." He gave her a meaningful look.

"Why do you look at me like that?" Bridget demanded. "You did that before. I don't care who investigates. I have nothing to hide."

Gonzales reached out and turned off the tape recorder. He folded his hands on the table and looked at Bridget. "You wouldn't say that if you'd seen your rap sheet," he told her. "It's quite impressive. Any law enforcement agency might jump to some conclusions."

"Sounds like you've already jumped." Bridget stared at him. "I didn't even know I had a rap sheet. What could possibly be on it?"

"Several murder investigations in Palo Alto," Gonzales said bluntly. "You were involved in at least four suspicious deaths. How can you explain that?"

"I'm friends with a Palo Alto homicide detective, Paul Drake," Bridget said after a minute. So this was why Claudia and

Liz had come rushing over when they couldn't get through to her on the phone. They thought she might have already been arrested. She felt a sinking sensation in her stomach, and wished she hadn't had that muffin.

"Sounds like you have other, less savory friends." He flicked one particular piece of paper. Bridget found herself longing to know what was on it. "This woman, Elizabeth Sullivan. Served time for attempted murder. She's been implicated in some of these investigations, too, and in that celebrity kidnapping last winter."

"She tried to kill her abusive ex-husband before he killed her," Bridget said through tight lips. "She served her time for that. It's not her fault these other things happened around her. She was cleared of any imputation of guilt, and in the kidnapping thing, she was the hostage, not the other way around. She's a wonderful person."

"Too bad she isn't here right now," he said, giving her a skeptical look.

Bridget spared a moment to be thankful that Liz and Claudia had gotten away when they did. "Look, I never met Johanna until yesterday. I had no reason to do anything to her."

"You had a public altercation with her. You were the last person to see her alive."

"The last one who's told you about it," Bridget pointed out, trying to keep her voice from trembling.

"You were there when her body was discovered. Those things definitely involve you in the thick of my investigation."

"Only like everyone else is involved. And several of these people knew her much better than I did."

"We're aware of that." Gonzales steepled his fingers and looked at her over them. "Interesting how everyone points out that someone else knew her better. You guys are good at passing the buck."

"What are you looking for, one of those sick people who confesses to things they didn't do, just to save you trouble?"

"I wouldn't mind being saved trouble." The sheriff reached over and poised his finger on the tape recorder's On button. "Anyway, I wanted you to know that no one here is above suspicion. You can have all the homicide detectives in your address book that you want, and we'd still be taking a very close look at you."

"I imagine *you* have friends," Bridget said hastily before he turned on the tape recorder. "How would you feel if, through no fault of their own, they became involved in an investigation, and the police thought their friendship with you made them more suspicious? Are you saying that cops shouldn't have friends?"

He gave her a disgusted look. "Not at all. But none of my friends has been involved in murder investigations." He hesitated. "Well, so many of them, anyway."

Bridget had the sense to keep her mouth shut at that point. He turned the tape recorder back on. "The question before you, Mrs. Montrose, is whether you heard or saw anything else last night?"

"Well," Bridget said reluctantly. "I heard a Volkswagen engine in the distance."

"You could tell it was a Volkswagen?"

"I'm not a hundred percent certain, but it certainly sounded like one. I am well acquainted with the sound a VW engine makes."

The sheriff made another note on his pad. "Now, Mrs. Montrose, if you'd take us through what happened this morning."

Dutifully Bridget recited her encounter with the surfers, her walk down the beach, and watching the surfers find Johanna's body, "although, of course, at the time I didn't realize what it was. I thought it might be a seal or sea lion or something."

"And have you all been talking this over amongst yourselves?"

Bridget was surprised at this question. "You must know we have, since Deputy White was right outside the living room several times while we were waiting to be interviewed."

Gonzales put down his pen and regarded Bridget. Once more, he reached out to turn off the tape recorder. "Mrs. Montrose, I have to tell you that I've spoken to your friend Paul Drake. He told me that you have a gift for observation. In fact, that was his excuse for letting you meddle in those previous murders." His mouth tightened. "I have no intention of turning you loose here. But I want you to know that I am interested in anything you overhear, anything that you notice, anything that occurs to you during the course of my investigation. I expect you to come right to me with your findings."

"Of course," Bridget said, affronted. "I don't have any desire to play Jessica Fletcher. I'm leaving that to Madeline."

The sheriff grimaced. "Right. Well, as long as we understand each other. I'm keeping an eye on you. And you're going to be totally up-front with me. Is that correct?"

"Yes." Bridget tried to speak with quiet dignity. It irked her deeply to be treated like a nine-year-old—to be treated, in effect, as if she were her son Corky, who was famous in the family for going his own road and stirring up trouble. She couldn't imagine what Drake had said to this man.

Gonzales closed his notebook and picked up his tape recorder. He looked at Bridget as if surprised to see her still there. "That's all, Mrs. Montrose. Thank you for your cooperation."

She headed for the door, thinking that there was nothing like a stern interrogation to take away your appetite.

When she pushed the heavy door open, Madeline was standing on the other side. She darted into the dining room. "I believe I left it in here—oh, here it is." She picked something up from the chair seat next to the one Bridget had been sitting in. "I must have dropped it. My lucky pen." She smiled brightly, shoved the bulky silver pen into her pocket, and darted out again.

"Writers," Gonzales said, shaking his head.

21

MADELINE WAS UNLOCKING her bedroom when Bridget went past. She had been put across from Johanna, in the Isadora Duncan Room.

Bridget nodded, and Madeline paused in the doorway. "Was it terribly grueling?" she asked sympathetically.

"Not really," Bridget lied. She noticed a used tray on the floor near Madeline's door, and the remains on the tray were not from breakfast. "Did you already have lunch?

"They brought us trays," Madeline explained. "Since the dining room was busy. It was good, as usual. But it was hard to eat, I was so upset."

"Why?" Bridget wondered if it had been Sandra's comments that bothered Madeline. Or did she just sense that everyone was starting to hate her? And though she was "upset," Bridget noticed that the lunch tray was picked clean.

"I just went to speak for a moment to Dorothy," Madeline said with a tone of injury, "and she as much as said that I was some kind of snoopy snitch."

"I'm sure you misunderstood," Bridget murmured.

"I don't know," Madeline said darkly. "I'm going to tell Norbert. Mr. Rance. I think he should know about her."

Bridget opened her mouth, but couldn't think of anything to reply to this, so she turned away.

"And they really wrecked our rooms when they searched," Madeline called after her. "You'll see."

Bridget went to her own room. A covered tray had been left there. She unlocked the door, picked up the tray, and let herself into the room with trepidation.

It wasn't as bad as Madeline had implied. Her suitcase had been dumped on the bed and all its contents pawed through. Her notebook was open on the desk, and that peeved her; a person's journal should not be read by the police. She leafed through it to see what she'd written, and was embarrassed by several entries complaining of Emery's long hours and inability to help with the housework and care of the four small children that drove her crazy. It was a relief to find that in a later entry she'd acknowledged that providing for all those children was, of course, the reason for his long hours.

If only she could finish this new book and get the very pleasant advance that had been promised her, maybe he could slack a little. Her agent had advised her to sell the book based on the first few chapters and reap half the advance that way, but she was too nervous about completing it to do that; once they gave her money, she wouldn't know a minute's peace until the book was done.

Of course, she felt like that already.

She pulled her mind away from the sense of panic that filled her when she thought of all the work that was left to do on her book, and focused on the trouble at hand. The most important thing, of course, was to check and see if anyone had messed with her computer. She turned it on, relieved when it made its little spin-up noises. The booting up seemed to take forever. She opened the file where she saved her chapters. They were all there, safe and sound.

She took the cover off her lunch tray. Chicken Caesar salad, looking a little wilted now that it was an hour past lunch time,

but still tasty, with accompanying bread and fruit salad. Munching on lettuce, she began to scroll through the chapter she'd been working on when she'd gone down to the beach that morning for her fateful walk.

When she'd finished the last mouthful of chicken, it occurred to her to check her e-mail. At first the program wouldn't open, and then she discovered that she'd been disconnected from the Internet line. Maybe the police had unplugged everyone to keep them from trumpeting Johanna's death to all the media outlets. She wasn't sure how they would manage to muzzle the surfers, who had probably spread the news in Davenport, where some enterprising newshound might offer to be a stringer for the national press.

She plugged the cable back in and was able to get her messages. A series of them from Emery had more and more urgent subject lines, ending with one marked with high-priority symbols.

Emery had written,

> Bridget, the number you gave me for Ars Ranch isn't answering. I'm very concerned in light of Drake's phone call. If I don't hear from you by 2 p.m., I'm driving over.

The previous message said,

> I haven't heard from you yet, and am wondering what this is all about. Please reply soonest.

The message before that said,

> Hey, sweetie, hope things are going well for you. Got through breakfast with no spilling and only one tantrum. Liz stopped by and took Mick and Moira to preschool. Sam said he had a stomach ache, but he ate

two bowls of cereal for breakfast, so I am not too concerned. Drake called a few minutes ago and said someone in your group died, and the Santa Cruz County Sheriff's Office is investigating all of you. Don't get mixed up in that. Let me know what happens. Much love, Emery.

Bridget picked up the telephone by the bed, but when she dialed out, all she got was an annoying beeping sound. Wishing she had taken Emery up on his offer to buy her a cell phone, she went back to her computer and sent a message.

Emery, I'm okay. Johanna Ashbrook died last night or early this morning; her body was found by surfers in some rocks just offshore. Everyone else is fine, but they are investigating the death. I think they've fixed the phones so we can't call out; I'll go talk to the woman in charge and see if she knows what's hap-pening. In the meantime, we'll have to communi-cate by e-mail. I am getting some work done, though the investigation is a major distraction.

Seeing what she'd written, she stopped for a moment.

That sounds very callous, but you know what I mean. I am doing my best to keep out of it. No point in coming over here; I doubt they'd let you in unless you did like Claudia and snuck in the back. She and Liz will tell you I'm fine. Give my love to the kids and take some for yourself.

Among the other messages was one from Paul Drake, her friend in the Palo Alto Police Department, and not incidentally Liz's significant other.
Drake had written,

Bridget, I've just had to fax the Ars Ranch your police
record, such as it is. At least you're not getting into
trouble on my dime this time. Don't stress. Liz already
told me if you needed any help, it was up to me to dig
you out unless I want her to do it, which naturally I
don't. Keep your nose clean and tell the truth, and
you'll be fine.

Several nuggets of information in this message struck Bridget.
First of all, obviously the fax line was working, so it was even
stranger that the phone line was out. And she did feel a bit com-
forted knowing that Drake was looking out for her interests,
even remotely. Surely he could persuade Gonzales that she was
benign.

The last line made her a little indignant, however. She quick-
ly wrote a reply.

Drake, how nice of you to let them know how many
close brushes with murder I've had. Detective-
Sergeant Gonzales found that very suspicious. I always
keep my nose clean, and lying is so tedious, I try never
to do it, so no need to worry on that account. I am
counting on you to come bail me out if they arrest me.
And don't alarm Emery. He's already skittish.

After catching up with her correspondence, she went back to her
book. She made a few corrections, pleased with what she'd done
the previous day. But then she sat, hands poised over the key-
board, while nothing happened. No words flowed. Her mind
was occupied with images of Johanna at dinner the night before,
her body floating to shore on Dave's surfboard, the ambulance,
the conversation in the living room. Her novel simply couldn't
compete with the unresolved questions of Johanna's death, and
finally she gave up trying and went to wash her face.

In the bathroom, all her toiletries had been dumped from

their case into the sink, and a very expensive jar of face cream
with which she was trying to keep incipient wrinkles at bay had
broken. She tidied up the bathroom, moved on to neatening her
bedroom, and then opened the door to put her lunch tray out.

Dorothy was walking down the corridor. She greeted
Bridget and unlocked her door. "I've just been down to com-
plain about the phones."

"I was going to do that, too. What happened?"

"Sharon says she doesn't know anything about it. The police
evidently disconnected them somehow when they searched the
office." She gestured toward the entrance hall and the office
above it. "But the fax line still works."

"Yes, I know," Bridget said, grimacing. "My friend on the
Palo Alto police force e-mailed me that they were asked to fax my
record."

"Do you have one?" Dorothy appeared fascinated.

Bridget hesitated. "Why don't you come in for a minute?"
She didn't want to talk about her previous experiences with
murder out in the corridor. Given Madeline's proclivity for gos-
sip, she was probably right inside the door of her room at that
moment with her water glass pressed against the panels, hoping
for juicy revelations.

Dorothy followed Bridget into her room. "You have a love-
ly view, don't you?" She walked over to the window that looked
toward the ocean. "The hedge has grown over the view from my
window."

"It is nice," Bridget said, feeling vaguely guilty that she, a
newcomer to the writing field and relative unknown, should
have a better view than this fine, veteran writer. "Please, sit
down." She gestured Dorothy into the room's easy chair, and
pulled the desk chair around to face it. "We'll have a little par-
ty."

Dorothy smiled wearily. "Just like we do at conventions, only
with rather less to drink."

"Right." Bridget forbore mentioning that she'd never been

to a writers' convention, just to the workshops at the local junior college. "As a matter of fact, Johanna drank up my little bottle of brandy. But I can offer you some sparkling water."

"How kind. Thank you."

Bridget got out one of the bottles of Crystal Geyser she'd brought from home and shared it between the two small glasses that were all her room provided. "Here you go."

Dorothy raised the glass. "To long life and prosperity," she said, and drank. "I guess that sounds a little callous after what happened to Johanna."

"Not really." Bridget sipped her water. "I keep doing that, too, saying things that sound callous, and I don't mean them that way. It's just so hard to take it in."

Dorothy shook her head. "It's very sad. A terrible waste of someone who was potentially a fine writer." She pointed a finger at Bridget. "Now, mind you don't go that way. I look forward to seeing your work just get better and better."

"If I can ever get this book done, I may never write another one." Bridget looked resentfully at her computer.

"Blocked?" Dorothy patted her hand. "You'll get past it. There are wonderful things in you, Bridget. Don't give up."

"Thanks. I needed that."

"Now," Dorothy said briskly, "you were going to tell me about your police friend, and why he had something to fax to Detective Gonzales. Were you arrested at sit-ins?" She laughed. "I'm sure it wasn't shoplifting or something of that nature. Honesty is written all over your face, my dear."

For some irrational reason, this kindly but patronizing remark made Bridget feel reckless. "I haven't been arrested," she said, "you're right about that. But evidently my name is associated with a few murder cases."

Dorothy's eyes widened in disbelief. "You were suspected of murder? Oh, no."

"Not really," Bridget hastened to say. "But people I knew were suspected, and I ended up—well, kind of involved."

"Let me get this straight," Dorothy said slowly. "You have been involved in murder investigations in the past? Doesn't that make you look suspicious to Detective Gonzales?"

"Probably." Bridget shrugged. "I am a bit worried about that, but the police usually do find the right person, so I'm assuming they will this time, too."

"I find this really hard to take in," Dorothy confessed. "I mean, I didn't know people were ever murdered in a place like Palo Alto."

"Actually, we have at least one murder a year in our quiet little town." Bridget saw the skepticism on her face. "Once the murderer was someone in our poetry group. Not a good poet or a good murderer, as it turned out. And I got involved in one because my friend Liz was a suspect. And another time they found human bones under the sidewalk in front of my house."

"How grisly." Dorothy looked at her with a strange expression on her face.

"They had been there since long before we bought the place," Bridget explained. "But then there was a fresh assault, and it got a little messy. We were actually in Hawaii when it all happened, but it might have gotten into my permanent record, as my mother used to say."

"And now you're mixed up in another death."

"I'm not sure this is a homicide." Bridget thought for a minute. "Although, when they found the computer—I mean, someone went to the trouble of trying to destroy Johanna's electronic files. Why would anyone do that if she'd just had an accident?"

"Maybe there was something in those files that person didn't want known. The identity of the ghost, for instance."

"That makes sense." Bridget brightened. "Thanks, Dorothy. I feel better."

"Well, the old cliché is true. You can't judge a book by looking at its cover," Dorothy said. She finished her water and got to

her feet. "I had you down as a nice suburban matron with a gift for writing, not the Miss Marple of Palo Alto."

Bridget winced. "It's certainly not like that," she said, following Dorothy to the door. "If anyone is the Miss Marple of Palo Alto, it's Claudia. And I would appreciate it if you would not say anything to anyone else. I probably shouldn't have told you, but I got an e-mail from my detective friend just now, and it's on my mind."

"I won't say anything," Dorothy assured her. "But maybe you have a talent for detection as well as writing. If so, I wish you would put it to work here. None of us can be easy in our minds until the truth is discovered."

22

AFTER HER CONVERSATION with Dorothy, Bridget felt restless. She tried to settle into her writing, but in spite of Dorothy's encouragement, the words wouldn't flow. She wandered around her room with the uneasy feeling that she had told Dorothy far, far too much.

The afternoon had turned unseasonably hot, and the air felt close and stuffy. A bank of clouds hovered just off the coast. She looked at the glittering silver-blue water, and decided she would have a swim. Not in the ocean, which would be very cold, she knew, but in the lovely pool.

She put on her suit and covered it with a long, baggy T-shirt to veil the surfeit of hips it revealed. Taking a towel from her bathroom, she locked up and skulked her way to the living room, hoping she didn't meet anyone. She was tired of the other writers; they were all probably tired of each other, needing their solitude as she needed hers.

The double doors to the dining room were open; the chair where Gonzales had sat was empty. But voices drifted down from the office above the entrance hall.

Norbert sounded angry. "No way in hell am I gonna let you

just roam through my files. The Ars Foundation is privately held. We don't have to submit to that kind of scrutiny."

Gonzales raised his voice, too. "This is not a tax audit, Mr. Rance. This is an investigation into the suspicious death of a famous woman. Believe me, all the nonprofit status in the world won't keep us out of your books if we think it will further our investigation. I'm not interested in your financial dealings. All I want is the guest list from the last time Ms. Ashbrook was here."

"The FBI might even butt in, Norbert, honey." That was Sharon's voice. "Remember, Johanna was doin' the horizontal mambo with one of their deputy directors once. I think that guy is still there."

"She was not," Norbert said, but it lacked conviction. "Well, if all you want is the guest list—"

Realizing that she was eavesdropping, Bridget hastened through the empty living room and out the French doors into the back garden.

The slate-floored terrace stepped down to wide brick paths surrounded by lush flowerbeds, all carefully tended, filled with daffodils and tulips in bloom. It was the kind of setting where Fred Astaire and Audrey Hepburn might waltz out of the gateway at the side and down the garden paths.

The swimming pool appeared to be a regulation twenty-five meters. Its sparkling waters beckoned. Bridget put her things on one of the steamer chairs that invited basking and jumped in at the end opposite the spa. The water was deeper than it looked, and she came up sputtering, treading water. Her swimming was not showy; she did a garden-variety crawl stroke that had her plodding up and down the length of the pool. After six laps, she turned over on her back and floated for a minute, letting the sunlight wash over her.

V.J. walked down the terrace steps. He also intended to swim, judging from the towel draped over his arm, and the open shirt he wore over swim trunks.

"Bridget," he called, waving. "You see we think alike!"

"The water's pleasant," she called back.

He arrived at the edge of the pool and stripped off his shirt. His skin was smooth and very brown, his torso economically muscular.

"How deep is it?" He shaded his eyes with his hand, looking into the pool.

Bridget took a breath and sank to the bottom, letting her hands float up as she went down. She came back up and shook the hair out of her eyes. "I judge about eight feet."

"I can dive, then," he said, and proceeded to do so, slipping neatly into the water. His head popped up nearby, and he, too, shook back hair. "Smashing," he said, and began swimming toward the other end in long, powerful strokes.

A bit intimidated by his skill, Bridget began a lazy breaststroke, trailing him the length of the pool. It was about as wide as three lanes at the Palo Alto pool where she normally swam. She kept a respectful distance from V.J.'s expertise.

She had done a couple of laps of sidestroke, to V.J.'s eight or ten freestyle laps, when he stopped at the end of the pool and rested his arm on the edge, waiting for her to finish her lap. His face was calm, and she realized that the lines of tension she'd seen there that morning were not usual for him.

"Now I feel better." He wasn't even breathing that fast, she noticed with just a tad of resentment.

"It is relaxing, isn't it? My friend Liz swears it's the perfect exercise. She's the one who turned me on to it. Before last year, I'd hardly swum since I was a kid."

"Yoga is the perfect exercise," V.J. said. "But swimming, too, is all about your breath. I find it—therapeutic."

"Well, we could all use some therapy about now. And I know it's been particularly hard on you."

V.J. held up one hand and turned his head away. When he turned back, his face was composed again. "Sorry. I am trying to see Johanna as at rest, but it is difficult for me. She was always so

much alive." He was silent a moment, and Bridget, not know-
ing what to say, was silent as well.

"I cannot believe she would commit suicide. So what
happened?" V.J. looked at Bridget. "If only I knew. Was it an
accident? Did she provoke someone? Finally go too far?"

"Would she do that?" Bridget, chilled, ducked into the water
until only her head showed. "I mean, I know she was capable of
mean remarks, because of dinner last night. But when we talked
on the beach—"

V.J. moved closer. "You spoke to her last night. That's right.
What did she say? How did she look? I must know. I must un-
derstand."

Bridget backed away. One felt very vulnerable in the water,
she reflected uneasily. "Hey, it wasn't a big deal. She didn't an-
nounce that she meant to end it all, or that she thought anyone
had evil designs on her. I apologized for calling her down in front
of everyone, and she seemed a bit amused that anyone would
think something like that deserved apology. I kind of scolded her
a bit, and she shrugged it off. She walked away, and that was it."

"But she seemed normal? Not despairing, not depressed?"

"Despairing?" Bridget thought. "I wouldn't say that. She
was just rather matter-of-fact that she knew she was doing
wrong, but she was powerless to stop." She blinked. "Hmm. I
just now realized that she was an addict in other areas of her life
than alcohol."

"And what was it she could not stop doing though she knew
it was bad?" V.J.'s hands clenched on the side of the pool. "Did
she go to meet someone? Is that what the police have found
out?"

"I couldn't really say," Bridget said.

"You lie very poorly," V.J. observed. "She was going to meet
someone, without doubt. Whose love was she toying with this
time?"

Bridget stared at him. The bitterness in his voice was plain to
hear. "V.J., I'm sorry—"

"It is not for you to be sorry." He pushed the wet hair off his forehead and heaved himself out of the pool. Dripping, he stood looking down at her. "Always she must have what she wants, no matter what the consequences to others. This is what I ask myself. I know she has been worse than thoughtless to those who deserved her respect and concern. Who that she has treated this way would kill because of it?" He looked away. "I have found myself unable to take the middle path because of her, unable to live with the moderation I desire. That, of course, is my own struggle. But her death certainly has not helped."

He picked up his towel, but without using it, strode back toward the house.

23

A SOBER CROWD GATHERED for the cocktail hour before dinner. Bridget walked down the hall with Dorothy, who had called her on the house phone to ask if she meant to go. "I wanted to say a few words about Johanna," Dorothy told her. "It would be nice if we were all there." So instead of more fruitless staring at her computer screen, Bridget had showered and dressed again in her black skirt and white shirt, adding the pearl earrings Emery had bought her on their fifteenth anniversary. Looking in the mirror, she thought she might be mistaken for one of the wait-staff, but the iridescent silk shirt didn't seem appropriate.

She and Dorothy joined Ed, Sharon, and Norbert in the living room. V.J. followed them in, and Sandra and Elaine came soon after.

Everyone made polite, low-voiced conversation while Norbert mixed drinks with surprising skill and Sharon made sure the appetizers—wonderful little shrimp dumplings with a spicy ginger–chile dipping sauce—circulated further than Ed's reach.

Madeline dashed in, wearing a glittering sequined black top. "I hope I'm not late," she said, breathless. "And I know this is the wrong thing to wear, but it's the only black thing I had."

"You didn't need to wear black, dear," Dorothy said.

Bridget glanced around the room. V.J. wore white, she noticed, which she thought might be the color of mourning in India; his loose white pants and long, embroidered white tunic looked exotic against his dark skin. Ed wore black slacks and a blue oxford cloth shirt open at the throat. Sandra had put on cropped black pants and a sleeveless black linen shell; Elaine wore a short black dress and high, square black shoes; both looked very chic. Dorothy had worn the same long black dress with a scoop neck to dinner every night. The previous evening, she'd worn a bright scarf at the neck; now she had only a string of pearls.

Sharon wore her signature white, and in her case, Bridget didn't think it was due to mourning. Her three-tiered skirt was embellished with colorful Mexican embroidery; the white silk blouse tucked into it was an off-the-shoulder peasant style with red cross-stitching around the neckline. She had discarded her turquoise jewelry for a cameo strung around her neck with a red ribbon. It looked unpleasantly as though she'd had her throat slit.

Norbert wore his customary jeans, but had changed into a black cowboy shirt trimmed with white piping and pearl buttons; his boots were black snakeskin. His silver bolo tie was set with a monstrous chunk of onyx.

Looking around at everyone, Madeline smiled brightly. "Isn't there a mystery novel somewhere where they figure out who did the murder because the person has brought mourning clothes with them? A lot of us are wearing black."

"A lot of us are from New York," Dorothy pointed out. "Black is the color of choice for any social gathering there."

"That's true," Madeline conceded. "I guess you're not guilty just because you brought a black skirt, Bridget."

"Thanks, Madeline." Bridget forbore saying anything about glittery sequins being guilty of some kind of fashion crime. She felt quite virtuous as a result.

Dorothy raised her glass of wine, and her voice. "I wish to propose a toast to Johanna. I know she could be insensitive and selfish, but she had a tough, unsentimental eye for human foible and a most felicitous turn of phrase. I, for one, shall miss her, and the books she might have written had she been able to come to grips with her demons. May Johanna rest in peace."

V.J. murmured an assent, and drank deeply, though Bridget had noticed that his drink was sparkling mineral water. Bridget, too, murmured a brief "Amen." She had the uneasy feeling that Johanna, wherever she'd ended up, was laughing at them.

"Well, speakin' of that," Norbert drawled, "I have to tell you people that Detective Gonzales is dropping in to our little cocktail gathering to give us an update. I don't mind telling you, I hope he's figured out some way to leave Ars Ranch and all of us out of the official reports on Johanna's death. We had to unplug the phones earlier, when word got out. It just got to be too much for Sharon."

"It was hell," Sharon said baldly. "I don't consider it part of my position here to be issuing statements to the press about one of our guests. Y'all are here to work, not court publicity."

Madeline looked thoughtful, and Bridget noticed that Ed, too, rubbed his chin.

"Well, whatever," Norbert said. "We've muzzled 'em for now, and we've put a message on the phone and turned off the ringer until this dies down. If you want to dial out, come on up to the office and Sharon will fix you up with an outside line. Otherwise, people who call you will get the message that our phones are temporarily out of service. So please send your families e-mail or use your cell phones or something, until we get a handle on all this."

"I don't mind talking to the press," Madeline volunteered. "If they want one person's emotional response to this devastating death."

"She already sees herself on the nightly news," Dorothy whispered to Bridget.

Norbert was quick to squash Madeline. "Y'all signed confidentiality agreements when you accepted your invitations to the ranch," he said, a steely note in his voice. "We've had trouble in the past with people tryin' to get in to write up some kind of behind-the-scenes crap for the tabloids. Anyone who breaks their signed agreement will be hearing from this whole passel of lawyers I got eatin' their heads off on retainer back in Houston."

Madeline took a sip of her tequila sunrise, her expression rebellious. It was a relief when the doorbell rang.

Sharon went to answer it and came back with Detective Gonzales. She kept him at arm's length, rather as if he were a particularly smelly bit of laundry.

"Detective Gonzales." Norbert came forward, with an air of authority that was surprisingly commanding from someone so short. "Hear you have some news for us."

"Not exactly news," Gonzales said easily. "More in the nature of an update." He smiled. "And I would like all of you to remember that I tell you this information in confidence, as a courtesy. Please do not relate it to anyone else, and especially not to any news outlet."

"I've already covered that," Norbert broke in, fixing Madeline with a glare.

"Here's what we know so far," Gonzales went on. "Ms. Ashbrook was unconscious when she went in the water. She was evidently hit on the head with something, probably a beach rock. It appears that she fell or was pushed into the surf, and ended up being swept out and lodged in the rocks offshore. Perhaps whoever hit her wanted her body to disappear, but that rarely happens on our beaches. Tidal action brings anything that goes in right back; that's why we're pretty sure she went in from somewhere along the Ars Ranch beach."

"But couldn't it have been accidental?" Sharon asked the question urgently. "Maybe she tripped and fell at the surf line, hit her head on something there, and drowned. People do."

Gonzales looked at her, not unkindly. "It's possible. But

postmortem bruises are consistent with her being pushed. For that reason, we're looking into it as a suspicious death." He paused. "The state investigators are planning to be here tomorrow. And they queried Ms. Ashbrook's New York publisher and her personal staff for us; we'll have that information tomorrow also."

"So they'll find out who was going to ghost her new book?" Madeline was still chirpy.

"Or if anyone was going to," Ed said, also glaring at Madeline. "And that's still no indication of guilt. The ghost is now out of a job."

There was a moment's silence, before Madeline filled it. "Or else the publisher could have the book written and publish it posthumously as hers."

More silence. Then Dorothy said, "You're just full of good ideas today, Madeline."

Norbert waved an impatient hand. "This kind of thing gets us nowhere. Detective Gonzales, we want all this cleared up as much as anybody can. What do you want us to do?"

"Just stay on the grounds. Don't wander off alone until we figure it out. If anyone remembers something they saw or heard and wants to tell me about it, give me a call." He walked around the circle, handing out copies of his card. "Above all," and here he looked hard at Bridget and Madeline, "don't try to sleuth around for yourselves. Please leave the investigation to professionals."

"Naturally I would never dream of interfering," Madeline announced. "But the few things I have noticed, I told right away to Deputy White, and I must say that she didn't seem to care much. That's why I thought—" She stopped, closed her lips, and shook her head when Gonzales looked at her.

"Rest assured that we are paying attention to everything you tell us, even if you don't think so." He smiled slightly. "Your input is important to us."

Norbert cleared his throat. "Now, sir, how are you gonna

handle the press? Because, let me tell you, based on the phone calls we've gotten, there'll be camera trucks at the gates in no time."

"You do have gates," Gonzales said. "Don't open them. Don't let anyone in. Don't let anyone out." He frowned slightly. "I'm not sure why you've gotten so many inquiries already. We've released no statement, and as far as I know, her publisher hasn't yet either. How did the press know about her death?"

Nobody spoke up, but Bridget thought Madeline looked self-conscious.

"Well, with cell phones and e-mail, people have instant communication at their fingertips. Please, folks, before you go telling the world about this, think about the impact you make on our investigation."

"And on all the other writers who are tryin' to work," Norbert growled. "This ain't no media circus. And anyone who thinks so will find she's sadly misjudged the influence Norbert Rance carries in the world of arts and letters. Me 'n' Murdoch and some of his pals have a standing poker game every month at my Texas spread."

There was no mistaking who this was aimed at. Norbert's pointed look at Madeline, and the way she flushed, were clear indicators.

Madeline tossed her head, recovering her normal complexion. "A writer who doesn't self-promote these days is a writer with no sales," she observed.

"That, unfortunately, is true," Dorothy said. "But please do consider the rest of us, dear. All of us have work to do. And on top of that, some of us are grieving for a lost friend."

"Oh, right." Madeline looked around the room. "Some of you, for sure. But certainly not all, as far as I can see."

A wall phone next to the terrace doors rang, and Sharon went to answer it. "Dinner's ready," she announced, glancing at Gonzales. "Do you want to join us?" Her invitation was conveyed in a lackluster tone.

"No thank you," he said. "It's been a long day, and I still have paperwork to do at the office. Remember, I'm just a phone call away. And I've stationed a couple of deputies around, in case anyone feels nervous."

"Should we be nervous?" Sandra said. "Do you expect someone else to be hurt?"

"I don't expect it," Gonzales said, his voice level. "I want to prevent it. So please treat my deputies nicely and follow their instructions."

"Right." Norbert drew himself up. "I certainly don't want my writers jeopardized. We'll get this all cleared up, folks, and until then, well, everything you could need is already here, so no reason to leave."

"As long as that's understood." Gonzales moved toward the door. "Thank you all for listening. Be sure to let me know if you have any further thoughts. I'll be in my office before you're finished with dinner, and I won't be leaving until after ten tonight."

Sharon showed him out, and the rest of them moved slowly toward the dining room. Delicious scents were in the air, but they had no power over Bridget. She knew that dinner the previous night, with Johanna a prominent player in the action, would be in everyone's thoughts when they sat down to eat.

24

THERE WERE NO PLACE CARDS that evening. Sharon apologized. "I have just been rushed off my feet today, y'all. Just sit anywhere."

Norbert stood in front of the chair at the head of the table. Instead of taking the chair at the foot of the table, Sharon sat at his right. Bridget plopped down with Dorothy beside her, and Madeline quickly sat next to Dorothy, at Norbert's left. V.J. ended up at the foot of the table on Bridget's left. Sandra and Elaine sat across from Bridget and Dorothy. Ed, with a sour look at V.J., went to the only vacant seat between Elaine and Sharon.

The salad was a wonderful pile of field greens, lightly dressed with lemon and olive oil, but Bridget couldn't enjoy it. Dorothy, too, she noticed, picked at her food. Madeline also took a while to eat her salad, but that was because she had started questioning Dorothy about Johanna.

"So you all lived in New York? Did you hang out together?"

"Not really." Dorothy took a forkful of greens, but didn't lift it to her mouth. "I had small children, and so did a couple of the other writers. We met every couple of weeks to work on our manuscripts."

"What book was Johanna writing? Her first one?" Madeline wrinkled her forehead. "What was it called?"

"Her working title was not the one it ended up with. I don't know if I can remember it." Dorothy passed a hand over her forehead. She looked tired, and Bridget thought, distressed.

"*Fatal Passage*, wasn't it?" Bridget thought Madeline was being very matey with Dorothy for someone who had complained about her earlier, but obviously she had an agenda.

Ed broke in. He'd cleaned his salad plate and was buttering one of the crusty rolls that were still warm in their napkin-lined baskets. "Why do you want to know all this, anyway?" He looked at Madeline suspiciously. "You've even got your notebook out on the table. If you're planning to use this information, you should tell Dorothy. She might not want to provide fodder for whatever it is you're writing up."

"It's nothing much," Madeline said defensively. "Just occurred to me that one of the papers might want a sort of 'Last Days of Johanna Ashbrook' kind of thing."

"And what makes you qualified to write that?" Sandra took up the cudgel. "You didn't even know Johanna."

"Not as well as *you* did," Madeline said, and watched Sandra's brows contract. "But we met, we chatted. We were here on a common mission—"

"Dammit, woman. Didn't you understand what I said earlier?" Norbert pounded his fist on the table. "Nobody here writes anything about anyone else. That's in the rules. You signed 'em. I've got your signature right upstairs in my office."

"I don't think an attorney would find that kind of permission-slip thing binding," Madeline argued.

"It's an abuse of hospitality, that's what it is," Norbert sputtered. "And you're not even the real Madelyn Bates! That's it. You're out of here."

Everyone sat silent for a moment. Then a babble of voices broke out.

The clearest voice among them was Madeline's. Her face was

composed, though spots of color burned on her cheeks. "You can't kick me out," she said, her breath coming fast. "The detective said we all had to stay here."

Stymied, Norbert stared at her. His jaw tightened, his lips compressing, and Bridget thought it was easy to understand, with that look on his face, how he'd parlayed his inherited cattle ranch into an empire. "Fine," he said shortly. "You stay. You write as many damn articles as you want. Book after book, if you want to waste your labor. Because there ain't no newspaper, no magazine, no publisher in the world who's gonna touch what you write."

"I don't—" For the first time, Madeline's voice sounded less certain. "What do you mean? You can't blackball me everywhere."

"Norbert Rance is very influential in the world of publishing," Sharon said proudly. "Only an idiot would get on his bad side."

Having nothing to add to this, Norbert simply sat back in his chair and folded his arms.

Madeline turned red. "You're all against me, just because I self-published my first book. That's so unfair. You know, we do have a free press in this country, and I'm free to publish what I write."

"You're free to try," Norbert agreed.

Dorothy put a hand on Madeline's arm. "It's not because you're self-published," she said. "It's because you are taking advantage. We are guests here, and it's only common courtesy to comply with the rules."

Madeline jumped up from her chair. "I don't think much of a host who threatens his guests, especially when one's already been murdered," she shouted. "You all act so superior, like you're the only ones worthy of being published authors. Well, I know a few things about some of you, the kinds of things that if I chose to write them up, no way could any of you keep them from being published. The kinds of things tabloids pay big money for. So you all better watch out!"

She ran from the room.

Silence fell over the table. Norbert broke it, stirring uneasily in his chair.

"Guess maybe I was kind of hard on her," he muttered.

"Woman's an ingrate," Ed pronounced. Servers came in with the entrée, and he looked at his with interest. "Maybe she used to write that tabloid tripe for a living—maybe she still does. She should never have been here with us."

Bridget didn't say anything, but she wondered if she should be there with them, either. The writing world seemed divided into two camps; those deserving of perks like a couple of weeks at Ars Ranch, and everyone else, who had to bootstrap their way up with no such attentions.

Dorothy seemed to understand what she was thinking. "Certainly Norbert is at liberty to choose his guest list from the ranks of new writers as well as more established ones," she said.

"Yes, otherwise I wouldn't be here," Bridget blurted.

"You're here on your merits," Norbert said firmly. "Everybody is. Well, everyone but that Madeline, who got in under false pretenses." He added, "And Johanna. She asked to come, and I was glad to fit her in, given that I knew her and all."

"Given that she really needed to get some work done," Ed muttered. "Million-dollar contract like that, and can't even write a book."

"It's a scary feeling." Bridget shivered, thinking of her own book, which had not grown any longer over the course of the afternoon.

The veal stroganoff smelled wonderful. Bridget hated that she was only able to choke down a couple of bites. The tension in the air made it hard to eat.

Only Ed seemed to enjoy his usual hearty appetite. He eyed Madeline's plate, set down when her salad had been removed, although she had left the room. Bridget wondered if he'd actually go so far as to ask Dorothy to hand it across to him, but evidently he drew the line there.

"What do you think she meant about telling things about us?" Sandra finally broached the topic that was on everyone's mind.

"She was just blowing hot air," Ed said firmly. "There's nothing to know about me. I lead a blameless life."

"A little heavy on the calories," Dorothy said under her breath.

"Yes, we all live blameless lives," Sandra said impatiently. "That doesn't mean we want to see bits of them spread across the tabloids."

"True," Norbert conceded. "You can always dig up something that can be made to look bad. And since this whole thing happened on my watch, I'll make sure to include all of you when I have a little chat with my poker buddies."

"I don't like this," Dorothy said. "I know she's behaved badly, but really, the circumstances are so odd—"

V.J., who'd hardly spoken, said vehemently, "You are right. There is a miasma over everything." He passed a hand over his eyes and pushed away his untouched plate. "If you will excuse me. I do not feel well."

"Of course," Norbert said politely. "You rest now." But when V.J. left the room, he said sourly to Sharon, "Well, they're dropping like flies."

Bridget wanted to leave, too, but it looked like Norbert would be unhappy to lose any more dinner companions. Conversation was desultory for the rest of the meal, ending with a lemon sorbet that should have been refreshing but instead fell as flat as the conversation. Even the delicate butter cookies served with it didn't perk Bridget up.

"Well," Norbert said, standing at the conclusion of the meal, "I hope we'll get some closure on all the bad stuff that's been happening. I know y'all are having as much trouble coping with it as I am. Let's all get some rest. Things will be brighter in the morning."

"You said it, Norbert, honey." Sharon beamed at him.

There was no gathering of writers in the living room that night. Sandra and Elaine went up to their room. V.J. had already disappeared.

Bridget and Dorothy walked down the hall together. At the door to her room, Dorothy said abruptly, "I'm going for a walk on the beach. I need fresh air to blow that most unpleasant dinner away."

"Good idea," Bridget said.

"Want to come?"

"I'll get a jacket and meet you at the front door in a few minutes."

She took the opportunity to freshen up, then grabbed her warm jacket and headed for the front hall. It was deserted when she got there, and while she waited for Dorothy, she saw that Ed was in the living room, legs stretched out comfortably to the fire, enjoying coffee and cookies.

Bridget didn't want any coffee, but she thought after the walk with Dorothy she'd make some herb tea or hot chocolate. Though only Johanna was gone, the vast ranch house seemed much emptier and colder than it had before. She looked into the dining room to see if the cookies and hot water carafe had been left on the sideboard.

Sharon was there, her back to the door, head bent over something on the table. Bridget walked over and looked over her shoulder. "What's up?"

Sharon jumped and put her hand on her heart. "Lordy, you scared me. I was just—just trying to figure out who left her purse here."

The purse was on the table, wide open to Sharon's rummaging fingers.

"Well, it's Madeline's," Bridget said. "We've seen it everywhere she goes. She must have really been upset to forget it when she left dinner."

"Right," Sharon said with an uneasy laugh. "Madeline's. You know, she'll probably be back for it, and I have to say I'm

in no mood to be waitin' on that girl. I'll just put it right here on the chair seat where she's sure to find it."

Dorothy appeared in the dining room door. "Are you ready, Bridget?"

"You gals going out?" Sharon looked at them. "Just remember to stay on our grounds."

"Yes, Mother," Dorothy said, smiling faintly.

"Sorry." Sharon dropped Madeline's purse on the chair and followed Bridget and Dorothy out of the dining room. "Didn't mean to be preachy. Just be careful. That's all."

25

IT WAS A DARK and stormy night. The wind had picked up since the afternoon lull, and blew Bridget's hair straight back. Dorothy clutched at the scarf she'd wrapped around her head.

"Hear that surf crash," Bridget said.

"Smells like a storm coming in," Dorothy said, sniffing the salty breeze.

"The clouds were way out there at sunset," Bridget said. "I didn't think it could come in so fast."

"I don't know much about California weather, but we had a house on Cape Cod for a number of years, and a storm is a storm."

They reached the picket gate and stood there for a minute. The darkness was less intense now that their eyes had adapted to it. A half moon hung in the sky, giving luminescence to the waves.

From the corner of her eye, Bridget saw movement. A dark form loomed up beside the gate.

"Who on earth—"

"Excuse me, ma'am." The man turned on a flashlight, pointing it at his badge. "Detective Gonzales asked me to keep an eye on things. May I ask what you're doing?"

"We want some fresh air and a walk on the beach," Dorothy said, somewhat belligerently.

The man looked uneasy. "Well, I don't know...."

"Look," Bridget said. "Have you been here for a while?"

"Since five." A faint note of resentment colored the deputy's voice.

"And has anyone come around?"

"A couple of reporters. No one since it got full dark."

"So what kind of trouble do you think we could get into here? There's nobody around. We're going to walk down the beach for a few minutes and walk back again."

The man scratched his chin. "Well, when you put it like that—"

"We'll be back shortly," Bridget promised. She held the gate open for Dorothy and let it close behind her.

They waded through soft sand, their eyes growing accustomed to the dark again. On the ocean side of the high-tide mark the walking was easier. Dorothy said, raising her voice over the boom of the surf, "You're good at that."

"Four children," Bridget said. "Really does wonders for your negotiation skills."

They paced along quietly for a while. The white ruffle of foam that marked the edge of the water advanced and retreated a few feet away; bigger waves crashed, splashing close to their feet. Further offshore the water was more ferocious, rearing up in glassy walls that broke over the tops of the jagged rocks where Johanna's body had been found. Dorothy stopped. "Is that the place?"

"Yes." They stood, watching the surf engulf the rocks and pour down the sides in violent cataracts. Dorothy started walking again.

"It's still hard to believe," she said. Bridget could barely hear her over the roar of the water. "That someone could have tried to kill her, I mean. Not that she's dead—I can believe that easily enough. The drinking, the men, the messy situations... It's not

hard to believe that Johanna would end up dead before her time. But to be murdered—it's just too bizarre."

"I know what you mean," Bridget said. "But it does happen."

"Madeline was telling everyone that you'd been mixed up in murders before. She said that made you really likely to be the killer."

"How would she know about that? I think she must go around with a stethoscope listening at doors."

Dorothy didn't say anything for a minute. "Is this one going well?"

"Excuse me?" The dark and the rhythmic walking pace had made Bridget's mind veer off to her book. She reflected that when she was alone with her computer, the perfect time to think about these things, she ended up thinking about where to go for a family vacation if Emery could get time off, or what would be the best snack to send to school with Corky, given that he wouldn't eat some things, and the things he would eat were bad for him. And when she should be paying attention to the conversation, when there was no possibility of actually writing her book, it seemed to be constantly in her thoughts.

"Do you think this investigation is going well, based on what you know about them?"

"Well," Bridget said frankly, "I don't actually know much about them. It's Claudia Kaplan who likes to sit down and make notes and try to put things together. I have only just stumbled around the edges of this stuff. Detective Gonzales strikes me as a competent sort, and he certainly seems to be well staffed. I think he'll figure it out, and if he doesn't, the state investigators will—"

Dorothy interrupted, pointing ahead. "What's that? What's going on?"

They had ascended a little rise in the sand. Ahead was a blazing bonfire with several dark shapes crouched around it.

"Teenagers partying, I suspect," Bridget said, thinking of an interesting scene Corky's Cub Scout troop had come across on a camping trip to Manresa Beach. "I bet they got someone to buy them beer."

They were closer by this time, and the figures around the fire became clearer.

"They look older than teenagers," Dorothy observed. "Probably got the beer legally."

"I think they're the surfers I saw this morning," Bridget said, recognizing the long, gray-blond braid of Nance's hair. "Maybe they have bonfires every night."

One of them stood up. He didn't see Dorothy and Bridget, who were outside the circle of light cast by the bonfire.

"Hmm, that's Dave."

"You know these people?"

"Not really. He works at the Cash Store. Evidently he and Johanna were…"

"You don't have to spell it out. I heard Sharon talking about it. Sounds like Johanna's usual bad behavior." Dorothy's voice was unexpectedly tart.

Dave had moved away from the fire. Nance got to her feet and called after him. "What are you doing?"

One of the other surfers stood up, too, putting a hand on Nance's arm. "Look, he'll be okay. Give him some space."

Nance shook off the hand. "I don't think he'll be okay. I think he's acting crazy." She had to shout to be heard over the increasing roar of the surf.

Dave's white face showed at the edge of the circle, but not the rest of him. It took Bridget a moment to realize that he had put on a wet suit. He carried a surfboard under his arm.

"This is the only way to end it," he shouted, and turning, ran into the surf.

All his friends were on their feet. "No, man!" the one who had counseled Nance yelled.

Nance didn't speak. She ran the opposite way, into the dark;

one by one the others followed her. On the sand farther up the beach, headlights blinked on. A VW engine roared to life, and Dorothy and Bridget stepped out of the way as it came inching toward them, headlights aimed at the waves. In the light, they could see that the waves were huge.

"At least thirty feet tall," Dorothy breathed.

Bridget couldn't see Dave at first, and then the headlights caught his surfboard cutting across the line of surf. He wasn't riding those monster waves, just paddling the board parallel to shore, back toward Ars Beach.

A couple of the other surfers came into view, running along the sand, surfboards under their arms. They were yelling incoherently. One of them launched his board, paddling furiously after Dave. The other one hesitated, then followed suit.

The bus stopped inching forward. Nance hopped out, leaving the lights on. She had a big flashlight in her hand. "We've got to get help," she shouted, spying Dorothy and Bridget.

"Right." Bridget felt as though she'd been briefly paralyzed. She whirled around. "There's a deputy by the gate down there."

Dorothy waved them on. "I'll follow," she said. "I know you'll go faster."

Bridget ran clumsily along the hard sand by the high-water mark; she noticed that Nance had no trouble keeping up with her, despite being older. In fact, in a few minutes Nance had outpaced her, but Bridget kept going, falling farther and farther behind.

While she ran, Nance raked the waves with the flashlight. Its powerful beam found two moving forms in the surf. Bridget hadn't dreamed that anyone could travel so fast by paddling a surfboard.

They were opposite the jagged rocks before Nance stopped, her flashlight beam fastened on the water. Bridget saw another prone black figure on a pale surfboard; instead of following the shoreline, he was battling into the surf, the board climbing through the tall waves.

"I'll get the deputy," Bridget panted. Nance, her face rigid, nodded.

Bridget jogged another hundred feet, then plodded through the dry sand again. When she got up to the Ars Ranch seawall, she was still some way from the gate. She cupped her hands around her mouth and shouted for all she was worth. "Help! Help!"

A flashlight came on, and the beam found her. She ran in slow motion in the sand beside the seawall.

"Oh, it's you," the deputy's voice said as she got nearer. "Where's your friend? Has there been an accident?"

"Someone's in trouble," Bridget gasped. "By the rocks. Surfer—"

"None of the local surfers would come out at night with a storm coming in," the deputy said incredulously.

"He—knew—Johanna."

The deputy stared at her for a moment, then whipped out a cell phone and started talking urgently into it. Bridget turned to make her way back down to the water's edge.

"Wait," the deputy said. "Where are you going?"

"I might be able to help," Bridget said. "Get the ambulance." Again.

The wind seemed to grow stronger every minute. Bridget saw Nance's powerful flashlight beam and went through the sand toward it.

They stood side by side, watching the pale shape of the surfboard. A wave broke over it in a thundering crash, and Bridget caught her breath, but in a moment Nance's beam found the board again, still with the black form clinging to it.

Another wave built. Nance muttered under her breath, "Don't try for it. Just come in now." The person on the board didn't take her advice.

The flashlight beam climbed up the black face of the wave, following the surfer. He seemed to be struggling to position his board. Then the wave broke, and he was riding its thirty-foot

crest. The other two surfers, who had arrived in time to see the eerie scene, were yelling.

"My God, he's got it." The flashlight beam wavered, and Nance jerked it back. "He might just—"

The black wave curled in on itself, toppling over, knocking the frail body of the surfer aside. Surfboard and rider went down in a tumbling cascade of water.

Nance played the flashlight beam wildly over the water. It picked up the other two surfers, who fought through the wreckage of the waves.

The pale surfboard popped out of the water, swirling restlessly in the ebb of the wave. One of the surfers grabbed it, and the other one used its leash to reel in a limp body. Together, they somehow managed to roll Dave onto one of their boards, and headed in to shore.

Dorothy had reached them by this time. "Is he—"

Nance was already heading to the water's edge. "We don't know," she threw back over her shoulder. "But we need blankets and brandy, at the least."

"I'll go up to the house and get them," Dorothy said. "I'm useless here." Indeed, in the fitful beam of the flashlight, her face was white and drawn.

Despite wearing jeans instead of a wet suit, Nance was waist-deep in the water, helping to guide the surfboard with Dave's body on it to shore. "He's still breathing," she shouted, her fingers on the pulse in his neck. "Pull the board in."

Bridget helped haul the surfboard up the sand. Nance did a quick, thorough check of Dave, her manner crisp and professional.

"You're really good at this," Bridget said.

"It's my day job." Nance pulled one of Dave's eyelids back. "I'm an emergency medical technician."

"Thank God."

"It does come in handy." Nance gently placed Dave's arm at his side. "He's got a broken arm. Definitely a concussion. Don't know how bad yet. May be internal injuries, too."

The deputy joined them. "I got someone else on the gate there. What's happening?" He regarded Nance and the two other surfers with suspicion. "No one's supposed to be on this beach right now. Detective-Sergeant Gonzales's orders."

"Suicidal young men don't take orders," Nance said dryly.

"You fellows were heroes," Bridget added, smiling at the other two surfers. "You saved his life."

"Hope he takes better care of it after this," one of them said.

"That was awesome," the other one said. "I mean, I know he wiped out big-time, but what a thrill to ride something like that."

"Don't even think about it," Nance ordered, holding Dave's hand. "What he did was stupid in the extreme. He might not make it." Bridget saw that she was taking Dave's pulse. The worry lines around her eyes deepened. "His pulse is slow, and so is his respiration, but he *is* breathing."

Albert, the young waiter, burst through the gate. He carried a bundle with him, and the sand seemed like no impediment at all to him. "Dave's down?" His voice was ragged. The wind caught at the edge of a blanket in the bundle he carried.

"Hey, man." The surfer who had brought Dave to shore stood up. "He's still alive."

Nance wouldn't let them roll Dave over to unzip his wet suit. "The ambulance crew will cut it off," she said.

"Hey, that's a good wet suit."

"We can't move him any more than we have to." She fished around in the bundle Albert had brought and found a flask. "What's in here?"

"That one's hot tea with lots of sugar," Albert said. "Tiffany remembered that it's good for shock. And that one is brandy."

Nance nodded in approval. "Did you bring cups?"

Albert hit his forehead with the palm of his hand. "Forgot that."

"Never mind. I'll use the thermos lid." Nance poured a little of the hot, sweet tea, added a generous dollop of brandy, blew

on the mixture to cool it a bit, and dribbled a little of it into Dave's mouth. Most of it ran out the sides, but Bridget saw his faint, reflexive swallow.

"Damn, I wish the ambulance would get here," Nance muttered.

Another long five minutes passed before they saw the flashing lights at the Ars Beach access road. Bridget and Dorothy found themselves standing on the sidelines while Nance assisted the other EMTs. They had Dave out of his wetsuit, bundled in blankets, with an IV fixed, in no time.

The ambulance drove away. Nance went with them, but the other surfers were left on the beach.

"You should come up to the house and get warm and dry," Bridget suggested, pulling her fleecy jacket closer around her. The noise of the wind meant all conversations were carried on by shouting. She felt moisture on her face, and realized it was starting to rain.

"Yeah," Albert said. "We'll fix you up."

"I dunno, man." One of the surfers stretched. "The big guy doesn't like us, so it's wrong to accept any favors from him, even indirectly."

"I don't care about that," the other one said, "but I gotta take care of my board. And I think Nance left the lights on in the bus. We should just go on back."

The deputy spoke up. "I know you want to take care of your stuff," he said, "but Detective Gonzales is going to want to talk to you. How about if I send someone along the beach to bring your car up here? We can lean your boards against the seawall. No one will bother them there."

After a little discussion, the surfers agreed to accept Albert's offer of hospitality. The rain began in earnest as Bridget and Dorothy trudged back to the house in their wake.

26

ONCE MORE Bridget huddled in the living room close to the fire. Dorothy, in the armchair on the other side of the fireplace, was silent, her face drawn. Both held hot toddies, which had been expertly prepared by Norbert, who paced up and down the rug alternately inquiring after their well-being and inveighing at Detective Gonzales, whose laxness had permitted another besmirching of his toy ranch.

"It shouldn't be allowed," he raged.

Gonzales, who was present to receive this burst of temper, maintained a stolid facade.

"I'm not sure how we could know that a local surfer would attempt to commit suicide right in front of your beach," he said, when Norbert paused for breath.

"If you'd done a decent job of lookin' into Johanna's death, he'd be safely in jail right now, instead of half-dead in the hospital," Norbert insisted.

"You think Dave was responsible for Ms. Ashbrook's death?"

"Isn't it obvious?" Norbert snorted. "Boy has unsuitable yen for famous older woman. She gives him the brush, and he kills her, then tries to kill himself because of remorse. Mind you," he added, in a spirit of generosity, "I don't say he meant to kill her.

Probably got mad and pushed her, like someone said, and her head hit a rock. Panicked and put her in the water."

"Interesting theory," Gonzales conceded. "Only problem is, the local surfers know very well that anything you put in the water here washes right back up. Dave wouldn't have tried to dispose of a body that way."

"Maybe he thought it would make it look more like an accident." Ed offered this suggestion. He was on the sofa facing the fireplace, with Elaine huddled in the opposite corner. Sandra perched on the sofa arm. V.J. had taken up his usual stance by the mantel, keeping the fire blazing. Sharon could be heard talking to someone in the dining room. Only Madeline was missing.

Sharon came bustling in a moment later. "Here you go." She handed a flannel-covered hot water bottle to Bridget, and another one to Dorothy. "Just hold these. They'll warm you up." She peered at Bridget's cup. "Need a refill on that toddy? It is cold on the beach this time of year."

"Always cold on the beach in California," Dorothy said, low-voiced. It was the first time she'd spoken since they'd come back into the house, after the ambulance had taken Dave to Santa Cruz. By that time, V.J. and Norbert had come down to the beach to see what all the ruckus was.

Bridget felt a little sick. She didn't think Dave's death-surf had been the result of guilt suffered through causing Johanna's death. She thought it had actually been the other way around—Johanna's death had caused Dave's attempted suicide.

"Sounds to me, from what people have said, that Ms. Ashbrook was behind the whole thing with young Dave," Gonzales said. "Her idea, not his. Treated him like a boy toy, you know? From what I heard, she had no intention of giving him the gate for at least the next couple of weeks."

Norbert stopped pacing. "Hell and damnation," he said, his voice almost pleading. "It had to be this Dave kid. None of my writers would off someone."

"We're still looking at a variety of avenues for investigation,"

Gonzales said smoothly. "It's early days yet to say what we'll find."

Norbert went back to pacing, and added flapping his arms, like a bantam rooster trying to reach a taller perch. "How can it all take so long? My writers here are delicate flowers. They gotta have peace and quiet in which to create, not tension and uncertainty."

Gonzales surveyed them all. "They'll just have to deal with it," he said with finality. "That's how we ordinary people handle things."

"I assure you," V.J. said, "no matter what caused Johanna's death, some of us will be unable to recapture our serenity for a long time."

"Ain't that the truth," Norbert muttered. "Still can't believe it."

"I want to talk to Mrs. Montrose and Mrs. Hofstadler about what happened tonight." Gonzales turned away from Norbert to address the room at large.

"Do you want to take them into the dining room?" Sharon sprang into action. "There's coffee and tea on the sideboard there."

"That would probably be best," Gonzales said.

"What I can't understand," Dorothy said suddenly, "is why Madeline isn't here. It isn't like her to miss out on exciting happenings."

"Interesting point," Gonzales said. "She could be asleep." He glanced at his watch. "It's almost eleven." A yearning note crept into his voice.

Sharon spoke reluctantly. "I could go check on her, if you want," she said, with a notable lack of enthusiasm. "I'm sure she's just fine. Probably working hard, or all tucked up beddy-byes. And I have a little dab of paperwork to finish."

"I'll go with you to check," Gonzales said, "as soon as I've interviewed Mrs. Montrose and Mrs. Hofstadler."

Bridget offered Dorothy a hand up out of her chair, and they

followed Gonzales into the dining room. He sat at the end of the big table, where V.J. had sat just a few short hours ago. Bridget and Dorothy flanked him on either side.

"I want to hear more about why you decided to go down to the beach, and exactly what you saw and heard," he said, setting his little tape recorder on the table.

"Nance would know more about it," Bridget said. "We were just spectators."

"I just wanted a walk on the beach. Dinner was not very pleasant," Dorothy said.

"Massive understatement," Bridget added.

Gonzales looked at them impassively. "You folks seem to tangle a lot at dinner."

"I wasn't the troublemaker this time," Bridget said defensively.

"Everyone was angry with Madeline, because she was so nosy," Dorothy explained. "In spite of me giving her a dressing-down earlier, she was pumping me for information about Johanna again, we think to write a story for some tabloid. Probably already sent them a query. That's why I wondered where she was. Not like her to miss out on any new developments."

"Anyway," Bridget added, "when Dorothy said she needed a walk on the beach, I realized that I needed one, too."

"I stationed a deputy there to keep you all from wandering off," Gonzales said.

"We just wanted to walk down the beach and back again. We weren't trying to sneak out or anything," Bridget told him.

"I love walking on the beach, and one of the mental images I had when I got my invitation was strolling along the Pacific coast and watching the waves," Dorothy said.

"We went less than half a mile," Bridget added. "In fact, I was going to suggest we turn around because the wind was so strong. Then we saw a bonfire with some folks gathered around it, and when we went closer, I recognized them as the surfers I'd met this morning."

"I should speak to each of you separately about what you saw, but it's late, and we all want to get this day over with." Gonzales rubbed one hand over his face, and Bridget realized that he still hadn't shaved. It had indeed been a long day for him.

"I'll tell you what I saw," Dorothy said, "and Bridget can tell you what she heard, because I could hear very little over the noise of the ocean."

In tandem, they related the events they'd witnessed. Gonzales whistled when Bridget told of running along the ocean, and seeing the surfers paddle faster than she could run through the crashing waves.

"Good thing Dave didn't wait a couple of hours later to get suicidal." He cast his glance toward the ceiling fourteen feet above them, and Dorothy and Bridget could hear the angry lash of wind-driven rain on the clay tiles of the roof. "This is working up to be a pretty good storm. The surf is high enough to hold a Mavericks competition."

Even Bridget had heard of that. She told Dorothy, "Only the top surfers are invited. Mavericks is this place near Half Moon Bay where the waves get really huge. They actually tow the surfers out to the waves, and one year one of them died." She stopped talking, her words bringing back the images she had just witnessed. For the life of her, she couldn't understand why anyone would want to challenge the ocean to a duel.

Gonzales continued the conversation about Mavericks. Bridget pulled her brain back to the dining room. "A while ago, PBS did a documentary about the big-wave competition," he said. "The organizers try to keep all the publicity down until it's over, but ever since the program, people try to find out when it is and come and clog up Highway One, though the action is so far away from the road that you can't see anything without a spotting scope. Luckily it was held last December, or the media would already be in full cry."

"Aren't they?" Bridget glanced at Dorothy, who shrugged. "I guess I thought they would be, though I haven't noticed."

"Norbert has lots of security," she said. "Johanna told me he had added extra people because of the threats she'd received." She looked at Gonzales. "You knew about those, I suppose?"

He nodded. "Mr. Rance himself told me all about it, and showed me his setup. He didn't want to show me the surveillance tapes, but I persuaded him."

His wide-eyed gaze suggested irony to Bridget.

"Surveillance tapes?" She shivered. "I didn't know we were being watched."

Gonzales nodded. "Mr. Rance's security setup is excellent. It makes undetected access to any part of his compound difficult."

"Even from the beach?" Bridget asked.

Gonzales looked at her. "The cameras are small and unobtrusive, but the whole compound, including the seawall and gate, is monitored twenty-four hours a day. He even has infrared cameras for nighttime."

"Big Brother," Dorothy muttered.

"In this case, it's come in very handy. We have good daytime tapes and not-so-good but adequate nighttime tapes from the cameras, and only guests came and went over the wall or through the gate."

"Don't the tapes show what happened to Johanna?" Dorothy asked.

"No, they don't go all the way to the waterline, or even very far down the beach. We can see the encounter between Ms. Ashbrook and Mrs. Montrose." Gonzales nodded at Bridget. "We can see Ms. Ashbrook walk off down the beach. She's lost to view almost immediately."

"Who else was roaming around then?" Bridget blurted the question.

Sheriff Gonzales looked at both of them and spread his hands. "Over the course of that evening, pretty much all of you," he said.

27

SHARON MET THEM as soon as they came out of the dining room. "Madeline's door is locked," she said with no preamble. "I've looked around the place, and I can't find her anywhere." She wrung her hands. "I don't like this. I don't like it at all."

"Did you unlock the door?"

"No. I thought it wouldn't be proper," she said primly.

"But you can unlock it." Gonzales rubbed his forehead. "Jeez, this day will never end."

"I have a master key, yes."

"Lead the way."

Sharon led the way, and Dorothy and Bridget followed. Bridget didn't intend to tag along, but her room was also down the hall, and she was desperate for rest herself.

Sharon knocked on Madeline's door. "Madeline, Detective Gonzales is here to see you."

No answer. "Madeline, if you're in there, please open the door."

"Unlock it," Gonzales said to Sharon.

Bridget didn't want to go to her room until she knew that everything was okay, and she could see that Dorothy felt the

same. They stayed back while Sharon fitted the key in the door and unlocked it.

The room was dark. Gonzales stepped in front of Sharon at the threshold. Without going inside, he reached in and flicked the light switch on.

Madeline was in bed. Craning over Sharon's well-padded shoulder, Bridget could see her still form.

"Ms. Bates?" Gonzales spoke loudly. The figure on the bed didn't stir.

Sharon tried to move forward. "Is she ill?"

"Stay back, please." Gonzales stopped Sharon with a peremptory gesture. He went over to the bed and pulled back the covers, turning Madeline over.

Her labored breathing was loud enough to be heard out in the hall. Bridget and Dorothy crowded behind Sharon in the doorway.

"Ms. Bates?" Gonzales shook Madeline's shoulder and pulled up one of her eyelids. He took his cell phone out of his pocket, lifting Madeline's wrist while he barked into the phone, "Gonzales here. We need another ambulance at Ars Ranch. Yes, another one. Yes, it's really me, not a reporter. Get it here, stat. She's still alive, but her pulse is slow. Looks like an overdose of some kind."

"Is that the pill bottle?" Agog with interest, Sharon forgot herself and stepped into the room to scoop up a prescription bottle that had rolled under the desk chair near the door.

"Please don't come into the room. Don't touch anything." Gonzales pulled on latex gloves as he spoke. "I'll take that." He set the bottle down on the desk.

"Sorry." Abashed, Sharon started to retreat, but her skirt caught on the desk, and brushed Madeline's lucky pen onto the floor.

A tinny voice began speaking. "—don't really know anything about it," said Ed's voice. "I haven't even been to the beach yet."

"Why, it's a tape recorder pen." Sharon bent to scrutinize it.

"Don't touch it," Gonzales said sharply. He picked it up as his voice came out of the pen. "Could you just tell me your movements, Mr. Weis?" the pen asked.

Gonzales pressed the pen in a couple of places, and it stopped speaking. He studied it, then took plastic bags out of his pocket and put the pen in one and the pill bottle in another. "I want you all to leave now," he said, looking at the three women who crowded the doorway. "My team will be back to go over this room tonight before we seal it. Tomorrow will be soon enough to talk to everyone." He shook his head. "Man, you writers are hard on each other."

"Not usually," Sharon protested. "Writers are the nicest people—"

"Well, obviously one or more of your current crop is seriously bent." Gonzales herded them into the hallway. "I'm going to need your help," he decided, looking at Sharon. "You two, don't be talking to the others about this."

"I think most everyone has gone to their rooms." Sharon looked up and down the hall. "Bridget and Dorothy are the only ones left on this floor."

Bridget shook off the chill that chased down her spine and grinned weakly at Dorothy. "The mad stalker eliminates all writers on the ground floor."

Dorothy did not grin back. "Is that what's happening?" Her voice was strained. "I'm locking my door and windows tonight."

"Good plan." Gonzales sounded brisk. "Get some rest, ladies. I'll see you bright and early in the morning."

"Will she survive?" Dorothy looked over her shoulder at Madeline, who emitted loud, breathy snores every so often.

"We'll keep her breathing until the ambulance gets here. Further than that, I can't say right now." He shooed them away.

Dorothy looked very shaky. Bridget went into her room with her and looked in the refrigerator. "I see your medicinal tot of brandy didn't survive either."

"Johanna helped herself almost first thing," Dorothy said dazedly. "However, I didn't tell her I travel with a flask of whiskey in case I can't sleep." She gestured vaguely. "It's still in my suitcase on the rack over there. I certainly could use a slug tonight. Fix us both one, would you, dear?"

Bridget found two glasses in the bathroom and the flask of whiskey where Dorothy directed her to look. She splashed a bit of spirit into each glass. A little whiskey would go a long way for her, she knew from experience.

"Cheers," Dorothy said, raising her glass when Bridget gave it to her. "Or rather, not cheers. Courage, I suppose, would be a better toast."

"I don't understand what's going on, but I think Detective Gonzales will get a handle on it," Bridget said, forcing optimism.

"I certainly hope so, and before the maniac killer finishes off everyone on this floor." This time, Dorothy managed to smile. "Why Madeline, do you suppose?"

"That pen. It was in the dining room while the interviews were going on. She was the first one interviewed, right?"

"Right." Dorothy took a swallow. "She must have turned her little gadget on and left it there to record what everyone told Detective Gonzales. *That's* how she knew about your previous experience with murder investigations."

"All those hints she dropped at dinner about knowing stuff were true, I guess." The whiskey burned down Bridget's throat.

"Someone felt threatened by it, obviously." Dorothy set down her glass.

"Unless Madeline decided to commit suicide," Bridget said slowly. "Maybe she was despondent because people were mad at her. Maybe she had personal reasons."

Dorothy didn't look convinced. "She seemed like the last person on earth to be sensitive enough to commit suicide."

Bridget stood up. "Well, we'll find out in the morning. It's late, and we should get some rest. They'll be putting us through another wringer tomorrow."

"Yes, we should rest." Dorothy didn't stir in her chair. "Lock yourself in well, dear. We don't know who might be next."

Bridget crossed the hall and stood at the door for a minute. She could see light spilling out of Madeline's room, and wondered when the EMTs would arrive. Shrugging, she went into her room and locked the door behind her. She looked in the closet, in the bathroom, and even, feeling very foolish, under the bed. Brushing her teeth, she thought about Madeline and why anyone would want to kill her. None of what had happened made any sense to her, but then, she was tired. She hoped Gonzales was thinking better than she could.

Before going to bed, she looked at her e-mail. Emery had replied to her reassuring message; it appeared to have done the trick. She decided to wait until morning to tell him what had happened since she sent that message. He would need his rest to get everyone off to school.

Claudia had sent a message as well. She wrote,

I tried to dig up something on Ed, but couldn't find anything except that his last book, the one on Kaiser Wilhelm, was slated to be his breakout, and it tanked. They had given him a big advance, too, and even done some promotion stuff. Madeline Bates actually turns up a lot of hits on Google. She writes fodder for the lower-paying magazines, stuff about cooking, pseudo-scientific medical breakthroughs, etc. According to her website, she's written for both the Star and the Inquirer. I've asked my friend on the East Coast to refresh my memory about Dorothy's history with Johanna. Nothing any more scandalous about Sandra than you already know. Ditto V.J. I'll keep ferreting. Love, Claudia.

Bridget hadn't brought a printer. She carefully copied down the parts of Claudia's message that applied to Madeline and took it

down the hall. The door to Madeline's room was ajar. She knocked on it, and after a moment Sharon came. "Yes?"

"I just got an e-mail from a friend who looked Madeline up on a search engine. I imagine Detective Gonzales has probably already done that, but just in case, here's what she found out. I copied this from her message, but I'll save the message and he can look at it tomorrow."

Sharon took the piece of paper. "Fine. Get some rest, Bridget. You look all in."

"I am." She didn't linger to see if Gonzales wanted more information. She went back to her room, locked it again, and took a moment to go through the meager pages she'd written that day before she shut down her computer.

As she snuggled into bed, she heard the ambulance pull into the courtyard. Red lights flashed, giving her bedroom a lurid tinge. Despite that, despite commotion in the hall, her eyes drifted shut. She slept.

28

THE NEXT MORNING Bridget found a note in her muffin basket asking her to report to the living room at 11:00. She hoped it wouldn't be to hear that Madeline had died. Irritating though the woman was, death was far too permanent a punishment.

She sidled down the hall to the dining room. It was empty, and she got herself a hasty bowl of granola, a container of yogurt, and the makings for tea, and fled back to her room before encountering anyone else. She ate while e-mailing an update on the situation to Emery, and then actually managed to write a few pages, emptying the thermos of hot water in the process. She was ready for a break and more tea by 11:00. And she was anxious to find out what had happened to Madeline.

Stopping in the dining room, she saw Dorothy getting some coffee. "Is she okay? Have you heard?"

Dorothy seemed to have aged ten years overnight. "I haven't heard, no. Couldn't sleep for a long time, and I just woke up an hour ago."

Bridget put an arm around her shoulders for an impulsive hug, but let go when she felt Dorothy stiffen. "Sorry. I just felt you needed a hug."

"I probably do," Dorothy confessed, "but we Easterners aren't so free with that as you Californians."

They went into the living room together. Sharon was at the door, anxiously counting heads. She heaved a sigh of relief when she saw Dorothy and Bridget. "Excellent. Y'all are the last ones. Go right in."

The familiar figure of Detective Gonzales waited in front of the fireplace. Elaine was curled in her usual place at the corner of the couch, with Sandra perched on the arm beside her. Ed had nabbed one of the armchairs by the fire, but was finding it less comfortable than he wanted, judging from his restless movements. V.J. had pulled one of the straight chairs closer to the group by the sofa. Norbert, uncharacteristically quiet, occupied the other chair by the fire. He wasn't having a pint-sized hissy fit, for a change.

Sharon and Bridget each brought chairs over to the group by the fire; Dorothy sat on the other end of the sofa from Elaine. Detective Gonzales looked at them all gravely.

"Let's get started," he said. "As you all probably know by now, Madeline Bates is in the hospital in Santa Cruz." He looked at Norbert. "Ars Ranch is certainly doing its part to keep the health care industry afloat."

"Just get on with it," Norbert growled.

"What happened?" Elaine sounded scared. She exchanged glances with Sandra.

"She took, or was given, an overdose of prescription sedatives. If no one had found her until this morning, she would have died. Luckily for her, though unluckily for Dave Rodgers, it was noticed that she hadn't responded to the commotion last night. Ms. Buskins thought to check her room, and she was discovered in the first stages of an overdose coma. The doctor assures me she will probably recover, barring any unusual problems with her heart or kidneys, although there is the possibility of mental impairment."

"Who did it?" Elaine looked around. "Who is doing all these awful things?"

"Well, if we knew that, I wouldn't have called you all together here." Gonzales looked tired, too, Bridget thought, and no wonder.

"Detective Gonzales is looking for information you may have about these episodes," Norbert said. He, too, was a member of the baggy-eyes club. "And I must apologize to those of you who came expecting a peaceful place to write. I am most mortified that what's been happening here has made your work harder."

"It's never happened before," Sharon chimed in. "I, too, wish to say how upset I am by these occurrences." She looked less than pulled together; her shirt was ordinary white linen, badly wrinkled, and instead of her usual white pants and cowboy boots, she had put on jeans and sneakers.

"Be that as it may," Gonzales said, "if you had a conversation with Ms. Bates yesterday, I'd like to hear about it. If you're shy about talking in front of everyone, we'll go into the dining room. But I want to hear everything she said to anyone."

There was silence for a moment, then Sandra spoke up. "Well, I'm not shy," she said. "And I had the weirdest conversation with her yesterday afternoon. Elaine and I were in our room, talking, and this note was slipped under the door."

Elaine nodded. "It was strange," she confided. "I was already keyed up because of poor Johanna."

"She wasn't poor Johanna to you when you first got here," Ed pointed out. "You snubbed her every chance you got."

"You can dislike a person and still feel sorry for her," Elaine shot back. Sandra put a hand on her knee, and she clamped her mouth shut.

"Anyway, the note was from Madeline. She said she knew why I killed Johanna, and if I cared to meet her by the pool house later, she'd tell me how I could avoid being arrested."

"A blackmail note," Dorothy said.

"Exactly." Sandra sat up straighter. "I did meet her at the pool house. She had the gall to ask me to blurb her book, and I told her exactly where she could put her blurb. Then she said she'd tell everyone that I—" Her voice faltered.

"Would you like to step into the dining room?" Gonzales was, Bridget realized, recording everything; his tape recorder was on the mantel behind him, picking up the whole room.

"No." Sandra squared her shoulders. "You already know anyway, I told you yesterday in our interview. Madeline was going to reveal to the tabloids the way in which I worked my way through college."

Her chin came up. "I was a drug dealer. I told the detective because I knew if he dug around, he'd find out about my arrests. I'm certainly not proud of my record. I started dealing as a favor to a friend, and after my dad's bankruptcy, I was in danger of having to drop out of Bryn Mawr in my junior year, so I just kept on. It was good money, but I found a more conventional job for my senior year."

Dorothy reached over and patted Sandra's knee. "I won't tell anyone, and I'm sure no one in this room would be so tacky." She looked at Ed, and he looked away.

"I don't deal with tabloids," he said huffily. "But I have to say, it's a very good motive for murder."

"Blackmail is not a pretty thing." Gonzales spoke up. "There's no excuse for Ms. Bates's behavior. But the proper thing to do when you're being blackmailed is to report it to the police. Not take matters into your own hands."

"I didn't." Sandra looked worried. "I just walked away. Told her to tell whoever she damn well pleased. Thing is, I'm already considered a wild woman by my public. Even though I'm really a very domestic kind of gal."

"That's true," Elaine said, sending Sandra an adoring look.

"So this story probably just makes me more bankable for my

publisher. Everyone will rush out and buy my next book to see what kind of scumbag I am."

"It's a good spin," Ed said judiciously. "But your publisher might not see it like that."

Sandra shrugged. "At this point I don't care what they say. My syndicated column does really well, and I'm not enjoying fiction writing all that much anyway. I can easily give back my advance without feeling any pain."

"Well, that's one person who had motive. Anyone else?" Gonzales's gaze circled the room. "I must tell you all now that Ms. Bates managed to tape my interviews with all of you yesterday. I apologize for the breach of confidentiality. But as you can see, anything you told me during that interview, she knew. Did she approach anyone else with a blackmail demand?"

"Yep." Norbert spoke up. "She said she'd tell about my relationship with Johanna, and my wife would probably want a huge divorce settlement, so it made sense for me to work with her to keep her mouth shut."

"What exactly did she want from you?"

"Wanted me to back off the ban on writing up Ars Ranch for the tabloids," Norbert said. He seemed to get mad all over again talking about it. "Wanted me to agree to an interview, for God's sake!"

"Did you agree?"

"Hell no." Norbert snorted. "I know better'n to have truck with a blackmailer. Told her my wife already knew what she was threatening to say. We have an arrangement," he explained airily. "And my lawyers would be glad to drag any tabloid that published that kind of claptrap into a long, expensive legal battle. In short, I told her to take a flying—"

"We get the picture, Norbert, honey," Sharon said, hastening into speech.

"Did Ms. Bates approach you?" Gonzales turned to Sharon. "Well—"

"What did she have on you?" Norbert stared at Sharon. "Always told me you were squeaky-clean."

"She mentioned the adultery thing, but I told her the same as you did, darlin'," Sharon assured him. "Told her your wife and me were friends. Then she mentioned that other matter." Sharon cleared her throat. "The one I'd told you about, Detective Gonzales." She frowned. "And I can't help but think it was very careless of you to let her plant that tape recorder."

Gonzales sighed. "I assure you, I am in the doghouse over that."

"What other matter?" Norbert was agog.

"I'll tell you about it later," Sharon said, steel entering her voice.

"Oh, come on." Ed forced a laugh. "We're all sharing secrets. Why not tell us?"

"It's over," Sharon said sulkily. "I had a problem. I received treatment."

"Was it an STD?" Sandra sounded sympathetic. "They can be hard to get rid of."

"It's past now." Sharon waved away the sympathy. "I just don't want to talk about it."

Dorothy turned the conversation. "By the way," she said, "how is the surfer?"

"Yes, give us the update on Dave," Sharon said, eager to relinquish the spotlight.

"He's recovered enough to tell us a little about what happened the night Ms. Ashbrook died." Gonzales surveyed them all, and after a moment, he added, "He doesn't remember too much about last night. Evidently some drinking was going on at the beach. He just decided to go out like a surfer."

"What happened the night Johanna died?" Bridget didn't mean to ask the question, but her curiosity got the better of her.

"He met her as arranged at the beach access road. They had sex in his friend's VW bus. She was drunk, and they got high as well. He started talking about her staying on with him after

her time at Ars Ranch was up, and according to him, she just laughed. They argued, and she left about eleven-thirty, walking back toward Ars Beach. That's the last he saw of her."

"He says." Ed made the pronouncement, sounding like a TV attorney. "How do you know that's true?"

"Same way I know if anything anyone tells me is true." Gonzales shrugged. "I ask around and see if anyone can contradict it. No one's come forward to say they met Johanna on the beach after Dave says she left." He turned to Ed. "Mr. Weis, did Ms. Bates approach you yesterday?"

"What makes you think she did?" Ed sat up straighter.

"Well, I received a fax here yesterday from Ms. Ashbrook's publisher, giving me some information I asked for. And with Ms. Bates's highly developed skills at snooping, I have to wonder if she somehow got a glimpse of that fax." He looked at Sharon and Norbert.

"I was hardly in the office at all yesterday until you were finished," Sharon said instantly, "and then all I did was clean up the mess your fellas left behind. I don't know anything about any fax."

"Mr. Rance handed me the fax, so I assume he knows."

Norbert stared at his hands for a moment. "That woman was in the office when I came in and found the fax in the machine. She might have seen it. I don't know what she was doing there or how she got in. I had locked the door when I left."

"Your office lock—in fact, all your interior locks—are easily opened with a credit card," Gonzales told him. "You might want to get that changed."

Bridget looked at Ed. His face paled. He seemed to shrink back in the armchair, as if he wanted to be invisible.

"So we've established that Ms. Bates had an opportunity to see the fax."

"But what does that have to do with Ed?" Sandra looked at Ed. They all looked.

He didn't say anything, just burrowed deeper into the chair.

"What was it, Ed? You wanted to hear everyone else's se-
crets." Sandra tilted her head, smiling. "Let's hear your dirty lit-
tle secret."

Dorothy wrinkled her forehead. "It was from Johanna's
publisher, but it concerned Ed, who writes for a different com-
pany altogether." She looked at Ed, astonishment dawning on
her face. "Don't tell me. You're the ghost."

29

ED SAID NOTHING, but Sandra bounced on the chair arm and clapped her hands. "That's got to be it. Ed was going to ghost Johanna's new book."

"Why would they ask you?" Dorothy was puzzled. "You don't even write fiction."

Ed looked resentfully at Detective Gonzales, but he still didn't speak.

"This morning, I did some more checking," Gonzales said. "It turns out that Mr. Weis is more accomplished at fiction than most people know. He wrote several romantic suspense novels under a woman's name."

Dumbstruck, they all stared at Ed. He stared defiantly back.

"Look, it was fifteen years ago. I needed money, and my agent wrangled a contract for me to write three of the damned books." He paused, then went on, "And I was damned good at it, too. They wanted me to do more, but by then my first biography had come out and it did well, so I decided to write books I could put my own name on."

"What happened?" Dorothy looked dazed. "Why did you agree to ghost for Johanna? Didn't you know she would be impossible to work with?"

"My last book didn't sell too well," Ed said sulkily. "I didn't

get a new contract, if you want the truth. I needed the money."

"So Madeline threatened you with exposure as the ghost-writer."

"She said she'd tell it all—the ghosting and my previous pseudonymously published books." Ed sat up straighter and steepled his fingers. "Unlike the rest of you brave souls, I did not want that spread all over the place." He hesitated. "And she said she saw me." The words burst from him. "She saw me take Johanna's laptop. I didn't know she saw. I was just afraid there would be something on it that said I was the ghostwriter. She said everyone would think I killed Johanna."

"Is that why you put the sleeping pills in her coffee?" Gonzales's voice was quiet, conversational. Bridget caught a movement from the corner of her eye, and saw that Deputy White and another deputy were stationed just outside the living room archway.

Ed couldn't see them from where he sat. "I don't know what you're talking about," he said with bravado.

"I'm talking about you finding Ms. Bates's purse in the dining room last night. Ms. Buskins told me she left it there. You found Ms. Bates's prescription in her purse, dissolved the pills in a cup of coffee, and took that and some cookies to her room. Maybe you pretended you wanted to talk about the blackmail. We know from her stomach contents that she drank the coffee and ate the cookies, and when she passed out you tucked her into bed. Then you removed the dishes and left them on the dining room table. Albert remembers finding a plate and cup there after they'd cleaned up the dinner dishes. You just made one mistake, Mr. Weis. The pill bottle."

"What do you mean?" Ed jumped out of his chair. "I used gloves—"

"Exactly." Gonzales nodded, and Deputy White and her cohort came in to stand on either side of Ed. "Edward Weis, I arrest you for the attempted murder of Madeline Bates. You have the right to remain silent. Anything you say can and will be used

against you in a court of law...." His voice droned on through the standard warnings. Looking dazed, Ed made no fuss when the deputies led him away.

"Well, hell." Norbert, too, was dazed. "I never saw that coming. Sheesh, the attrition rate is climbing around here. You figure he was responsible for Johanna's death as well?"

"It's possible."

"What tipped you off?" Bridget scooted forward in her chair. "And why did you make everyone tell their secrets?"

Gonzales rubbed his forehead. "I was hoping he'd volunteer it, tell me how he told Ms. Bates off. When he didn't, I thought he might have agreed to pay the blackmail, unlike the rest of you."

"I wonder what she asked for?" Elaine sounded as if she'd been watching a movie instead of real life.

"Probably the same she asked from me—help with an agent or a blurb or something. She didn't know the threat of having his less-than-manly past revealed would push him over the edge." Dorothy looked shaken.

V.J. came and patted her shoulder. "We have both known Ed for a long time. It's hard to believe this of anyone you think you know."

"So I guess he killed Johanna, too," Elaine chirped. The revelation of the culprit had restored her to good humor.

Gonzales hesitated. "We'll pursue that line of questioning. But Ms. Ashbrook didn't know who'd been chosen as her ghost, and also wasn't privy to the information about Mr. Weis's past. We found an e-mail on Ms. Bates's computer from a friend of hers who wrote romances. She was answering a query Ms. Bates sent yesterday morning. The friend confirmed to us this morning that years ago she'd mentioned helping Ed with research for one of his romantic suspense novels. Evidently Ms. Bates remembered things like that."

"So that's it. Either Dave or Ed probably killed Johanna, and we can all breathe a little easier now." Sandra sounded almost jubilant.

"I just can't believe it," Norbert said. "Known Ed for years. I can see him knocking off that Bates woman. Miracle no one had tried it before, if you ask me. But Johanna..." He looked bewildered. "Why? What reason would he have for that? There's others here with better reasons." He slanted a look at V.J.

"It's true Johanna drove me round the bend sometimes," V.J. said with dignity. "But I would never harm her. I loved her."

"We all loved her," Norbert said. "But she could really piss me off," he added in a burst of frankness.

"I didn't love her one iota," Sharon said. "But it's a long step from disliking someone to killin' her."

Bridget wondered why Gonzales was still standing there, as if expecting further revelations. He should, she thought, be heading back to his office to start the process of getting Ed arraigned. It was, she knew from listening to Paul Drake, a long process. Instead, he stood in front of the fireplace, hands behind his back, as if he had all the time in the world.

"Well," Sandra said, stretching her arms over her head. "We don't have to worry about why Ed killed Johanna. It's just a relief to know it's all over."

"But it's not over, is it, Detective Gonzales." Bridget found herself speaking up. "You don't think Ed did it."

Gonzales shrugged. "I don't know, one way or the other. We'll be giving his movements a lot of scrutiny, checking his statements against everyone else's, rerunning the security tapes to see who was on the beach when." His gaze drifted around to each of them, and suddenly the giddy relief in the atmosphere evaporated.

"So you think that in this small group of writers, there are two murderers?" V.J. sounded incredulous. "Detective, we don't kill. We are creatures of reflection, not action."

"I'm not ruling it out," Gonzales said.

A babble of voices broke out. Chief among them was Norbert, who managed to shout everyone else down by virtue of being loudest.

"That's it. I've had it!" He stormed around, his arms going again. "This here writers' retreat is over. How the hell can any-one produce any art under these circumstances? I'm sorry, folks, but I'll have to ask you to leave. And it'll be a cold day in hell before I host another bunch of writers here. Who could figure they'd be so bloodthirsty?"

Sandra bristled. "Well, you had as good a reason to do in Johanna as any of us. I don't know why you act like we're the violent ones. Look at yourself!"

"Yes," Elaine snarled, uncoiling from her corner. "You're not one to preach, Norbert Rance. Despite all that's happened in the past couple of days, you managed to find the time to hit on me."

Sandra looked thunderstruck. "Pussycat, did he do that?"

V.J. gripped the back of the couch. "Please, what does all this matter? We have lost three of our companions in letters at this point. It is not time for quarreling!"

"Stay out of this," Norbert snarled, turning on V.J. "I only invited you because she wouldn't come unless you were here."

"And it was that important that she come?" Gonzales's voice was soft, conversational.

"Yes, damn it!" Norbert's face contorted. "Norbert Rance doesn't play the fool for any woman. I'm no Adonis, but there's a passel of women who'll tell you that ole Norbert is plenty big enough between the sheets. She trolled me, and then she just cut line. That ain't the way it ends!"

"We are both fools," V.J. observed with a cynical smile. "She played us both. No doubt she laughed at us when she was with her young lover."

Everyone was silent, startled by the bitterness of these out-bursts.

"So it seems there were many with strong emotions about Ms. Ashbrook," Gonzales said eventually.

"Well, she was such a bitch, wasn't she?" Sandra's voice was venomous. "After all the pain she cost me, all I went through

when she walked out, she had the nerve to suggest, not two hours after I got here, that we—"

"She did! I thought so!" Elaine rose up once more. "You denied it, but I could tell. She was there that first day when I came back from using the weight machines. She came on to you, didn't she? You were tempted, weren't you?"

"Don't be silly. I turned her down flat," Sandra said with a nervous laugh. "I've been with you all the time. You know that."

Elaine subsided.

Norbert, hands on his hips, was by no means subdued. "I want to know what you're up to here, Detective Gonzales. Settin' us at each other like this. As if any of this, or Sharon's kleptomania, had anything to do with Ed killin' Johanna."

"Norbert!" Sharon said. "How did you—"

"Everyone on my staff agrees to a thorough background check. You know that."

"But I didn't think you'd run one on me!" Sharon was outraged. "You said I was precious to you. You said—"

"I know what I said," Norbert said testily. "One thing is business, the other is separate. Although," he added, "I usually have the women who catch my eye investigated, too. Saves trouble in the long run."

Gonzales brought an end to this by cutting Sharon off when she tried to reply. "Right now we're talking about Ms. Ashbrook's demise. And according to the surveillance tapes, Mr. Weis did take a walk on the beach, despite his denial in our interview. In fact, he went down to the seawall with Ms. Bates around ten-thirty, soon after Ms. Montrose went back to the house. They walked out of camera range. Ms. Bates returned about ten minutes later, and then a few minutes after that, Mr. Weis came back. He didn't go out to the beach again. Whoever was responsible for Ms. Ashbrook's death was on the beach between eleven-thirty and one, judging from the coroner's report and what Dave tells us. That makes Mr. Weis highly unlikely to have caused Ms. Ashbrook's death."

30

ONCE MORE the room was silent. Bridget stared at all of them in turn. Norbert shifted uneasily. Sharon nibbled at one carefully manicured fingernail. Sandra gripped Elaine's shoulder until she squeaked in protest. V.J. stood behind the sofa, his face impassive.

Slowly Dorothy struggled out of the sofa cushions. "I know what you want me to say, Detective," she said. "And this has certainly gone on long enough. I thought, if no one was harmed by my silence, I would keep it forever. But I see that everyone *is* harmed." She looked around at the circle of faces. "I caused Johanna's death, as the sheriff so delicately puts it. It seems he has figured out the whole sordid event."

"You?" Bridget gasped, her heart plunging. "No! You're just saying that to—to help someone out or something!"

"That is true," Dorothy said, considering. "I'm helping you, Bridget, and even Sandra and Elaine, although I find both of them banal in the extreme." Sandra gasped with outrage, but Dorothy ignored her. She looked at Bridget as if seeking her absolution. "I am saving V.J., too, because I love him dearly, although he is such an idiot about women. It's lowering to reflect that even the most intelligent men are as much enslaved

by physical beauty as the stupidest men are." Her gaze flicked to
Norbert. "Yes, I'm even saving Norbert Rance's annoying hide.
And to save all these people, I don't have to lie." She smiled gen-
tly at Bridget. "It's true. I caused Johanna's death. I didn't mean
her to die. I didn't even intend her harm."

She took a deep breath and turned to face the room at large.
"I went out for a late-night walk on the beach, something I have
always loved to do when there's a moon. I saw Johanna stum-
bling along with her shoes off, wading in that ice-cold water.

"I went to help her," Dorothy continued conversationally.
"Took her arm, guided her up onto the sand. She was drunk, as
usual, but also high, I think. She laughed and laughed as we
walked, about her boyfriend Dave and how he wanted her to stay
with him. 'Not bad for a forty-year-old, is it?' she said."

Dorothy took a breath. "I told her she should be ashamed,
and she shook me off. Said she didn't need any more lectures,
thank you very much. She didn't need my help or anybody's
help.

"I looked at her staggering there, with the tide sucking the
sand from around her feet, and I was just so filled with contempt
for her." Dorothy's voice faltered. "I—suppose you should know
that ten years ago, Johanna seduced my son; he was eighteen at
the time. Old enough to make his own decisions, as he told me.
They both told me they were in love, it was true love, it was for-
ever, despite the difference in their ages."

She paused for a moment. "I most definitely did not
approve, but I tried to stay out of it. Of course, Johanna had no
more idea of constancy than a cat does. When she cut him loose,
Peter went through a bout of self-destructive behavior. He was
killed in a rock-climbing accident in the White Mountains a few
months after that."

"Oh, Dorothy." Bridget longed to put her arm around those
sagging shoulders, but knew that Dorothy wouldn't welcome
the gesture. "What a burden for you. How could you even be
civil to her?"

"It's true I blamed Johanna. But not out loud. Peter made his choices. He was young and foolish, and they were bad choices, but they were his. Johanna was penitent at the time, but she never remembers—" Dorothy's voice sank. After a moment, she went on valiantly. "She never learned from the pain, either hers or anyone else's. That's why I did what I did."

"What did you do, exactly?" Gonzales's voice was conversational, not interrogatory.

"Well, when she spurned my help, I said something like, Suit yourself, and walked past her. She reeled a little as I came even with her, and our shoulders bumped together, hard. I felt her stagger; I even heard a thud. I didn't turn around. I just kept going. I didn't know she was unconscious, at risk of drowning. I just thought if she got wet, she'd sober up enough to get back to her room. I could have pulled her up past the high-tide line and gone for help. I walked away, and left her there for the ocean to take."

Dorothy looked at the detective. "Go ahead. Arrest me. I know what I did was wrong."

Gonzales was satisfied. "I'm going to arrest you," he told Dorothy. "We'll corroborate your story as best we can. I can't say at this point what charges will be brought by the DA, but there's a good chance it will be manslaughter, maybe even involuntary manslaughter. You will probably be able to get bail."

Bridget could restrain herself no longer. She hugged Dorothy. "I'm so sorry. I'm so very sorry."

Dorothy patted her back. "Don't be, my dear. We all make our choices. I wish," she said, looking past Bridget to V.J., "a hundred times since then I've wished, that I had made the more generous choice. The one I did make is a burden I don't care to live with. Nothing can atone for it."

V.J. looked at her, his face expressionless. Then he came forward and folded his arms around her once. "If faced with the same choice, I am not sure I could have been generous. You could not know the consequences."

Dorothy smiled bleakly. "I'm a writer. I could imagine them."

"Let's go, then," Gonzales said, picking up his tape recorder. He took Dorothy's arm and led her from the room. She glanced back at the doorway, and once more her gaze beseeched Bridget.

Then she was gone.

31

"*SO WE PACKED UP AND LEFT,*" Bridget said, polishing off a dish of cottage cheese at her kitchen table. "Didn't even get lunch."

"Too bad." Emery had come home from work to meet her after getting the e-mail she'd sent before disconnecting her computer at Ars Ranch. "Judging from what you say about the food."

"Fascinating." Claudia had also gotten Bridget's e-mail, and had bullied Liz into driving her over. "So Dorothy Hofstadler just let Johanna drown. I never would have thought she could be so stern." Claudia's voice was almost admiring.

"It's not something light," Bridget protested. "You could tell Dorothy was really suffering from her actions."

"Not as much as Johanna suffered," Claudia said. "Though I admit that woman was on her way to an early grave, the rate she was going."

"It's not for us to judge," Liz said, low-voiced. She sat quietly, an uneaten brownie in front of her. Bridget had made the brownies first thing when she got home, needing to connect herself to her real life again.

"Liz is right." Emery finished the last bite of his brownie and

reached toward Liz's. "And it looks like she's not hungry, either."

"No dice." Liz slapped his hand away, and broke off a corner of the brownie. "Get your own."

"It's true, though." Bridget was still shaken by the discovery that a woman like Dorothy could have enough darkness in her soul to walk away from someone in trouble. "We don't know all the circumstances."

"Well, I'm sorry you didn't get the opportunity to work more on your book," Claudia said, returning to practicalities. "And I'm sorry Norbert's shutting down the Ranch. I loved my visit there." She frowned at Bridget. "Your rowdy bunch has spoiled things for everyone."

Bridget shivered. "Not my rowdy bunch. All the writers I've hung out with before have been wonderful."

"Most writers are wonderful," Claudia said staunchly. "Look at present company."

"Excluding me." Emery got to his feet. "If you're going to talk writer talk, I'm out of here. Glad you're back, honey. Can you pick up the kids this afternoon?"

Laughing, Bridget agreed.

"What will you do about your book?" Liz gave Bridget a worried look.

"Well, I did actually get a good start, and I think I can keep going on it. And I decided not to stress about it. Listening to everyone else for the past couple of days, I realized that making a lot of money isn't the most important thing to me. I mean, look at Johanna—she had buckets of money, and she was the saddest thing, really. And Sandra, too. I wouldn't have her life for anything." She looked around at the messy kitchen, with a sink full of dirty dishes, a refrigerator covered with kids' drawings, and roller-blade scuffmarks on the floor. "I like my life. I want to write, but I want to suit myself in how I do it. I refuse to cave in to this pressure."

"Good for you!" Claudia clapped her on the back. "Write

what you want and when you want to. That's how you did the first one, and it obviously worked that time." She stood up. "I'd better get going if I'm going to get to Santa Cruz before rush hour."

"Why are you going to Santa Cruz?" Liz looked resigned. "I guess I can go with you."

"I'll drive myself." Claudia was affronted by the offer. "I'm going to see Dorothy, of course. She may need a good attorney, and I just happen to know one in Santa Cruz. And I want to offer her a place to stay if she needs to stay around here after she gets bail."

Liz smiled. "I'll be glad to drive with you. Maybe I can help too."

"Here, take some brownies and go," Bridget said. "I have a couple of hours before I have to pick up kids, and there's something I want to write."

Jerry Smith

ABOUT THE AUTHOR

Lora Roberts lives in Palo Alto, California, with her family. She has not been hanging out in all the coffee places on the Peninsula, eavesdropping on your conversation and taking notes for one of her books. No matter what you might think.

Go right on talking…it was just getting really good.

Lora Roberts may be visited on the Net at www.NMOMysteries. com and e-mailed at myslora@pacbell.net.

MORE MYSTERIES
☠ FROM PERSEVERANCE PRESS ☠
For the New Golden Age

Available now—

Flash Point, A Susan Kim Delancey Mystery
by Nancy Baker Jacobs
ISBN 1-880284-56-1
A serial arsonist is killing young mothers in the Bay Area. Now Susan Kim Delancey, California's newly appointed chief arson investigator, is in a race against time to catch the murderer and find the dead women's missing babies—before more lives end in flames.

Open Season on Lawyers, A Novel of Suspense
by Taffy Cannon
ISBN 1-880284-51-0
Somebody is killing the sleazy attorneys of Los Angeles. LAPD Detective Joanna Davis matches wits with a killer who tailors each murder to a specific abuse of legal practice. They call him The Atterminator—and he likes it.

Too Dead To Swing, A Katy Green Mystery
by Hal Glatzer
ISBN 1-880284-53-7
It's 1940, and musician Katy Green joins an all-female swing band touring California by train—but she soon discovers that somebody's out for blood. First book publication of the award-winning audio-play. Cast of characters, illustrations, and map included.

The Tumbleweed Murders, A Claire Sharples Botanical Mystery
by Rebecca Rothenberg, completed by Taffy Cannon
ISBN 1-880284-43-X
Microbiologist Sharples explores the musical, geological, and agricultural history of California's Central Valley, as she links a mysterious disappearance a generation earlier to a newly discovered skeleton and a recent death.

Keepers, A Port Silva Mystery
by Janet LaPierre
ISBN 1-880284-44-8
Shamus Award Nominee, *Best Paperback Original 2001*.
Patience and Verity Mackellar, a Port Silva mother-and-daughter private investigative team, unravel a baffling missing-persons case and find a reclusive religious community hidden on northern California's Lost Coast.

Blind Side, A Connor Westphal Mystery
by Penny Warner
ISBN 1-880284-42-1
The deaf journalist's new Gold Country case involves the celebrated Calaveras County Jumping Frog Jubilee. Connor and a blind friend must make their disabilities work for them to figure out why frogs—and people—are dying.

The Kidnapping of Rosie Dawn, A Joe Barley Mystery
by Eric Wright
Barry Award, *Best Paperback Original 2000*. Edgar, Ellis, and Anthony Award nominee
ISBN 1-880284-40-5

Guns and Roses, An Irish Eyes Travel Mystery
by Taffy Cannon
Agatha and Macavity Award nominee, *Best Novel 2000*
ISBN 1-880284-34-0

Royal Flush, A Jake Samson & Rosie Vicente Mystery
by Shelley Singer
ISBN 1-880284-33-2

Baby Mine, A Port Silva Mystery
by Janet LaPierre
ISBN 1-880284-32-4

Forthcoming—

Death, Bones, and Stately Homes
by Valerie Malmont
Finding a tuxedo-clad skeleton, Tori Miracle fears it could halt Lickin Creek's annual house tour. While dealing with disappearing and reappearing bodies, a stalker, and an escaped convict, Tori unravels the secrets of the Bride's House and Morgan Manor, which the townsfolk wish to hide.

Slippery Slopes and Other Deadly Things
by Nancy Tesler
Biofeedback practitioner/single mom/amateur sleuth Carrie Carlin is up to her neck in snow, sex, and strangulation when her stress management convention is interrupted by murder on the slopes of a Vermont ski resort.

NONFICTION
Funhouse & Roller Coaster:
Creating the Reader's Experience in Mystery and Suspense Fiction
by Carolyn Wheat
The highly regarded author of the Cass Jameson legal mysteries explains the difference between mysteries (the art of the whodunit) and novels of suspense (the flight from danger) and offers tips and inspiration for writing in either genre. Wheat shows how to make your book work, from the first word to the final revision.

**Available from your local bookstore or from
Perseverance Press/John Daniel & Co. at (800) 662-8351
or www.danielpublishing.com/perseverance.**